SOVIET ART
IN EXILE

by Igor Golomshtok and Alexander Glezer

Introduction by Sir Roland Penrose

Edited by Michael Scammell

 RANDOM HOUSE NEW YORK

First American Edition

Copyright © 1977 by Writers & Scholars Educational Trust

All rights reserved under International and
Pan-American Copyright Conventions. Published in the
United States by Random House, Inc., New York, and
simultaneously in Canada by Random House of
Canada Limited, Toronto. Originally published in
Great Britain as UNOFFICIAL ART FROM THE
SOVIET UNION by Martin Secker & Warburg Limited.

Designed by Dennis Bailey

Library of Congress Cataloging in Publication Data

Golomshtok, I. N.
Soviet art in exile.

Bibliography: p.
1. Dissident art – Russia. 2. Art, Modern – 20th century –
Russia. 3. Dissenters, Artistic – Russia – Biography.
I. Glezer, Aleksandr, joint author. II. Title.
N6988.G58 1977 709'.47 77–3344
ISBN 0–394–41644–9

Manufactured in Great Britain

Contents

Acknowledgments

It is impossible to thank all the people who have contributed to the realisation of this book, but particular acknowledgments are due to my two Russian collaborators, Igor Golomshtok and Alexander Glezer. Without the first the idea would never have been sustained long enough to come to fruition, and without the second there would have been insufficient material available – and, perhaps, insufficient interest – to make it a reality. Very special thanks are also due to Sir Roland Penrose, whose lively interest and vast experience have guided us in the choice of works to reproduce for the benefit of a non-Russian public.

Others whose work and assistance have been essential to this book are Giles Neville, who compiled the bibliography; Hilary Sternberg, Antoni Marianski, Milada Haigh and Andrea Owen, who did the translations from Russian; and Jean-Claude Muller and Eileen Tweedy, who took most of the photographs. I would also like to thank the handful of Russian artists now in the West for their cooperation and assistance: William Brui, Victor Kulbak, Lydia Masterkova, Lev Nussberg, Oleg Prokofiev, Mikhail Shemyakin and Edward Zelenin. And also the collectors who made their work available but who prefer to remain anonymous.

Another category of people whose assistance I gratefully acknowledge comprises all those who encouraged me in the project from the outset, ran errands, made introductions, passed on information, read and commented on the texts, and in a thousand ways made the whole project possible. They include Mme Bernadette Gradis, Mme Liudmila D'Aguiar, Mme Maya Glezer, Mlle Alexandra Svechina, M. Stéphane Tatishchev, and M. Joël Bouessée in Paris; and in London Wolfgang and Jutte Fischer, John Golding, Mr and Mrs Eric Estorick, Anthony Hill, Gillian Wise, Ted Little, Mike Kustow, Andrew Nurnberg, Betty Assheton, T. G. Rosenthal and Elena Hope. Special thanks for their early interest and encouragement are also due to Messrs Allan Dowling (and his wife Helen), Yehudi Menuhin and Henry Moore.

Finally I should pay tribute to the tireless efforts and generous expenditure of their time (and patience) by my editor, Sophia Macindoe, and my secretary, Kay Bader, without whom none of this would have been accomplished.

Grateful acknowledgment is made to the European Cultural Foundation for their generous support of this project.

Michael Scammell

Preface
Michael Scammell

This book has been compiled in conjunction with a large, representative exhibition of contemporary Russian art, Unofficial Art from the Soviet Union, which opened at the Institute of Contemporary Arts in London on 18 January 1977. Almost all the work reproduced here was included in that exhibition and almost all the work in the exhibition has been shown here.

By normal standards both book and exhibition must be deemed somewhat unusual, because of the difficult circumstances in which they have been assembled. These in turn are due to the difficult circumstances in which the artists represented are obliged to live and work. Since there are so many of them, their personal situations obviously vary, but the one thing they have in common is the pressure exerted on them by the Soviet authorities to conform to a single artistic credo and style ("Socialist Realism") and their rejection of this style in favour of an individual and independent approach to the problems posed by their art. The pressures brought to bear on them vary enormously. At one end of the scale these pressures are administrative and indirect, exercised through commissioning policies and the granting or withholding of privileges. At the other they can extend to arrests, intimidation and physical brutality. The response of the artists also varies. Some are worn down by the vast array of pressures brought to bear on them. Others go to enormous lengths to circumvent them silently and with cunning. And yet others respond with vigour and indignation, resorting to virtually their only weapon – publicity – in their struggle to follow their vocations.

None of these artists, however, has openly sought a conflict with the political authorities and it is for that reason that we have eschewed such emotive terms as "dissident" or "underground" for this art and prefer to describe it more neutrally – and comprehensively – as "unofficial". This is only meaningful, of course, when applied to a society in which there is a positive and officially endorsed policy for every facet of social life, as is the case in the Soviet Union, and when the arts in particular are carefully policed

and controlled. "Unofficial" implies nonconformity with official prescriptions and a preference for individual judgment, but not necessarily adherence to any alternative ideology, nor unanimity as to the kind or degree of independence desired.

The situation of the unofficial artists is fraught with other ambiguities. For instance, although in principle the non-adherence of artists to the doctrines of Socialist Realism is itself regarded as reprehensible and subversive, in practice the mere painting of undesirable pictures does not lead to active persecution – so long as this activity remains strictly private. It is attempts on the part of the artists to make contact with the public, and particularly to organise public exhibitions, that provoke particular fury in the authorities and have led to such excesses as the calling in of the bulldozers in 1974 to crush the open-air exhibition on the outskirts of Moscow. Yet at the same time it is permissible for the artists to show their work to foreigners – to visiting diplomats, journalists and participants in cultural exchanges – and these have become both the principal public and the principal buyers of this work within the Soviet Union.

In a sense they thus act as a safety valve, but this phenomenon is highly unsatisfactory in other ways, for it tends to cast an unnatural, political shadow over the whole activity of unofficial painting and introduces an element of deplorable artificiality into the business of showing and appreciating, buying and selling pictures. Given the xenophobia and chauvinism that are normal features of Soviet society, actively encouraged by the government, the artists are automatically made vulnerable to charges of disloyalty, lack of patriotism and even sedition. To this is added the further complication of police attempts to infiltrate their ranks and place informers among them. Then there are distortions in the artists' relations with their audience caused by the simple fact that their principal public is neither Russian nor particularly expert.

Nothing can be done, of course, about the artists' isolation from the Russian public unless their government wills it. But the idea of producing this book (and mounting an exhibition) sprang from a desire to reduce the larger isolation. The Writers & Scholars Educational Trust, which has been responsible for compiling them both, is devoted to the study of censorship and of problems concerned with freedom of expression. There is no doubt at all that these artists are being both formally and systematically censored by being prevented from exhibiting their work. Those few exhibitions that have been held on Soviet soil have been so limited, brief and obscure as scarcely to count, and if they have been carefully listed later in these pages, this is for archival reasons

and should not be taken to imply equivalence with the usual sort of exhibition elsewhere. Yet these artists have at least a human right to have their work seen and appreciated, even regardless of its quality and even at the level of cultural anthropology, which possesses great interest of its own.

And it may be that this is the chief interest their work possesses, for it is extraordinarily difficult to arrive at any sort of judgment about its aesthetic quality or to settle on the right criteria for doing so. It would be wrong, for instance, to exploit the human and political emotions aroused by contemplation of their difficult situation as an alibi for the quality of their work. They themselves, I think, would not want to be shielded from the rigours of an appreciation and criticism based on the same standards as applied elsewhere. This is not to go to the opposite extreme of maintaining that all their art is apolitical, that the artists are not involved in the society around them. Their art spans a very wide diapason and the artists range from the socially committed to the almost wholly other-worldly and disengaged. But there is a sense in which all art has a political dimension and no one would wish to assert that these artists are totally detached from everyday reality. What one can assert, however, is that their vision of the world is an artistic vision, possessing the same validity (subject to the vagaries of individual talent) as the artistic vision of any other time and place. And it is as wrong to deny this validity and distort it into a crude political message for hostile reasons as it is misguided (if under-standable) to overpraise it for reasons of solidarity.

My own experience has been that specialists in the West, on first acquaintance with this work, tend to see in it little but a succession of pastiches of all the well known styles of this century, ranging from Cubism to Conceptual art. It is the conviction of the two Russian authors of this book that such a view is unjust. They maintain that the true character of Soviet society, particularly as it affects the position of the artist, is as remote from the contemporary West, and as little known to it, as the tribal societies of Papua and New Guinea. What they are attempting to do therefore is provide a context in which to understand this art better, and to show that the artists are not simply content to try on the various modern styles like secondhand clothing, but do in fact go beyond them to create something different. What they find, in other words, is fully concrete and individual responses to concrete situations and events. It may be, of course, that artists obliged to live in the cultural vacuum described by Golomshtok are doomed to retrace the whole history of twentieth-century art, step by step, and to remain imprisoned in mediocre provincialism. But they may also

perhaps make discoveries of their own. Another problem is that many of the strictures on the quality of the work seem to be prompted by a comparison, conscious or unconscious, with that brilliant Russian pleiade of artists who contributed so much to modernism during the first quarter of this century. Disappointment then results from making excessive demands, and perhaps also from a failure to find the expected and an inability to perceive the unexpected. At all events, one of the prime objectives of both book and exhibition is to try to find a middle ground between these two views and invite people to clear their minds of preconceptions and take a careful – and sympathetic – look at what this art has to offer.

Finally, a word about the timing and contents of this book. The single most important event leading to its appearance was the now notorious open-air exhibition that was bulldozed in 1974. This was followed by an officially sanctioned open-air exhibition in Izmailovsky Park, to which no less than seventy artists brought their works and which was visited by thousands of eager spectators. This apparent relaxation, however, was accompanied by harsher measures, one of which was the expulsion of Alexander Glezer, a collector and friend of some of the artists and a prime mover in staging the first exhibition. Glezer arrived in Vienna in February 1975, bringing several dozen of his pictures with him, and within a year of that time had succeeded in bringing out several hundred pictures more and establishing a "Russian Museum in Exile" in Montgeron, near Paris. It was the presence of this large quantity of paintings in France, and the knowledge that there were many more in private collections, that determined us to introduce them to a wider public.

The bulk of the pictures shown here, therefore, comes from the Russian Museum in Exile in Montgeron, but we have also drawn widely on various private collections in order to give as representative an idea as possible of what is happening in art in the Soviet Union today. But we are under no illusions that we have succeeded in identifying and illustrating all the artists who should be here. Indeed, we are already aware of some who are missing – Vladimir Galatsky, Oleg Kudryashov and Vadim Sidur among others – and there is much interesting work being done in the Baltic republics and in the Caucasus which has remained inaccessible to us. Nor have we necessarily got the best work by the artists represented, for nobody is in a position to know what or where the best is. What we have tried to do, however, is to obtain and show the best of what is available to us, although here again I should make it clear that we are aware of the presence of excellent works

in various countries that we simply could not photograph in time.

A similar caveat should be entered with regard to the artists' biographies and manifestos and the bibliography that appears at the back. In every case we have attempted to assemble all the information that is available to us – and I can confidently say that this book is more comprehensive than anything that has appeared so far – but much of the necessary information is so scattered and inaccessible that this can only be regarded as a beginning. What it is, in fact, is an explorer's chart, a tentative mapping out of a territory which remains to be more thoroughly investigated.

And one last point. A few of these artists have emigrated within the past year and it looks as though several others, despairing of their situation at home, may follow them in the fairly near future. This makes the present time a particularly good moment for surveying the scene so far. But in the case of emigrants we have limited the work shown in this book to that done within the Soviet Union, excluding their work in the West. This is an arbitrary decision. But our aim throughout has been to illuminate that art that is being produced within the Soviet Union and to exhibit a facet of a culture whose very right to existence has been placed in question.

Introduction
Roland Penrose

In a country where individual freedom of thought is claimed as a traditional right – the prerequisite for freedom of speech and expression – it is with alarm that we realise that elsewhere even this initial birthright is seriously threatened in the name of law and official doctrine. There is no society that does not harbour in some degree injustice and intolerance; and it may be that in some circumstances an element of struggle against tyranny can provide a valuable stimulus to the formation of a more liberal and equitable society. But a systematic denial of our most fundamental rights can only be met with revulsion and condemned as a crime against humanity.

William Blake declared that "a warlike state cannot create", a statement which proves how completely we are removed from those forms of tribal society in which the rites of the war dance and other ominous tribal ceremonies formed an integral part of the life of each individual. It would be rash to compare the creative atmosphere shared by the whole community in primitive societies with the sterility of the police state, where dogma is imposed by decree. Both are despotic, but the former results in a flowering of the arts as part of a way of life which is closer to nature, whereas the latter has an inhuman insensibility, a quality that resembles the most sinister aspects of the machine, man's own creation, a machine which in this case is calculated to crush all inspiration.

The principal impulse behind the compilation of this book and the mounting of the exhibition that gave rise to it was a desire above all to provide a means of communication with artists whose liberty of self-expression has been severely curtailed in their own country. In general, if an artist or poet should find himself unable honestly to subscribe to the judgment of an established power, whether it be imposed by academic principles or by the authority of church or government, it is an injustice to condemn him to silence. And it was primarily to break this silence that this book – and the exhibition – were conceived.

In the West we have become accustomed to the tolerance that

exists between artists and politicians. There is a gap between the two in which criticism of the state by the artist is permissible, whereas the reverse is highly suspect. This became evident in the attitude of Picasso when, having joined the French Communist Party, he was asked how he could reconcile this union in view of the extreme lack of understanding of his work by Russian official-dom. His answer was that on the contrary, he would feel seriously disconcerted should it be officially declared that his work was understood and valued. His allegiance to communist principles was idealistic, and having encountered all his life the scorn and indifference of official circles in the West, he fully expected the rulers of a powerful revolutionary state to be equally unreceptive. At the same time he still hoped for a new form of society which could evolve a new way of life with greater justice for all (a hope, however, that must now appear naïve to those who have been more closely involved).

The two authors of this book, Alexander Glezer and Igor Golomshtok, are in a position to explain to us clearly the fundamental difference between this optimistic Western view and the reality of the struggle as it has been, and still is, for artists who live in another political climate. Alexander Glezer gives us a chronological account of the persecutions through which these artists have lived. He describes the tactics employed by both sides in the dramatic struggle that has gone on in Russia for some fifty years between the authority of the state and a small body of artists who, with poets and philosophers, refused to surrender their human and artistic rights.

I welcome this opportunity to examine and appreciate the qualities peculiar to these artists. It becomes obvious at once that the common outstanding virtue of this otherwise heterogeneous collection of paintings and drawings is the sense of urgency that informs almost every one of them. It appears particularly in the *cris de coeur* of those untrained artists, who have been compelled to find the means of making a statement to the outside world when imprisonment has deprived them of all normal forms of expression.

But there are also those whose training has been thorough and for whom the great achievements of a former generation of revolutionary Russian artists in the heroic days of the early 1920s have not gone unheeded. The continuity of the ideas of a Revolutionary Avant-garde which made the Russian contribution to the discoveries of twentieth-century art of universal importance is admirably described here by Professor Golomshtok. The inventions of the Kineticist "Movement" group initiated by Nussberg and his friends, which, sadly, met with official tolerance for only a

brief period, are convincing examples of the continuity of the spirit of Constructivism, to which new kinetic elements were added. Elsewhere the influence of Western contemporary art is to be found in the work of "fantastic realists" such as Oscar Rabin and others, giving us a glimpse of their consciousness of developments outside Russia and their ability to grasp the fundamental meaning of Surrealism.

Throughout we are forced to admire not only the talent of these artists but above all the content and significance of their communication. There is much in their work that carries us beyond the skill of the painter. For many artists it is the manipulation of images that enables them, whatever their various techniques, to reveal the depth of their thoughts and the reality of their torments, and this is accompanied by the liberal use of sign, metaphor and symbol.

Official Socialist Realism concentrates on the glorification of the state and industry. It cannot be opposed by criticism in the press or anywhere else, but it *can* be bypassed by subtle and penetrating means, by other forms of visual language which are incomprehensible to those blinded by dogma. Yet it is easily understood by a vast section of the public, who for years have been served the official boring menu and now hunger for a more inspiring fare. "These artists opposed total Socialist Realism with a realism not of description but of understanding," writes Professor Golomshtok. It is indeed this necessity to attempt to understand reality which has escaped official dogma, while it remains forever the purpose of the search for truth which no political system can obliterate.

In the diversity of style that emerges among the unofficial artists there is a refreshing sense of individual freedom. The link between them all, whether they paint still-lifes, portraits, landscapes, abstractions or fantastic visions, is the insistence on individual expression. It is the necessity to rebel against regimentation which produces originality, humour and variety, and provides the exhibition as a whole with valuable contrasts in style. But at the same time it stresses the fact that these artists are Russian, that they share the same national traditions, stated often in the form of satire, and have grown up in the same environment.

It is paradoxical that one of the strongest links between many of these painters is the use of religious subjects and symbols. This happens at a time when, with few exceptions, the art of the West disfavours references to the Christian religion as being irrelevant, or else attacks religion as being hypocritical. On this point the "scientific atheism" of Soviet Russia is in general in accord with modern trends of thought in the West. Yet we find such frequent

and deliberate reference to religious subjects among the unofficial Russian painters that this can hardly be attributed merely to a romantic nostalgia for the past.

Igor Golomshtok points out that there is little uniformity in the motives of the artists in this matter. Many of them use these elements as symbols without orthodox religious meaning, but the fact that religion is officially condemned gives these images a new potency – a time-honoured phenomenon. Their reappearance contains a defiance of the official suppression of religious trends whether it be as a direct reference to traditional Christian beliefs or as a yearning for a wider pantheistic conception of religion. It marks a rebellious return to spiritual values in revenge for the slavish glorification of the material gains of an industrialised police state. This localised motive unites a large number of these artists.

A tendency towards Expressionism is also deeply engrained. It has a more traditional touch than is found in pre-War German Expressionism, to which it is otherwise related. Teutonic anti-social violence and psychiatric emotiveness are missing. They are replaced by an atmosphere closer to Russian folklore and the roots of Russian culture, reaching a point at times where it may appear to us to have an old-fashioned flavour. It would seem that this romantic tradition thrives more among the unofficial artists of Moscow, whose work is more emotional and spontaneous, than those of Leningrad, who prefer a more cerebral form of art.

The folkloric tendency is most frequently found in engravings and book illustrations. Artists have been encouraged in this direction because of greater tolerance on the part of the authorities towards illustrations of texts, and it has often been possible to intersperse among permissible engravings others which are more advanced or abstract, but which may have only an arbitrary relationship to the book.

In spite of the early flowering of the Constructivists and the widespread acclaim their abstract art received, it is figurative art, often relying on fantasy, that has been most in evidence. But there are some artists – notably Masterkova – who have returned to Abstraction. Their research into the mysteries produced by non-figurative colour and space is of high quality and a triumph over the ignorant hostility with which they meet.

There is much in their work to make us envious of the courage and tenacity of these artists. But it must not be forgotten that the motives for their struggle are not anarchistic or destructive. When unofficial artists began to make a stand, to quote Golomshtok, "it immediately became an opposition movement, opposed however, not to the state structure but to its official culture, not to the

régime but to the deceit which the régime disgorged." This accounts in some degree for the surprising lack of vituperative cartoons and caricatures, such as were a common enough weapon at another time in the hands of English artists like Cruikshank in their attacks on royalty or censorship. The need for polemics against the state structure is not present. Their struggle is to protect essential human rights. It is no less urgent or determined for being conducted in a more subtle and roundabout way.

The Parisian slogan, *"décourager les peintres"*, was in the early days of Surrealism aimed at those painters who saw no more in the arts than a pleasant and profitable pastime. To our Russian friends discouragement has been viciously administered. The acid test of persecution has proved their merit as human beings and intensified their message, an imperative demand for liberty of the spirit, for freedom to think and to express themselves as individuals.

Vyacheslav Kalinin

Plate 1
TEA DRINKERS 1970
Oil on canvas
65 × 89 cm
Alexander Glezer – Russian Museum in Exile

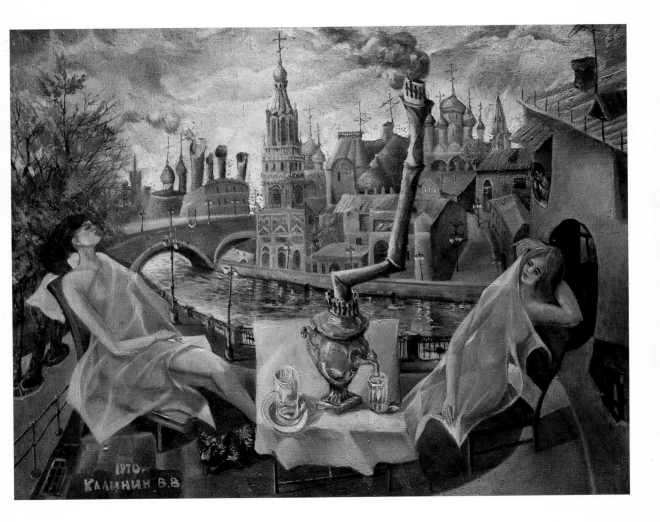

Vyacheslav Kalinin

Plate 2
LEDA 1974
Oil on canvas
80 × 65 cm
Alexander Glezer – Russian Museum in Exile

Ilya Kabakov

Plate 3
THE BROKEN MIRROR 1966
Mixed media
Alexander Glezer – Russian Museum in Exile

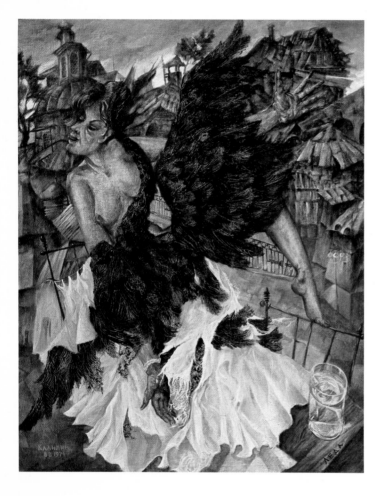

Otari Kandaurov

Plate 4
THE GRAVEDIGGER 1967
Oil on canvas
70 × 50 cm
Alexander Glezer – Russian Museum in Exile

Alexander Kharitonov

Plate 5
MAN WITH LANTERN 1961
Oil on canvas
85.5 × 55 cm
Private collection

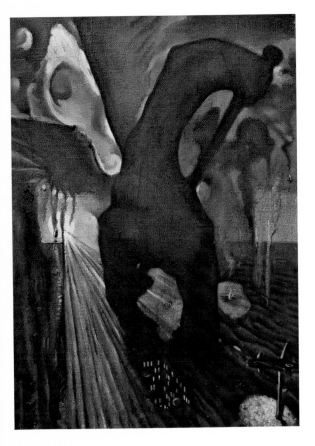

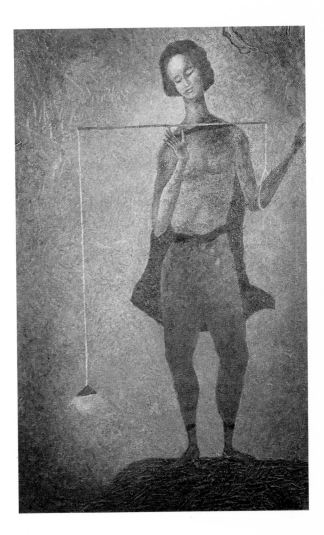

Dmitri Krasnopevtsev

Plate 6
STILL-LIFE 1974
Oil on hardboard
36 × 40 cm
Private collection

Victor Kulbak

Plate 7
CONQUISTADOR 1973
Oil on canvas
74 × 53.5 cm
Alexander Glezer – Russian Museum in Exile

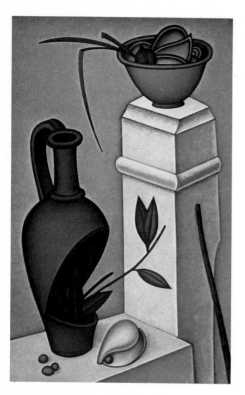

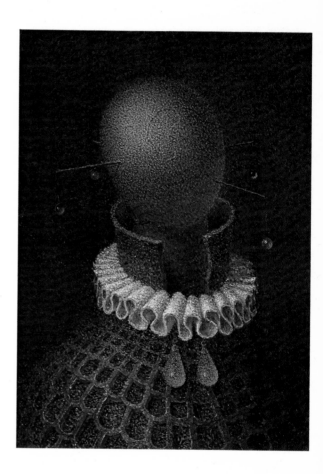

Vladimir Akulinin

1
KINETIC PROJECT 1964
56.5 × 81.5 cm
Private collection

Pyotr Belenok

2 *(below)*
FROM THE CYCLE "MADNESS" 1 1973
Indian ink collage
64 × 67 cm
Alexander Glezer – Russian Museum in Exile

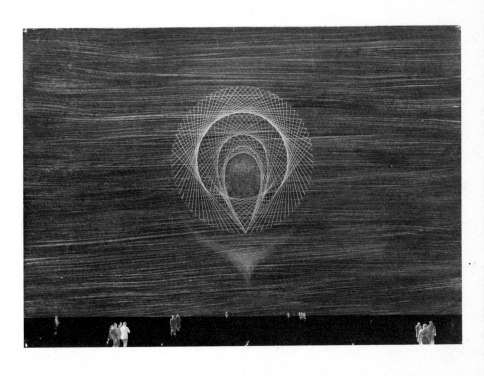

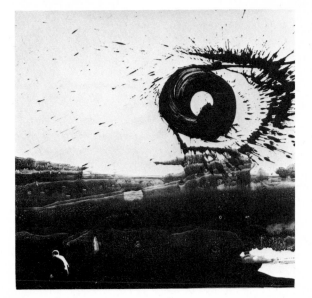

Boris Birger

3
PORTRAIT OF TATISHCHEV 1974
Oil on canvas
Private collection

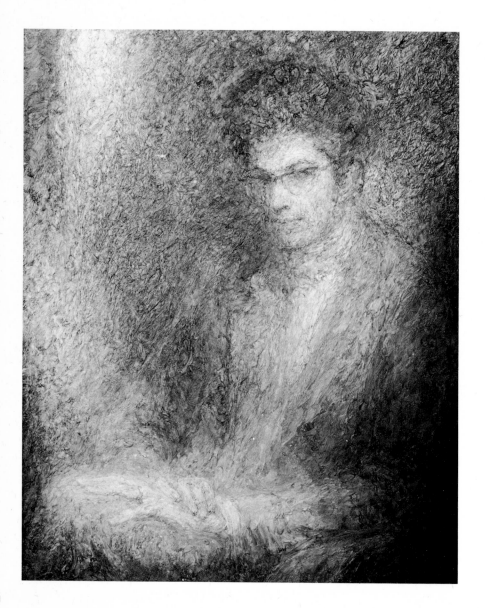

4
STILL-LIFE 1971
Oil on canvas
54 × 46 cm
Private collection

5
DON QUIXOTE 19?
Oil on canvas
59.5 × 49 cm
Private collection

Galina Bitt

6
KINETIC COMPOSITION 1965
53.5 × 53.5 cm
Private collection

William Brui

7
FROM THE CYCLE "HAPPENING" VI 1967
Etching
75 × 54 cm
Artist's collection

Erik Bulatov

8
NO ENTRY 1973?
Crayon on paper
24 × 24.5 cm
Alexander Glezer – Russian Museum in Exile

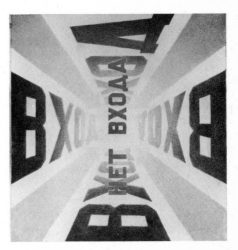

Sergei Esoyan

9
PRODIGAL SON 1975
Oil on plywood
60 × 43 cm
John Stuart collection

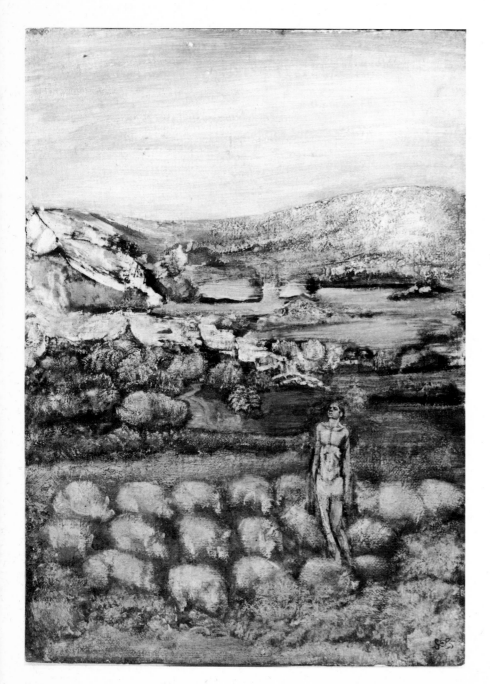

10
MASTER AND MARGARITA 1970?
Tempera on paper
25 × 25 cm
John Stuart collection

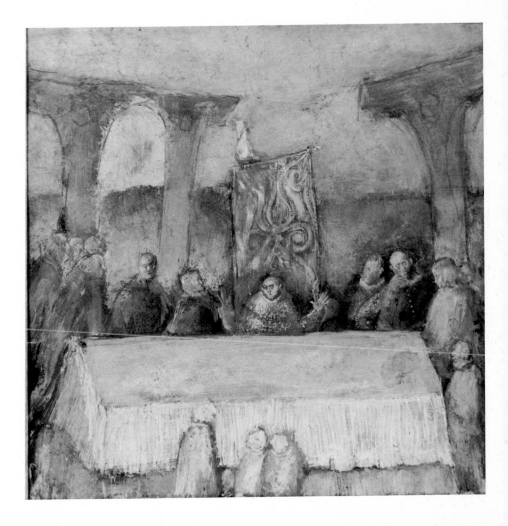

Francisco Infante

11
INTERPENETRATION 1963
Tempera on cardboard
24 × 24 cm
Private collection

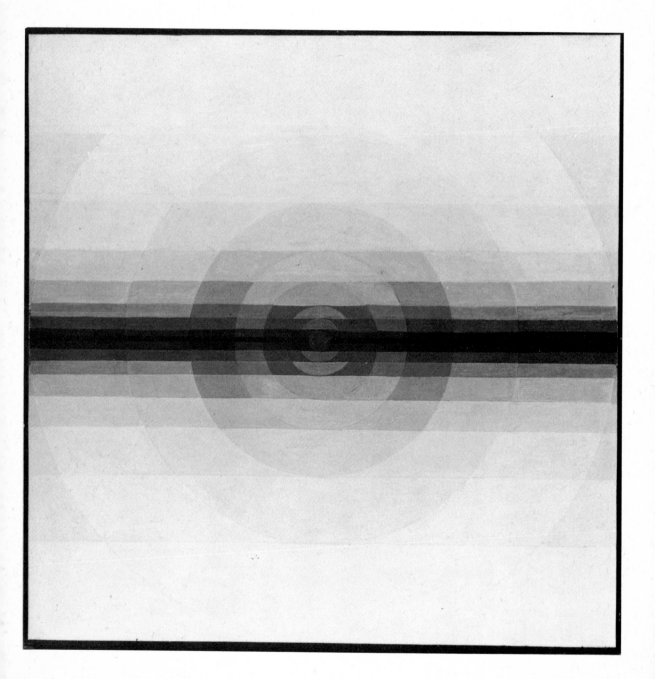

12
THE RECONQUEST 1963
Tempera on cardboard
24 × 24 cm
Private collection

Evgeni Izmailov

13
UNTITLED 1972
Gouache
12 × 64 cm
John Stuart collection

Ilya Kabakov

14
ABSTRACT 1967
18.5 × 16 cm
Private collection

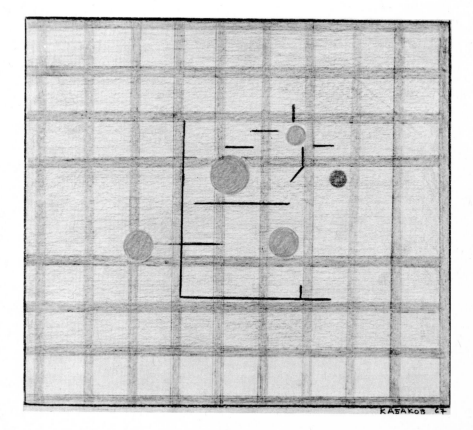

Ilya Kabakov

15
TEAPOT 1975
Crayon on paper
37 × 24.5 cm
Alexander Glezer – Russian Museum in Exile

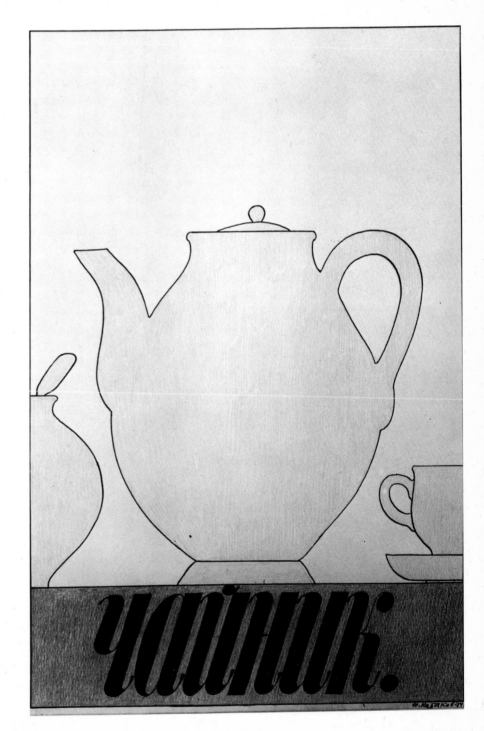

Vyacheslav Kalinin

16
SELF-PORTRAIT 1974
Oil on canvas
70 × 50 cm
Alexander Glezer – Russian Museum in Exile

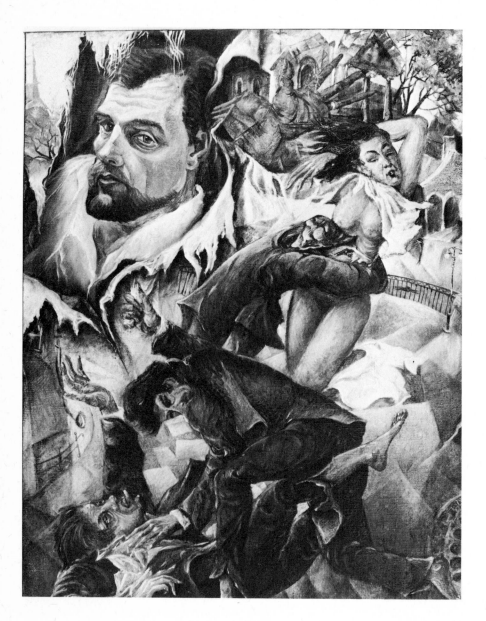

Alexander Kalugin

17
FREEDOM WITH A CLEAR CONSCIENCE 1974
Pencil on paper
75 × 55 cm
Alexander Glezer – Russian Museum in Exile

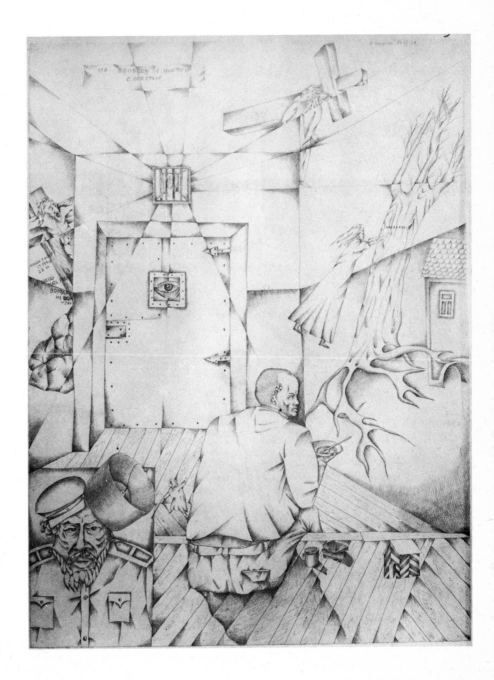

Otari Kandaurov

18
STILL-LIFE 1963
Oil on canvas
60 × 50 cm
Private collection

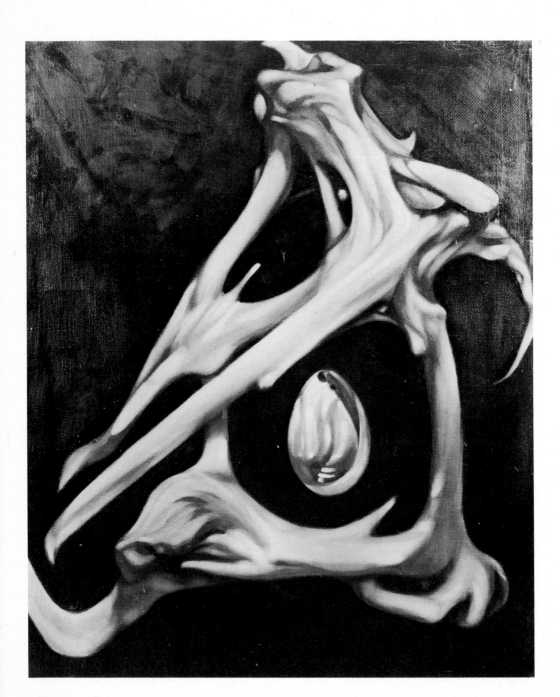

Alexander Kharitonov

19
THE DESOLATION OF ABANDONMENT 1969
Pencil on paper
30.5 × 42 cm
Alexander Glezer – Russian Museum in Exile

20
UNTITLED 1969
Oil on hardboard
26.5 × 29 cm
Private collection

21
UNTITLED 1970
Oil on hardboard
23 × 30.5 cm
Private collection

22
THE PRINCESS AND THE CASTLE 1962
Oil on canvas
58.5 × 56 cm
Private collection

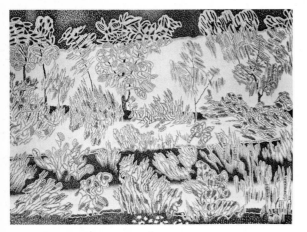

Dmitri Krasnopevtsev

23
N53. STILL-LIFE WITH VASE 1974
Oil on hardboard
44.5 × 29.5 cm
Private collection

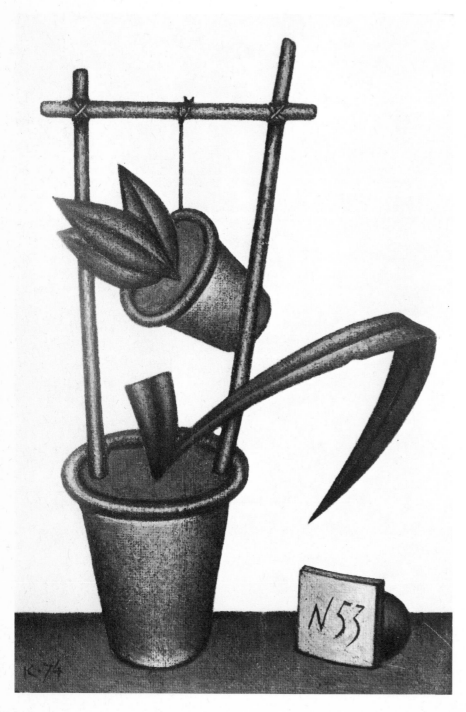

Lydia Masterkova

Plate 8
COMPOSITION 1967
Oil and canvas collage
100 × 83 cm
Alexander Glezer – Russian Museum in Exile

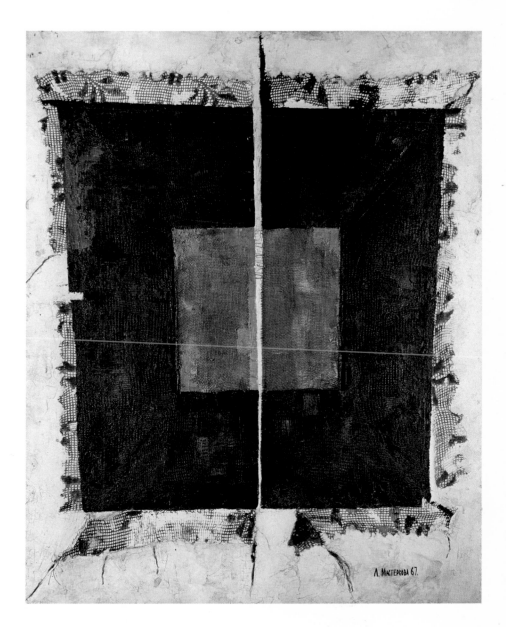

Vladimir Nemukhin

Plate 9
CARD GAME ON SKIN 1972
Oil, acetate tempera and collage on canvas
110 × 97 cm
Alexander Glezer – Russian Museum in Exile

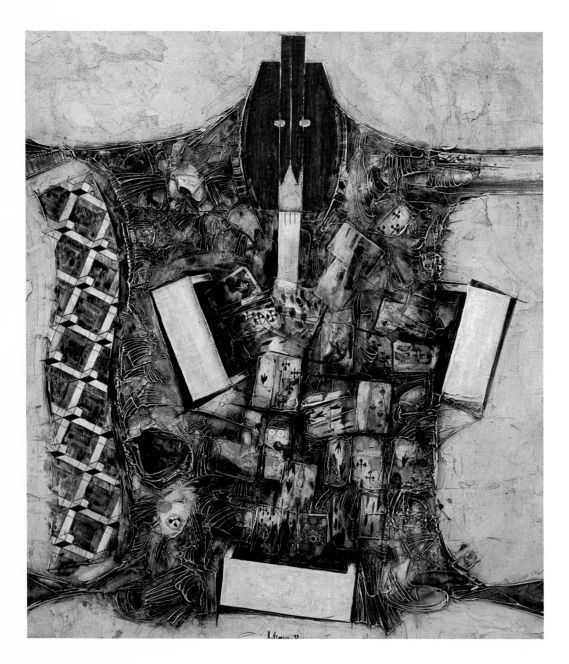

Vladimir Nemukhin

Plate 10
DEAD COCKBIRD 1968
Acetate tempera on paper
40 × 55 cm
Alexander Glezer – Russian Museum in Exile

Dmitri Plavinsky

Plate 11
THE TORTOISE 1967
Oil on canvas
100 × 150 cm
Alexander Glezer – Russian Museum in Exile

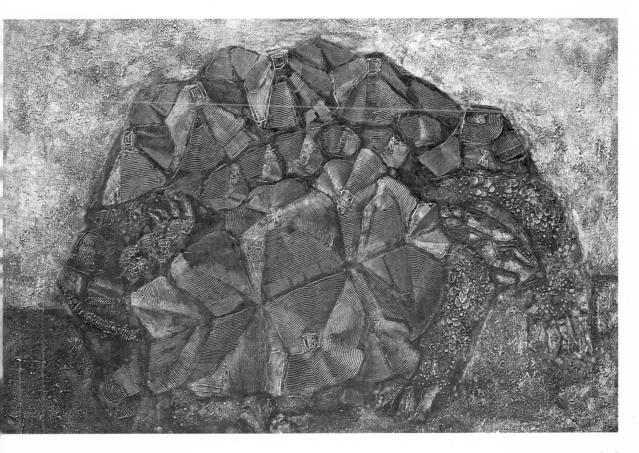

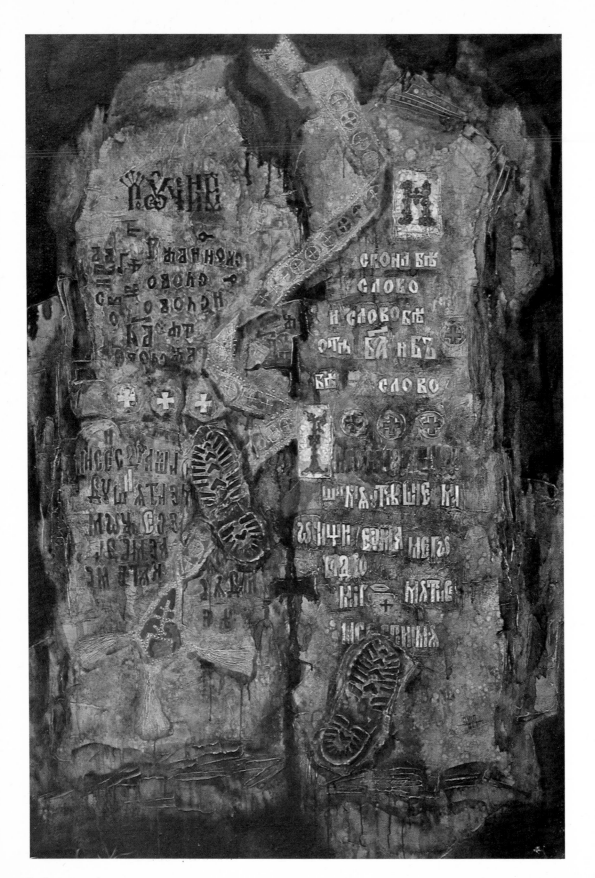

Dmitri Plavinsky

Plate 12 *(opposite)*
THE GOSPEL ACCORDING TO ST JOHN 1966
Oil on canvas collage
175 × 120 cm
Alexander Glezer – Russian Museum in Exile

Dmitri Krasnopevtsev

24
STILL-LIFE WITH STONES AND SKULLS 1962
Oil on canvas
43 × 63 cm
Alexander Glezer – Russian Museum in Exile

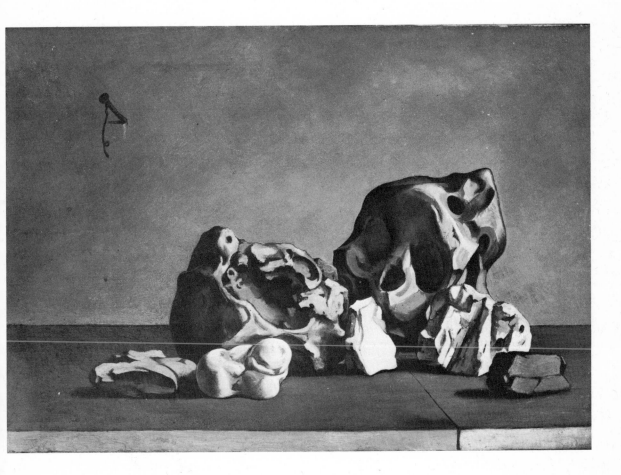

[25]

Valentina Kropivnitskaya

25
THE CAMP FIRE 1973
Pencil on paper
51.5 × 79 cm
Alexander Glezer – Russian Museum in Exile

26
EXHIBITION 1972
Pencil on paper
43 × 61.5 cm
Alexander Glezer – Russian Museum in Exile

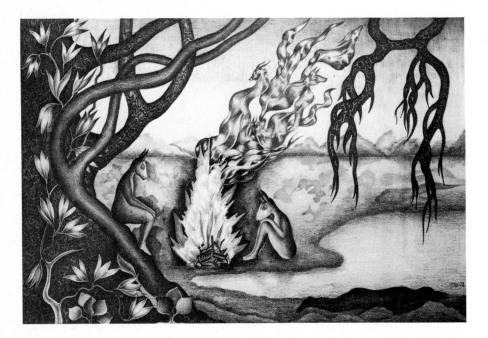

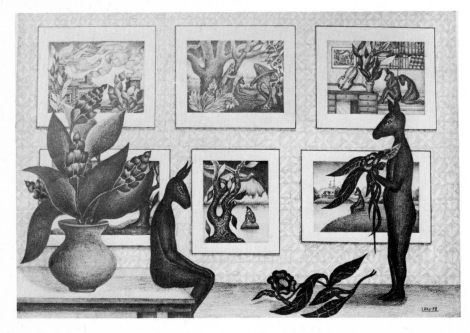

27
THE DROWNED CHURCH 1967
Pencil on paper
47 × 62.5 cm
Alexander Glezer – Russian Museum in Exile

28
COMPOSITION 1973
Pencil on paper
53 × 76 cm
Alexander Glezer – Russian Museum in Exile

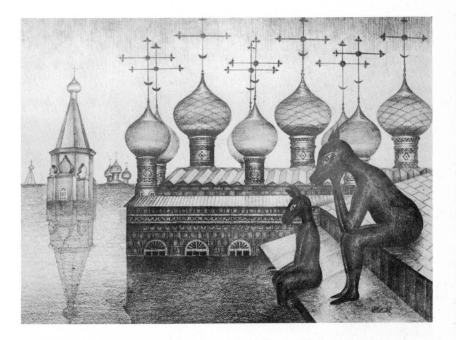

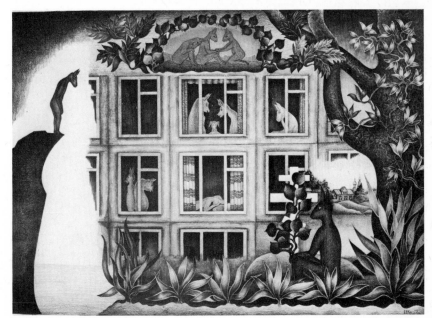

Lev Kropivnitsky

29
UNTITLED 1968
Oil on canvas
100 × 80 cm
Alexander Glezer – Russian Museum in Exile

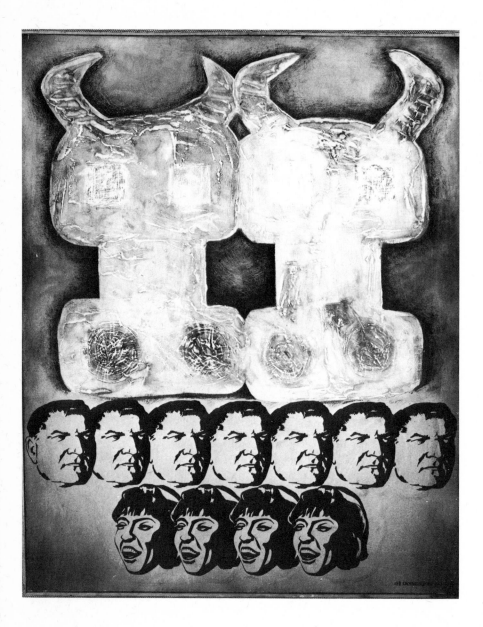

Lev Kropivnitsky

30
UNTITLED 1967
Oil on canvas
80 × 100 cm
Alexander Glezer – Russian Museum in Exile

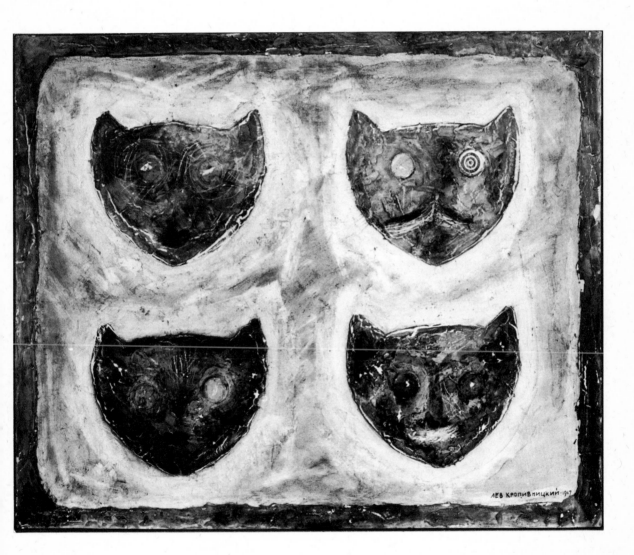

Victor Kulbak

31
AURA 19?
Oil on canvas
Alexander Glezer – Russian Museum in Exile

Alexander Makhov

32
EXECUTION I 1974
Indian ink on paper
85 × 61.5 cm
Alexander Glezer – Russian Museum in Exile

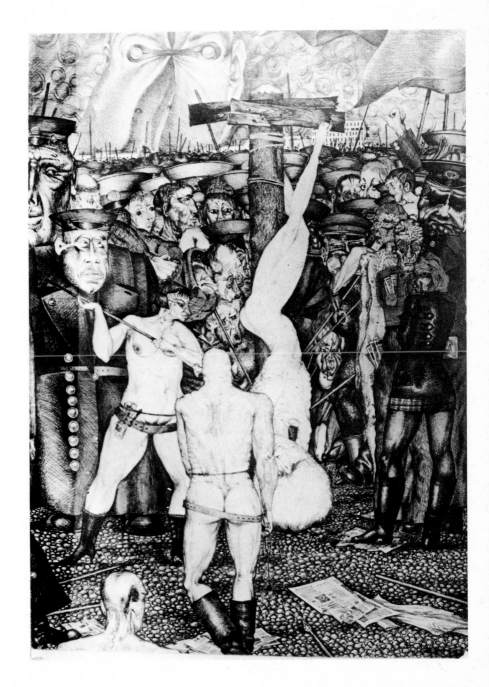

Lydia Masterkova

33
TRIPTYCH 1974
Oil and canvas collage
110 × 300 cm
Alexander Glezer – Russian Museum in Exile

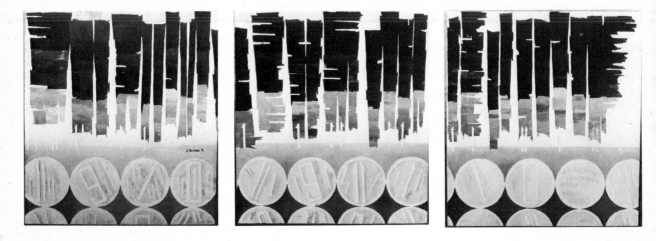

Ernst Neizvestny

34
TWO FIGURES 19?
Pen and wash
25 × 20 cm
Grosvenor Gallery collection

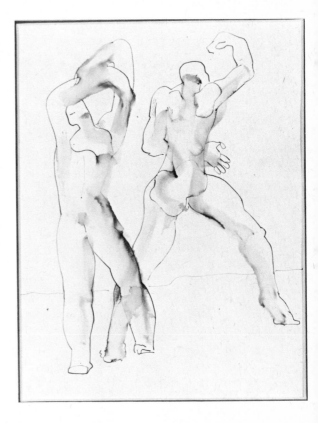

Ernst Neizvestny

35
TORSO 1962
Pen on paper
41 × 26 cm
Grosvenor Gallery collection

36
INTERLOCKING FORMS 1961
Pen on paper
25 × 38.5 cm
Grosvenor Gallery collection

37
UNTITLED 1964
Pen on paper
43 × 30 cm
Grosvenor Gallery collection

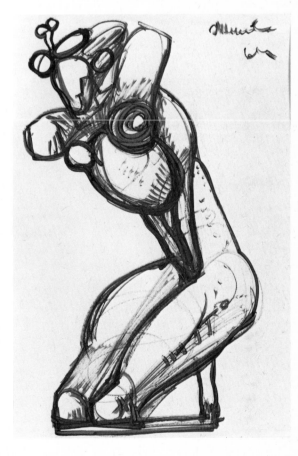

Ernst Neizvestny

38
FALLEN WARRIOR 19?
Bronze
Grosvenor Gallery collection

39
TORSO 19?
Bronze
Grosvenor Gallery collection

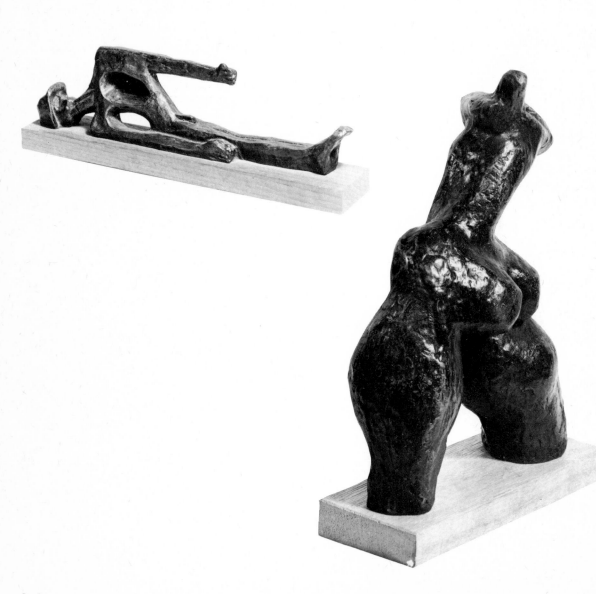

Vladimir Nemukhin

40
ABANDONED PATIENCE 1969
Oil, acetate tempera and collage on canvas
97 × 110 cm
Alexander Glezer – Russian Museum in Exile

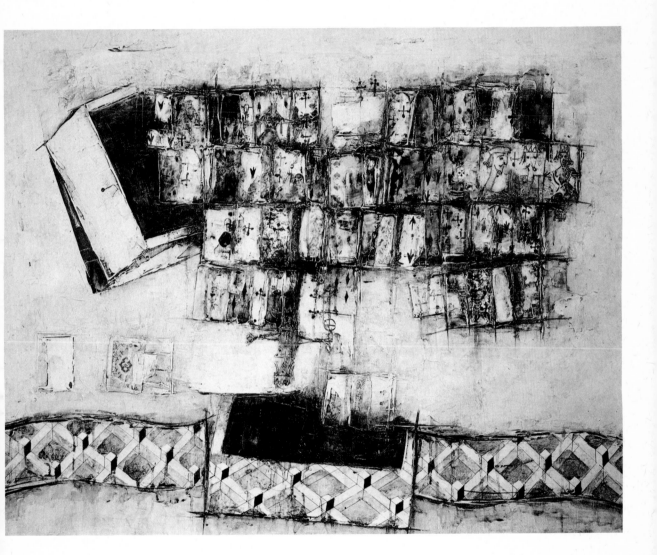

Vladimir Nemukhin

41
CARD TABLE 1974
Oil, acetate tempera and collage on canvas
71 × 82 cm
Alexander Glezer – Russian Museum in Exile

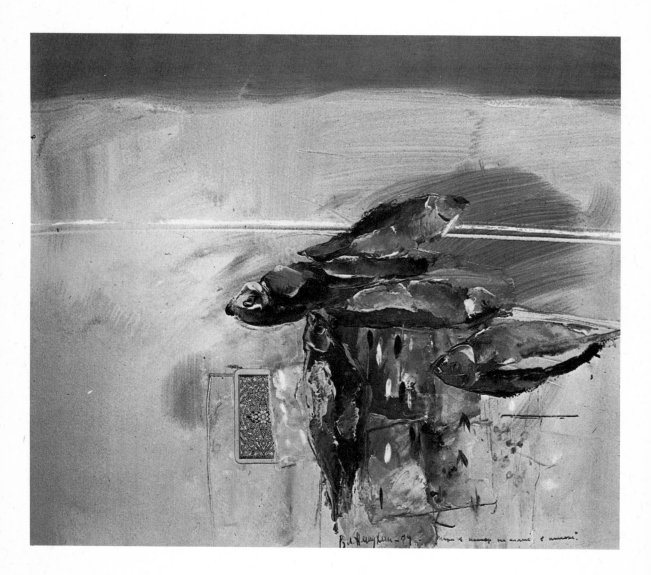

42
COMPOSITION 1963
Mixed media
59.5 × 41.5 cm
Private collection

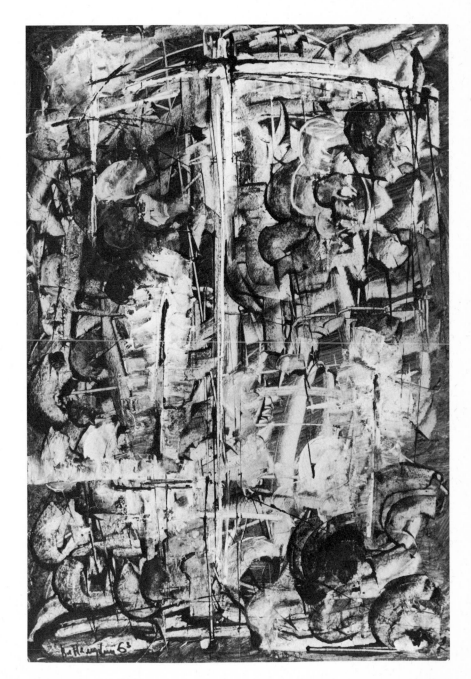

Lev Nussberg

43
CONSTRUCTION I 1963
50 × 81.5 cm
Private collection

44
CONSTRUCTION II 1963
58.5 × 81.5 cm
Private collection

Dmitri Plavinsky

45
RUBBISH HEAP 1972
Etching
48.5 × 64.5 cm
Alexander Glezer – Russian Museum in Exile

46
THE TORTOISE 1969
Etching
62 × 84 cm
Alexander Glezer – Russian Museum in Exile

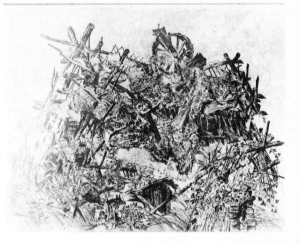

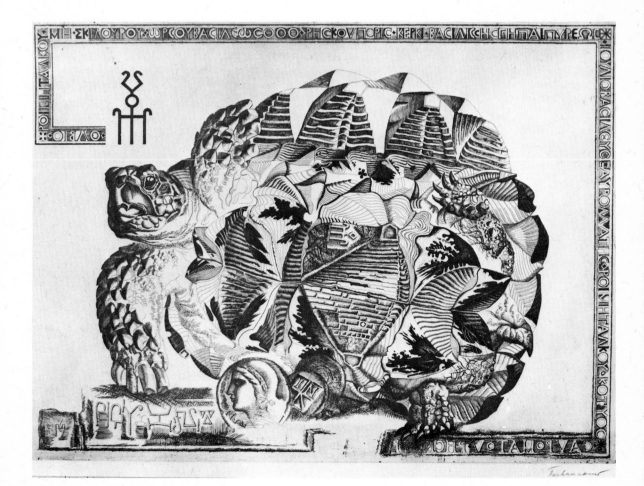

Dmitri Plavinsky

47
DEAD DOG 1974
Etching
65.5 × 50 cm
Alexander Glezer – Russian Museum in Exile

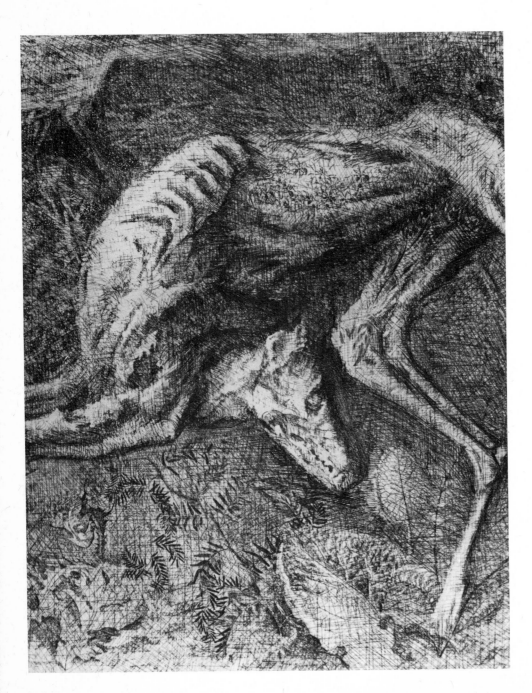

Oscar Rabin

Plate 13
STILL-LIFE WITH FISH AND PRAVDA 1968
Oil on canvas
90 × 110 cm
Alexander Glezer – Russian Museum in Exile

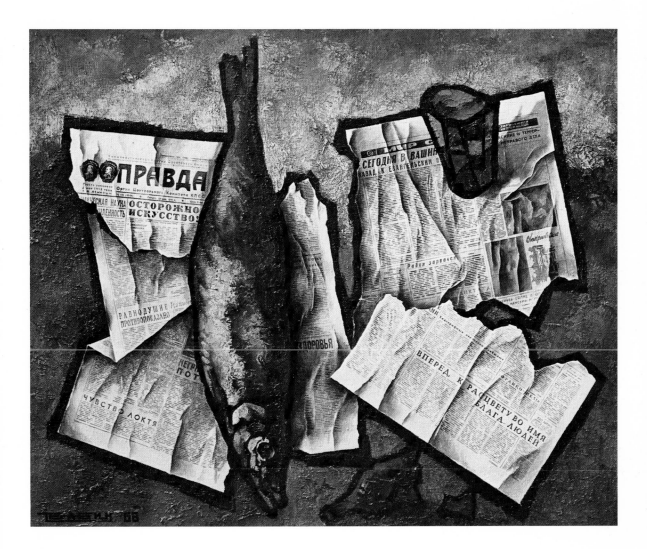

Oscar Rabin

Plate 14
VIOLIN AND COTTAGES 1970
Oil on canvas
50 × 70 cm
Alexander Glezer – Russian Museum in Exile

Evgeni Rukhin

Plate 15
THE LENINGRAD DRAINAGE SYSTEM 1974
Oil on canvas
101 × 97 cm
Alexander Glezer – Russian Museum in Exile

Vasili Sitnikov

Plate 16
LANDSCAPE 1974
Oil on canvas
88 × 130 cm
Alexander Glezer – Russian Museum in Exile

Boris Sveshnikov

Plate 17 *(below)*
LANDSCAPE OF THE BLIND 1960
Oil on canvas
69.5 × 64.5 cm
Private collection

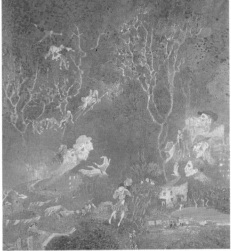

Boris Sveshnikov

Plate 18
PEOPLE WITH BRIEFCASES 1969?
Oil on canvas
71 × 81 cm
Alexander Glezer – Russian Museum in Exile

Dmitri Plavinsky

48 *(opposite)*
WHITE ON BLACK 1961
Oil on canvas
80 × 59.5 cm
Private collection

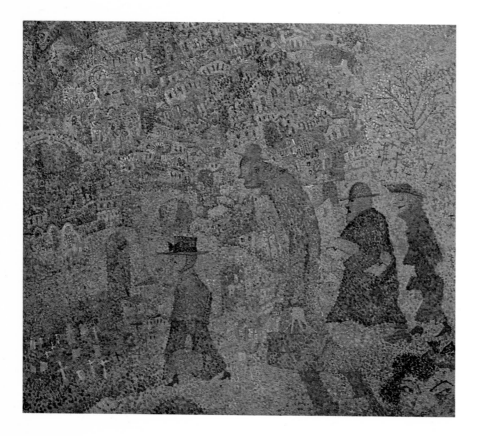

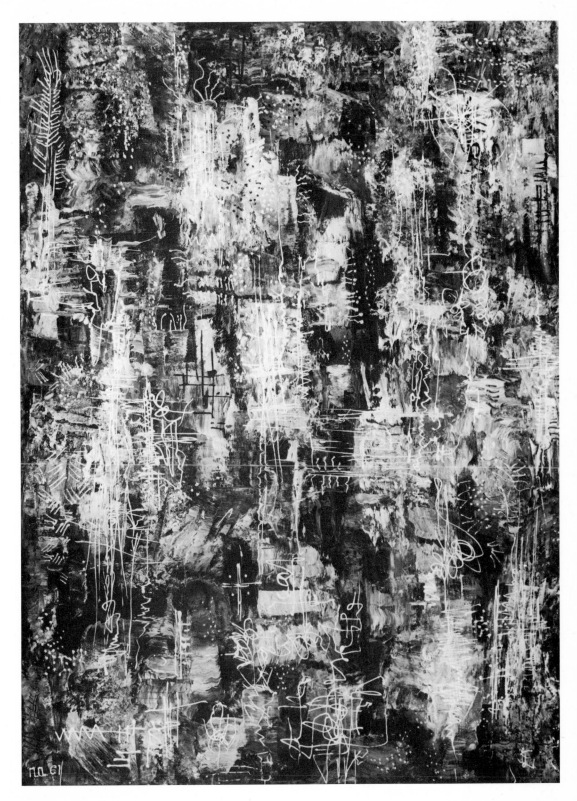

Dmitri Plavinsky

49
THE LOBSTER 1960
Oil on board
45.5 × 60 cm
Private collection

Oleg Prokofiev

50
MEMORY OF LENINGRAD 1968
Oil on canvas
67 × 79 cm
Artist's collection

51
ARCH 1971
Oil on canvas
75 × 77 cm
Artist's collection

52
"κ" 1969
Oil on canvas
77 × 65 cm
Artist's collection

Alexander Rabin

53
THE CITY IN RUINS 1974
Oil on canvas
80 × 100 cm
Alexander Glezer – Russian Museum in Exile

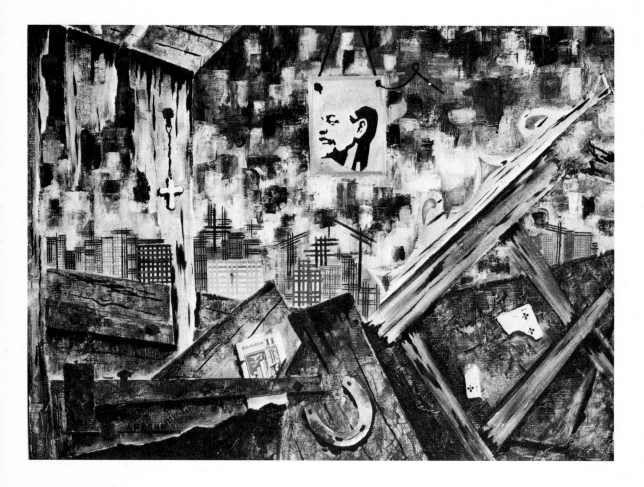

Oscar Rabin

54
VIOLIN AND CEMETERY 1969
Oil on canvas collage
80 × 100 cm
Alexander Glezer – Russian Museum in Exile

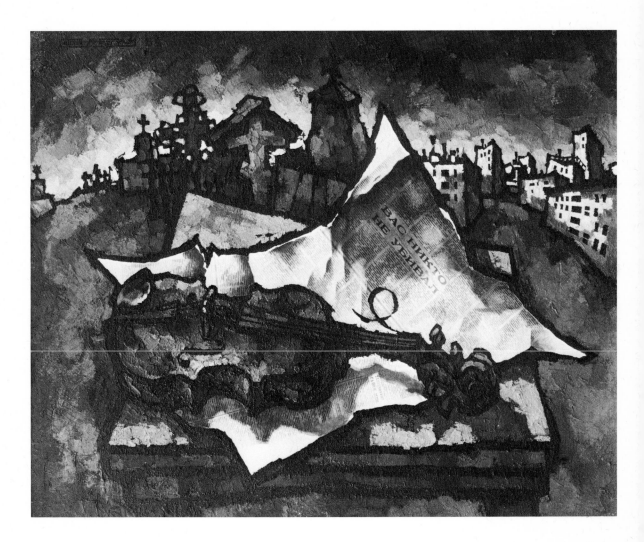

Oscar Rabin

55
THE CHEMISE 1975
Oil on canvas
110 × 90 cm
Alexander Glezer – Russian Museum in Exile

56
THE CRUCIFIXION 1964
Oil on canvas
110 × 80 cm
Private collection

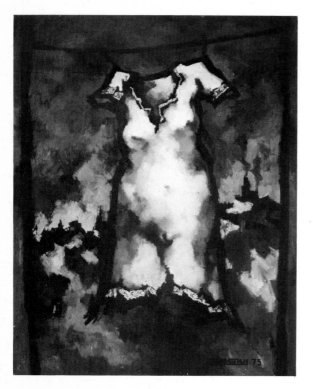

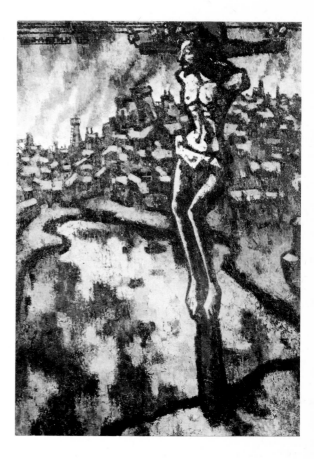

57
DETOUR 2 METRES 1965
Oil on canvas
108.5 × 87.5 cm
Grosvenor Gallery collection

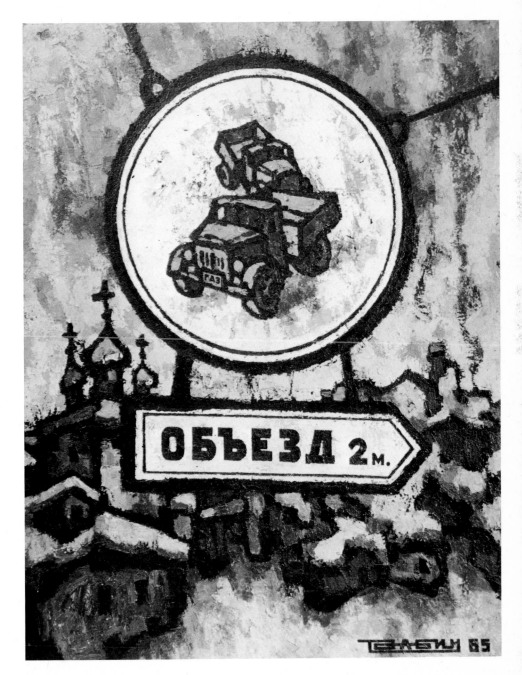

Oscar Rabin

58
AMERICA 2 1965
Oil on canvas
Grosvenor Gallery collection

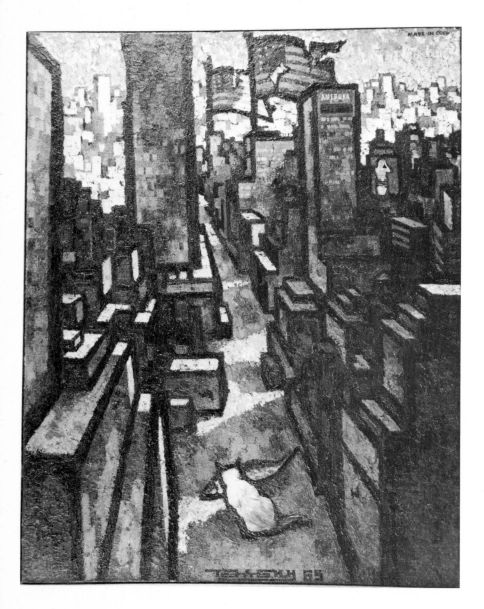

Evgeni Rukhin

59
COMPOSITION 1974
Collage, mixed media
70 × 66 cm
Alexander Glezer – Russian Museum in Exile

Valentina Shapiro

60
FROM CYCLE ON BAUDELAIRE'S "FLEURS DU MAL"
1972
Pencil on paper
17 × 14 cm
Artist's collection

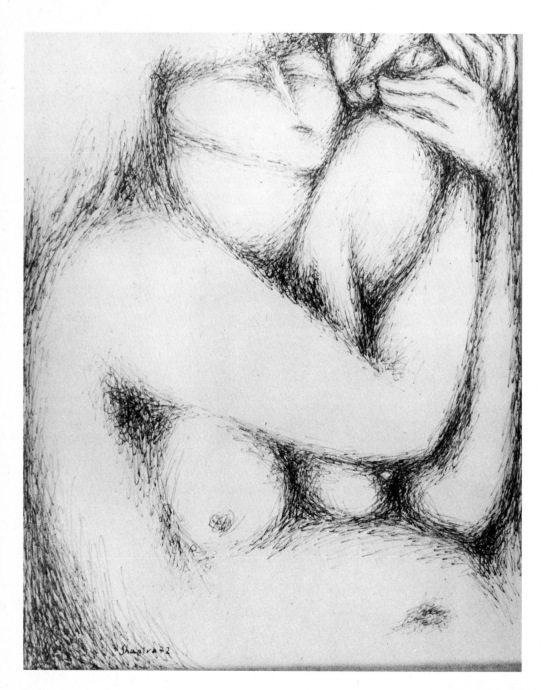

Mikhail Shemyakin

61
SVIDRIGAILOV'S DREAMS 1966
Pencil on paper
60 × 38 cm
Private collection

62
SCULPTURE 1971
Bronze
67 × 40 × 8 cm
Private collection

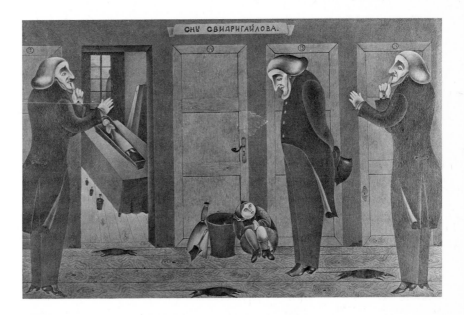

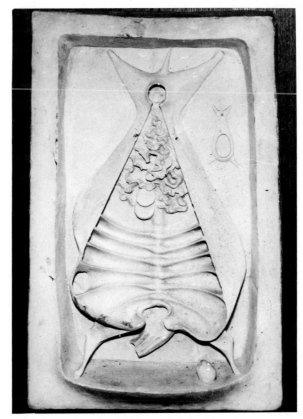

Mikhail Shemyakin

63
GOOD TIDINGS FOR THE KNIGHT 1968
Aquatint
38.5 × 28.5 cm
Private collection

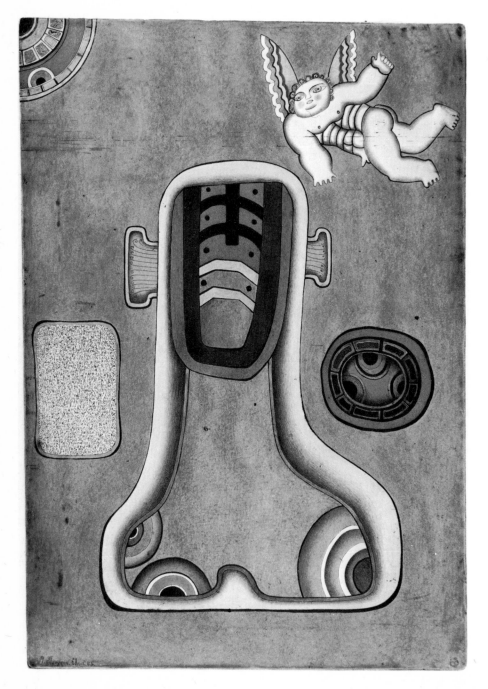

Edward Steinberg

64
COMPOSITION 1972
Oil on canvas
89 × 89 cm
Alexander Glezer – Russian Museum in Exile

Edward Steinberg

65
COMPOSITION 1971
Oil on canvas
100 × 80 cm
Alexander Glezer – Russian Museum in Exile

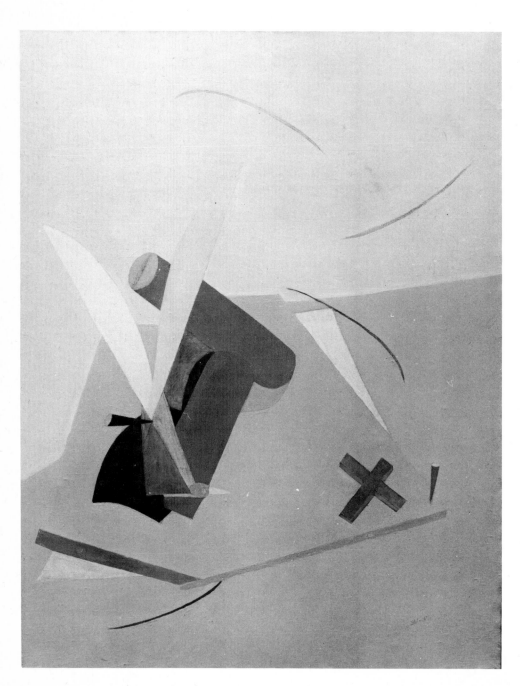

Victor Stepanov

66
KINETIC COMPOSITION 1963
60 × 63 cm
Private collection

Boris Sveshnikov

67
FUNERAL MEATS 1965?
Oil on canvas
74 × 74 cm
Alexander Glezer – Russian Museum in Exile

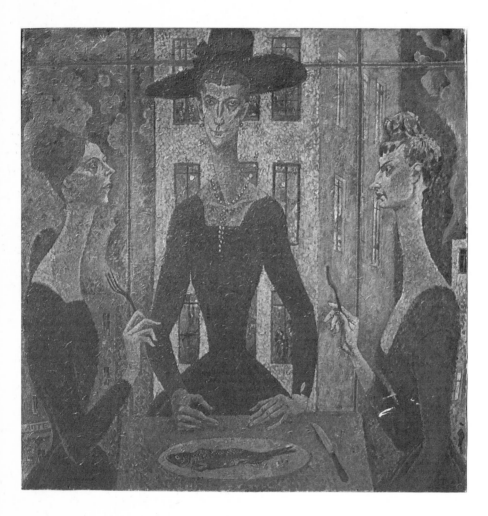

Oleg Tselkov

Plate 19
STILL-LIFE 1965
Oil on board
71.5 × 61.5 cm
Private collection

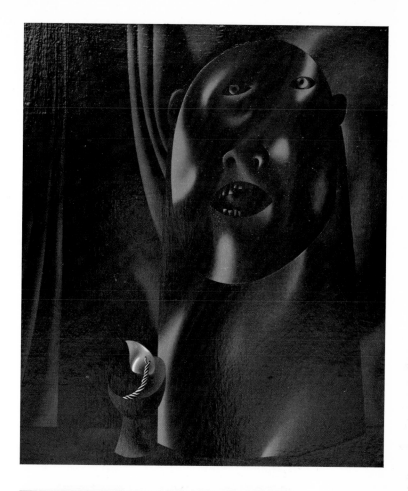

Anatoli Vasiliev

Plate 20
UNTITLED 1974?
Monotype
61 × 52 cm
Alexander Glezer – Russian Museum in Exile

Vladimir Weisberg

Plate 21
STILL-LIFE WITH CANDLE 1966
Oil on canvas
59 × 63 cm
Alexander Glezer – Russian Museum in Exile

Vladimir Yankilevsky

Plate 22
THE PROPHET 1968
Mixed media
163 × 100 cm
Alexander Glezer – Russian Museum in Exile

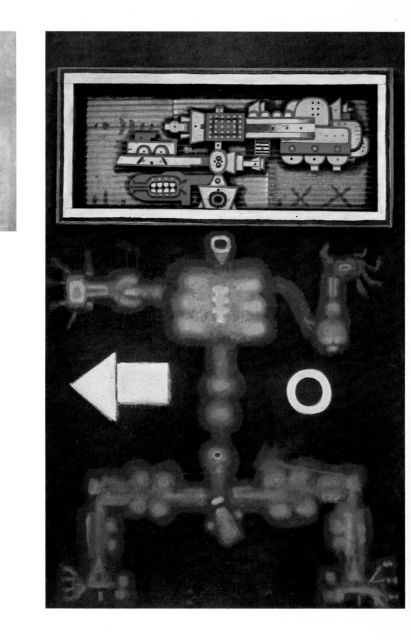

Edward Zelenin

Plate 23
SELF-PORTRAIT 1973
Oil on canvas
80 × 75 cm
Alexander Glezer – Russian Museum in Exile

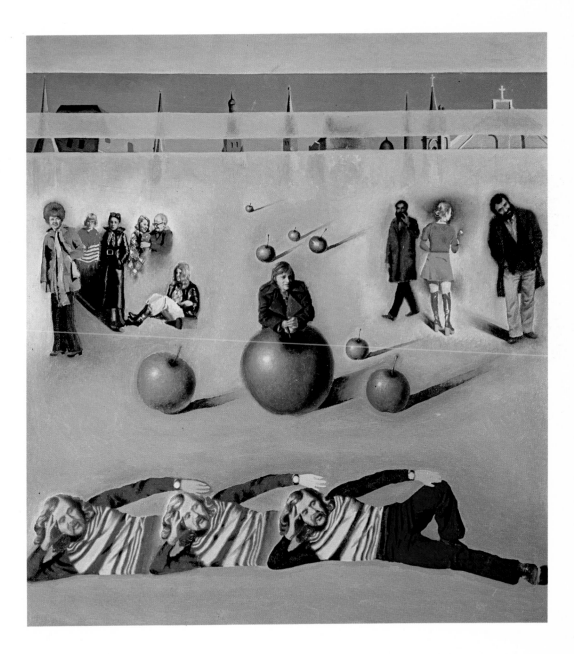

Yuri Zharkikh

Plate 24
PORTRAIT OF GLEZER 1974
Acrylic on canvas
118 × 81 cm
Alexander Glezer – Russian Museum in Exile

Anatoli Zverev

Plate 25
PORTRAIT OF AN ARTIST 1961
Gouache
59.5 × 41.5 cm
Private collection

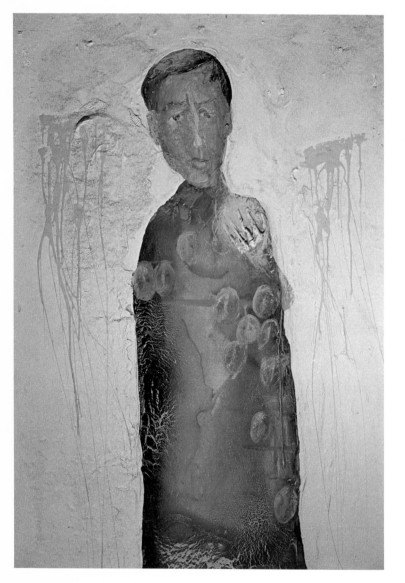

Boris Sveshnikov

68
THE CEMETERY 19?
Indian ink on paper
28.5 × 38 cm
Private collection

69
THE FIGHT 19?
Indian ink on paper
27.5 × 37 cm
Private collection

Boris Sveshnikov

70
SNOW LANDSCAPE WITH TREES AND HUTS 1962?
Watercolour
44 × 64 cm
Private collection

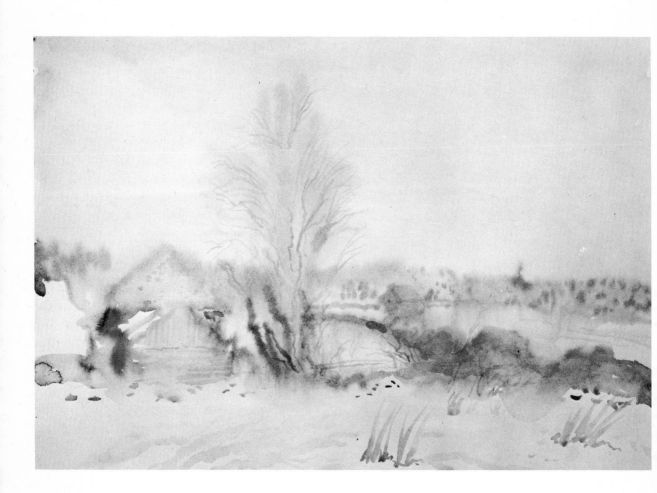

71
NIGHT CLAMOUR 1962–3?
Oil on canvas
75.5 × 85.5 cm
Private collection

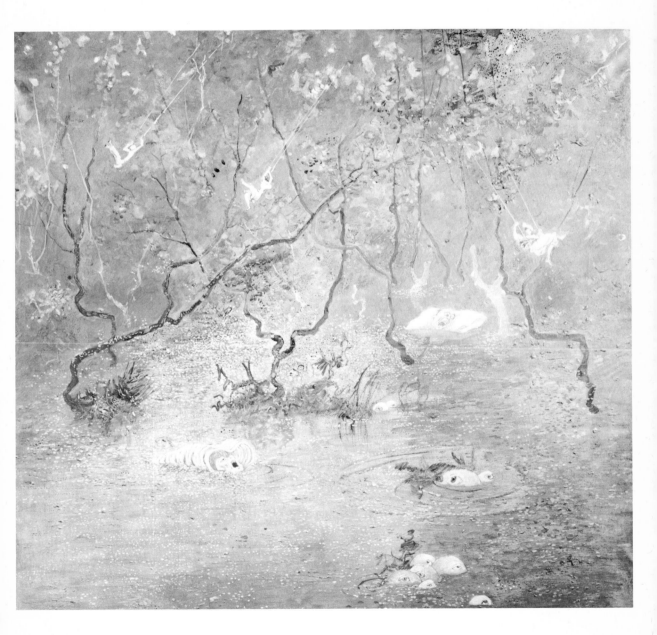

Oleg Tselkov

72
PORTRAIT WITH MASK 1974
Oil on canvas
80 × 80 cm
Alexander Glezer – Russian Museum in Exile

Avtandil Varazi

73
THE BULL 1973
Collage, iron on board
68 × 47 cm
Alexander Glezer – Russian Museum in Exile

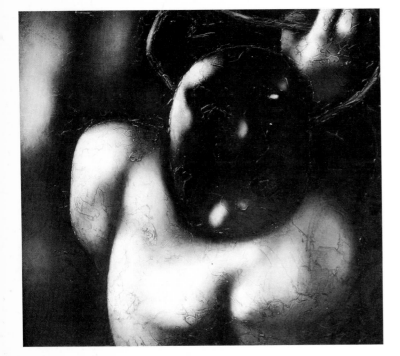

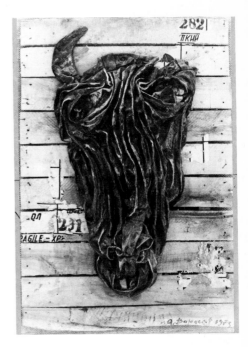

Anatoli Vasiliev

74
UNTITLED 1974
Monotype
65 × 49.5 cm
Alexander Glezer – Russian Museum in Exile

75
UNTITLED 1973
Monotype
71 × 47 cm
Alexander Glezer – Russian Museum in Exile

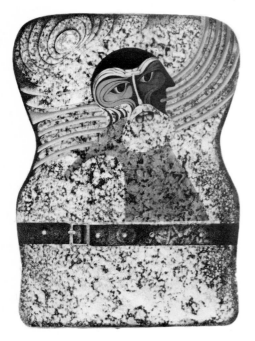

Nikolai Vechtomov

76
TWO CLIFFS 1967
Oil on canvas
71 × 50 cm
Alexander Glezer – Russian Museum in Exile

77
COMPOSITION 1973
Oil on canvas
91 × 80 cm
Alexander Glezer – Russian Museum in Exile

Nikolai Vechtomov

78
THE SUN 1963?
Oil on canvas
123 × 190 cm
Private collection

Vladimir Weisberg

79
STILL-LIFE WITH TWO COLUMNS 1975
Oil on canvas
53 × 53 cm
Private collection

80
STILL LIFE WITH SPHERES 1966
Oil on canvas
77 × 82 cm
Alexander Glezer – Russian Museum in Exile

Vladimir Yakovlev

81
BLUE FLOWERS 1972
Gouache
59 × 41 cm
Alexander Glezer – Russian Museum in Exile

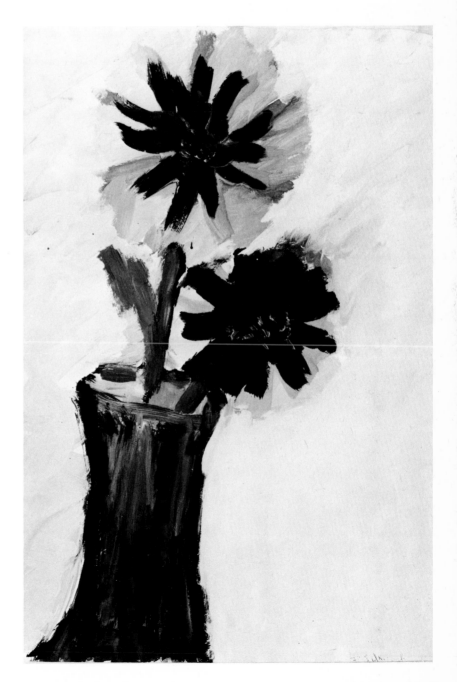

Vladimir Yankilevsky

82
FROM THE ALBUM "ANATOMY OF THE SENSES" 1972
Indian ink on paper
25 × 30 cm
Alexander Glezer – Russian Museum in Exile

83
FROM THE ALBUM "ANATOMY OF THE SENSES" 1972
Indian ink on paper
25 × 30 cm
Alexander Glezer – Russian Museum in Exile

84
FROM THE ALBUM "CITY MASKS" 1973
Indian ink on paper
49.5 × 65 cm
Alexander Glezer – Russian Museum in Exile

85
FROM THE ALBUM "CITY MASKS" 1973
Indian ink on paper
49.5 × 65 cm
Alexander Glezer – Russian Museum in Exile

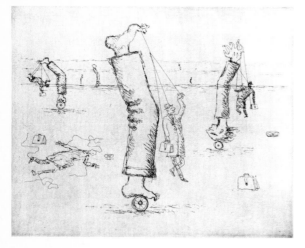

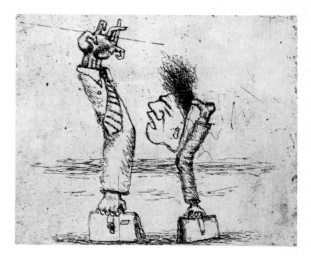

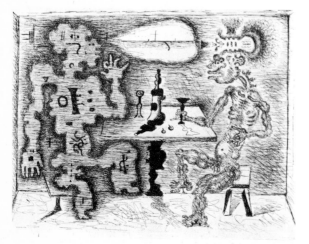

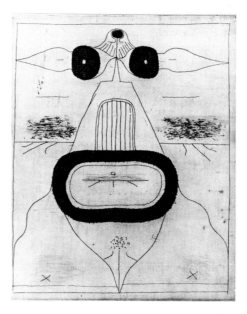

86
FROM THE ALBUM "CITY MASKS" 1973
Indian ink on paper
49.5 × 65 cm
Alexander Glezer – Russian Museum in Exile

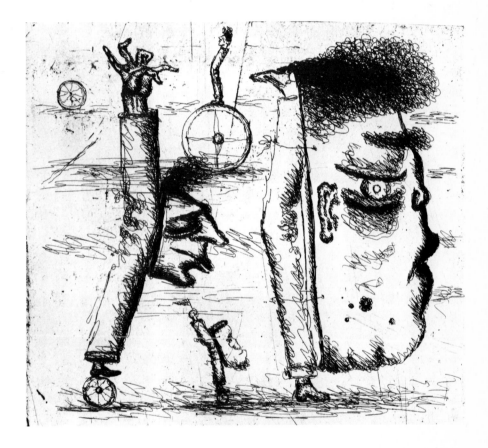

Yershov

87
GREEN BOTTLE AND TUMBLER 1961
Watercolour
25 × 18 cm
Grosvenor Gallery collection

88
MEN AT MEAL 1960
Pen on paper
25 × 17.5 cm
Grosvenor Gallery collection

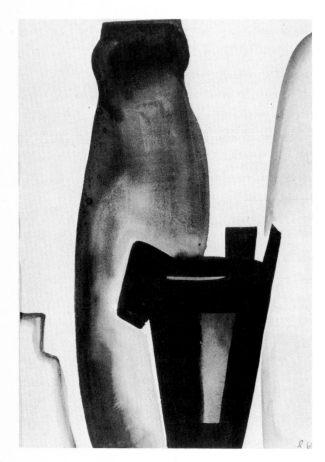

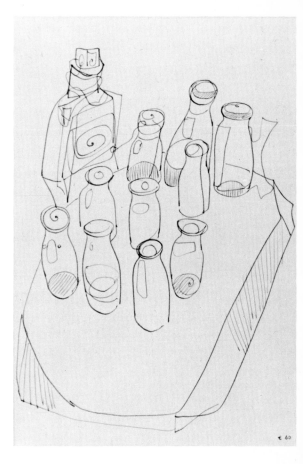

Edward Zelenin

89

LANDSCAPE OF VLADIMIR 1974
Oil on hardboard
48 × 43 cm
Alexander Glezer – Russian Museum in Exile

90
THE FLIES 1974
Oil on hardboard
43 × 48 cm
Alexander Glezer – Russian Museum in Exile

Yuri Zharkikh

91
INITIATION 1974
Acrylic on canvas
95 × 80 cm
Alexander Glezer – Russian Museum in Exile

92
SELF-PORTRAIT 1974
Acrylic on canvas
93 × 78 cm
Alexander Glezer – Russian Museum in Exile

Boris Zhutovsky

93
COMPOSITION 1963
Oil on hardboard
120 × 30 cm
Alexander Glezer – Russian Museum in Exile

Anatoli Zverev

94
PORTRAIT OF A MAN 1974
Oil on canvas
100 × 79.5 cm
Alexander Glezer – Russian Museum in Exile

Anatoli Zverev

95
MAN IN SPECTACLES 1961
Gouache
76 × 62 cm
Private collection

96
WINTER 1961
Gouache
59.5 × 40.5 cm
Private collection

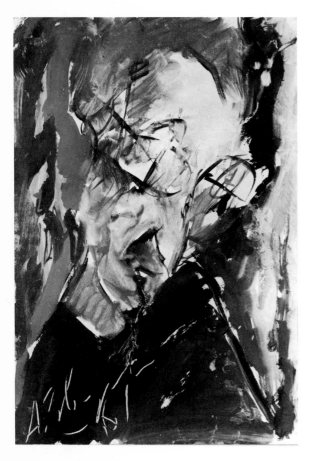

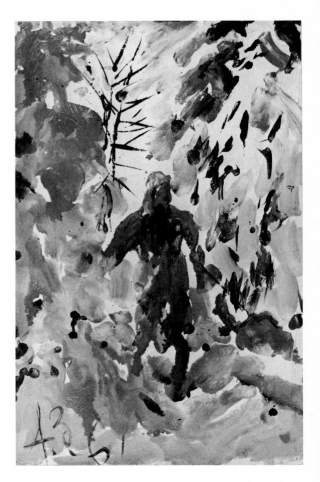

Unofficial Art in the Soviet Union
Igor Golomshtok

"It can probably be said that what is true of Soviet literature and poetry is equally true for most Soviet painters: too much of what is being rejected and forced into embarrassing illegality would most certainly bring honour to the Soviet Union. These works could free the country of prejudices which, unfortunately, are repeatedly confirmed through a Soviet cultural policy that 'disciplines' an author like Voinovich and disowns a painter like Boris Birger." Heinrich Böll

Most of the works shown in this book are remote in style from the present-day art of Western Europe. Moreover the vast majority of these works, which represent a powerful movement in the recent art of an enormous country, come from unofficial artists who are banned in the sense that in their own country they and their work do not, as it were, exist, being surrounded by an impenetrable curtain of silence and hostility, although in their work these artists do not adhere to any political doctrine and represent a purely aesthetic movement.

In the mid-Fifties, when this movement was only beginning, the majority of its initiators did not so much as suspect each other's existence. Each one began alone, guided above all by his personal inability – or disinclination – to adhere to the closed circle of political and aesthetic norms of the official culture of Socialist Realism. An orientation towards free creativity was and still is the sole factor unifying such stylistically dissimilar artists as Boris Sveshnikov and Ernst Neizvestny, Boris Birger and Anatoli Zverev, Ilya Kabakov and Vladimir Weisberg, and it is this orientation that defines the boundary between this group and the general mass of Soviet artists, who have willingly or under compulsion confined their creative potential to the non-aesthetic tasks of "educating the masses in the spirit of communism", "reflecting Soviet reality", "building socialism", and who have subjugated their art to these aims.

Under totalitarianism the orientation to-wards free creativity has determined from the start the social status of those artists who insist on pursuing it. The vast majority of them are not named in a single reference book, encyclopaedia, catalogue or article printed in the USSR, though in the West a few of them have already gained some popularity. Their works are, as it were, deprived of Soviet citizenship and in their country of origin are regarded only as examples of "formalism", "the influence of the decadent culture of the West", and "moral vacuity". It seems to me that "unofficial art" as a term defines better than all others the place of these artists' work in the structure of Soviet society, for while not being forbidden in the strict sense of the word and not hiding deep underground (as art of that kind had to in Nazi Germany), it receives not the slightest support from the Soviet state and is indeed subjected to all sorts of persecutions and repressions.

The chronology of unofficial art in the Soviet Union covers the last twenty years. Its representatives have never been united in an artistic grouping and have displayed no integrated stylistic trend. The styles in which their quests are carried out range from traditional realism (not, of course, in the narrow Soviet understanding of the term) to Pop art and Conceptual art. But even the boldest formal innovations by Soviet unofficial artists, which have departed so far from the generally required standards of Socialist Realism that in their own country they are seen as avant-garde extremism, seem at first

sight here in the West to be only a feeble reflection of things discovered long ago in the art of Europe and the USA.

It is possible that many will be inclined to explain disparities of this kind by referring to the "enigma of the Russian soul" or the age-old isolation of Russia from world culture, recalling at the same time the severe faces of Russian icons of the time of Leonardo and Raphael, or the Socialist-Realist propaganda pictures of the time of Picasso and Pollock. However, the development of Russian art over the last three hundred years contradicts such a view, while a closer examination of unofficial art in the context of Soviet reality reveals certain aesthetic traits which show that it is not merely a reflection of Western trends but a deeply individual artistic phenomenon.

Three centuries in Europe

From the beginning of the eighteenth century Russian painting, sculpture and architecture belong in the general line of European development. Through the window on Europe opened by Peter the Great there blew into the still Asiatic Russia of that time the air of a different culture. Dutch, Italian, French and English experts built the new capital of the Russian Empire, the brilliant St Petersburg. Their work educated a generation of Russian artists and architects who soon created a national artistic school. The Imperial Academy of Arts was founded in St Petersburg in 1754, fourteen years earlier than its opposite number in Great Britain. Rome, Munich and Paris became the places to which its alumni made pilgrimages. Since that time Russian painting has followed European painting, creating national variants of its principal trends.

Nevertheless, Russian art came to the beginning of the twentieth century in a state of relative backwardness. The so-called *Peredvizhniki* (Wanderers), its ideological avant-garde, started their class war with Academicism at a time when the French Impressionists were already mounting their first aesthetic attacks on the Salon; while their ideas on Social Realism (similar in certain aspects to the theories of Courbet) achieved total victory in Russian artistic life in the 1880s, when Cézanne was already beginning to overthrow the theories of Im-

pressionism. The *Mir isskustva* (World of Art) movement (corresponding in time and style to the international Art nouveau movement), which arose in the 1890s as a reaction against the social and national narrowness of the Wanderers, served as a powerful stimulus for further development. Its founders, who made one of their aims "the Europeanisation of Russian culture", bridged, so to speak, the gap in time which separated the Wanderers from new trends. Thenceforth Russian art, having assimilated in a short time the internal impulses and external forms of contemporary Western culture, began to develop according to that culture's internal imperatives and also to elaborate them independently on its own national basis. As a result, by the 1910s this extraordinarily intensive process had swept beyond the boundaries of the foremost innovations of the European avant-garde.

The last pre-Revolutionary decade (1907–17) was a period of such brilliant flowering in Russian art as had not been known since the time of Theophanes the Greek and Andrei Rublev. In 1907 Larionov and Goncharova, with their so-called Primitivism, created a variant of what a mere two years before had been attained in Dresden by the first Expressionists. At the same time Chagall, working in a remote part of

Oscar Rabin
97
STILL-LIFE WITH SKULLS 1973
Oil on canvas collage
88 × 110 cm
Alexander Glezer – Russian Museum in Exile

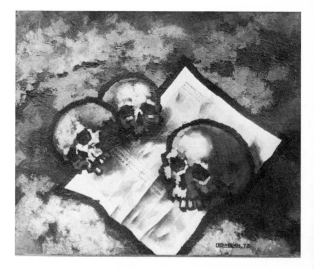

Russia, was anticipating poetic aspects of the coming Surrealism; soon, in the words of André Breton, "the social metaphor" of Chagall's Vitebsk pictures "began its triumphal progress through European painting". Close on the heels of French Cubism, and simultaneously with Italian Futurism, there arose in Moscow and Petrograd an original synthesis of those two trends, Cubo-futurism. Thus in the course of some five or six years Russian art overcame its longstanding backwardness and became a tributary to the general current. Perhaps its very impetuosity and its national overtones enabled Kandinsky, working in Germany, to step forward as its leader and be the first to direct it into a new channel, that of abstract art. Finally, in 1913–14, before Mondrian, Malevich asserted the principles of geometrical abstraction, and his spiritual twin, artistic enemy and antithesis, Tatlin, was producing the world's first "painted reliefs". Malevich's Suprematism and Tatlin's Constructivism became for the next decade generators of aesthetic ideas not only for Russia but to a large extent for the West as well. Such was the artistic heritage received by the young Soviet republic from Imperial Russia, and it cannot be said that it put it to the best use.

In the first post-Revolutionary years these, the most intensely revolutionary artistic trends, were said by Mayakovsky to have "flooded and inundated" the artistic centres of Russia. Their representatives perceived the social revolution as above all a spiritual revolution, a current breaking down barriers to the full creative freedom which they themselves had been realising in art. "Lenin turned Russia upside down just as I do in my pictures," Marc Chagall wrote at that time in his autobiography. In the hungry Russia of the time, ravaged by revolution and civil war, people were inventing new creative concepts and materials, planning hitherto unimagined towns, perfecting theories for the reform of all human life by means of art, forging the material forms of the world of the future. A brilliant pleiade of Russian masters – Tatlin, Malevich, Kandinsky, Chagall, Pevsner, Gabo, Rodchenko, Lisitsky, Olga Rozanova, Lyubov Popova and many others – inscribed one of the most brilliant pages in the history of the artistic life of Russia and the world under the collective name of the Soviet Revolutionary Avant-garde.

Its ideas strongly influenced the German Bauhaus, the Dutch group "De Stijl", Breton's Surrealism and Mexican Monumental art; and a further development of these ideas can be seen in the latest Western trends: in Pop art, Conceptualism, and in so-called Environmental art. However, in its own country this avant-garde was short-lived and its influence was artificially cut short in its prime.

The end of the Avant-garde

A mere five years after the Revolution it had become clear that the new masters of the country required not the creators of revolutionary forms, but *claqueurs* of the feats and achievements of Soviet power. The chief Avant-garde concept of art as "a means to rebuild man's material surroundings and through that his social consciousness" was replaced by the official aim that art should be a means of agitation and instruction of the masses in the spirit of Communism. By 1922 there was formed in Moscow, with the aid of the top Party leadership, the Association of Artists of the Revolution with its slogan "art to the masses". The Association declared that its main task was "to create memorials to the achievements of the Revolution by artistic documentation", and its instrument was to be a descriptive realism whose language was comprehensible to the masses. Artist members of the Association painted Red Army commanders, Red Army victories, workers at work and Party members at Party congresses. Style and technique reverted to those of the Salon at the end of the previous century, while being made out to be the sole method of a genuinely revolutionary proletarian art. The subject-matter and language of these works were completely dominated by the political demands made by the state at that time, and they received the full approval of the rulers. People's Commissar Lunacharsky, who was in charge of all the Soviet arts at that time, was quick to seize on this development and put a sharp stop to avant-garde experimentalism with the slogan "back to the Wanderers".

Then began the struggle for the destruction of so-called "formalism". This little word, which had originally arisen in the Avant-garde as a definition of its work ("for us . . . a new form gives rise to new content, since form and

Victor Kulbak
98
BUTTERFLY 1973
Oil on canvas
80 × 60 cm
Alexander Glezer – Russian Museum in Exile

being determine consciousness and not *vice-versa*"[1]), became – and remains – a propagandistic label used by Soviet ideology to denote everything that does not conform to the aesthetic standards laid down by the political establishment. It was immediately hung on all the representatives of the "non-realistic" trends without exception, both the adherents of pure form (Tatlin, Lisitsky), and those of the primacy of the subject-matter (Kandinsky, Chagall). After 1924 there were no significant exhibitions of the Revolutionary Avant-garde in Soviet Russia, and its representatives were squeezed out of the top jobs in artistic life and deprived of the chance to work. Between 1920 and 1925 a majority of the principal Russian artists emigrated from Russia (Kandinsky, Chagall, Gabo, Pevsner, and many others).

The resolution of the Central Committee of the All-Union Communist Party (Bolsheviks), dated 23 April 1932, "On the re-structuring of literary and artistic organisations", abolished all artistic groupings of whatever kind and with them the last vestiges of creative freedom in the country. The Union of Soviet Artists was established and became a powerful instrument of ideological control over all Soviet art. 1934, the year of the first Writers' Congress, saw the formulation of the principle of "Socialist Realism", which is summarised in the brief formula: "the truthful depiction of reality in its revolutionary development". The art of Socialist Realism was declared to be the "new and highest stage in the development of man's artistic activity", and became the sole type of creativity permitted in the Soviet Union.

However Socialist Realism, with its language of descriptive realism taken directly from the Wanderers, was not a continuation of Russian culture alone or specific to the conditions of the Stalin régime. It is one of the national variants of the "second international style" in the art of the twentieth century, a style that has flourished wherever a totalitarian state has made art serve its interests. "Realism" of this kind was declared to be the official art of Nazi Germany. From the middle of the Thirties the art of Mussolini's Italy adhered to it closely, and in our day it has been used to glorify the Mao Tse Tung régime in Communist China. So as to open the way for this style, totalitarian ideology strives to destroy all other artistic culture which does not fit in with its doctrine. In the Soviet Union, as indeed in other totalitarian states, this struggle was conducted on three main fronts.

Firstly, a crushing blow was struck against the art of the Avant-garde. From the end of the Twenties the works of Russian Cubists, Futurists, Constructivists, and in their wake those of the Symbolists and the *World of Art* artists, were transferred from museum displays into the bottomless vaults which contain them to this day.

Secondly, almost the whole of the contemporary artistic culture of the West was made inaccessible, being qualified as "bourgeois", "reactionary" and even "fascist". Thus in July 1937, at exactly the time when pictures by Kokoschka, Nolde, Kandinsky, Klee, Chagall and Max Ernst hung unframed and accompanied by insulting notices in the famous Munich exhibition of "degenerate" art, the

official organ of the Union of Soviet Artists, *Iskusstvo (Art)*, printed a leader on these artists: "In the West these 'jokers' have very quickly found their way to the hearts of people of 'culture' in the fascist countries – Germany and Italy – because their pretended lack of ideology serves fascism very well and very 'ideologically'. But in this country these 'left-wing' puppets, who formerly claimed a monopoly of artistic leadership, are still not tolerated."[2] In a totalitarian dictatorship these were not empty words. In the course of twenty-five years there was not a single exhibition of contemporary art, and there was not a single monograph, album, or article printed on the subject which diverged from the spirit of the above quotation. In 1947 the Moscow State Museum of New Western Art,[3] the country's sole collection of works from Impressionism to early Cubism (up to 1914), was closed down.

Thirdly, the whole history of world art was radically reviewed and official Soviet historians reinterpreted it in terms of a struggle between "realistic" and "anti-realistic" trends. Thus the greater part of the world's artistic culture was deemed "anti-realistic" and consequently "reactionary". All the rich traditions of old Russian icon-painting, of the Western middle ages, of painters like Bosch, El Greco, Turner, not to mention the Impressionists and all who followed them, went out of circulation. The work of the Russian Wanderers – the direct precursors of Socialist Realism – was declared to be the "supreme pre-socialist art, an art that scaled unprecedented heights unattained by the art of any other country either earlier or contemporaneously",[4] and in all Soviet museums exhibitions of Russian art ended abruptly with their works. This was accompanied, from the end of the Twenties, by the systematic selling off abroad of the treasures of the State Hermitage[5]. After the War, when the mania against the West and "cosmopolitanism" (accompanied by extreme Russian chauvinism in all spheres of intellectual life) was at its height, an interest in foreign art came to be viewed as almost a criminal matter. In 1949 came the closure of Moscow's only remaining collection of foreign art – the State Museum of Fine Art named after Pushkin[6] – whose building was re-equipped for a permanent exhibition of gifts to Comrade Stalin. A solid iron curtain impreg-nably protected Soviet culture against any penetration from outside. And all this, taken together, led inevitably to a further decline in Soviet artistic life, and the establishment of a cultural vacuum.

Although not all Soviet artists voluntarily accepted the *credo* of Socialist Realism, the creation of individual works outside the official standards was achieved without creative communications, sources of information or, above all, an audience. Furthermore, there was the very real threat of persecution for ideological deviation. Thus there was no chance of it becoming a social phenomenon. The art of these lone individuals did not go beyond the walls of their studios and the circle of their closest friends, remaining a deeply personal matter. Even the most important representatives of the former Avant-garde, like Malevich or Tatlin, only painted figurative still-lifes and portraits, and only for their own pleasure. Revolutionary art, with its bias towards collective creativity and a radical re-creation of the material world, with its spirit of freedom and bold daring, quickly faded in such circumstances.

Official into unofficial art

Unofficial art as a social phenomenon in the Soviet Union was born in the middle of the Fifties, when with the death of Stalin the Iron Curtain, which had firmly separated the country from the rest of the world, was raised a little. It immediately became an opposition movement, opposed however not to the state structure but to its official culture, not to the régime, but to the deceit which the régime disgorged along the channels of artistic information. The movement had two basic impulses, one coming from within – and the other from without – Soviet official art.

In the official party documents of the Khrushchev era unmasking the crimes of Stalin there was no mention anywhere of the crimes of his régime in the sphere of culture. Nobody revoked the government's decrees against formalism, lack of ideology and cosmopolitanism in the arts, which had led to the uprooting of Avant-garde art, the banning of the poetry of Akhmatova and the prose of Zoshchenko, and the persecution of the music of Prokofiev and Shostakovich. The whole political dogma of

Socialist Realism remained untouched. All the former Stalinist ideologues were in their old places as loyal guardians of totalitarian art. Yet the wind of change blowing across the country nonetheless induced a feeling of insecurity in some and a cautious spirit of hope in others. Under this double influence the aesthetic structure cemented together by means of Marxist-Leninist-Stalinist quotations was shaken, and something like a dislocation of strata took place in the ossified structure of Soviet art. First to be affected was the middle layer of the Soviet artistic intelligentsia, a layer hitherto completely without rights and without a voice.

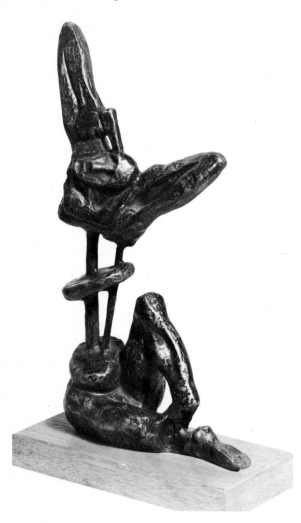

Ernst Neizvestny
99
SUICIDE 19?
Bronze
Grosvenor Gallery collection

To turn some ten thousand artists into loyal illustrators of party directives could of course only have been done through the cruel pressure and overt terror of Stalinism. And once the pressure of the ideological vice was eased a little, many artists began to affirm their right to freedom of creativity. In the main these were members of the younger generation, those who had entered colleges of art just after the War, many of them fresh from the front, and who in the middle of the Fifties were only beginning their careers. They still had vague memories – from what they had seen in their childhood, from the stories of their elders – of the revolutionary romanticism of the Twenties, of the art of the Soviet Avant-garde, and following the example of their Avant-garde precursors they understood freedom of creativity not necessarily as independence of a socialist state or of Communist ideology, but as the right to search for a personal path for the expression of revolutionary ideas. Some of them accepted the aesthetic formula of Socialist Realism, but understood it not as a political dogma, but as a real necessity for the artist "truthfully to represent reality in its revolutionary development", that is, to depict it in all its complex, sometimes coarse, dramatic, or tragic, collisions, and to use the forms of art, not those of rosetinted propaganda.

By the end of the Fifties this "middle layer" significantly affected the composition of exhibition selection committees, arts councils, the editorial boards of art journals and publishing houses, educational institutions and museums. Among the more radical young people in the Moscow Section of the Artists' Union a "left wing" came into being, where an active rôle was played by the sculptor, Ernst Neizvestny. In official exhibitions new names began to squeeze aside some of the venerable academicians of Socialist Realism, and evoked ecstatic reactions among the public. Eight artists, N. Andronov, B. Birger, V. Weisberg, the brothers P. and M. Nikonov, M. Ivanov, K. Mordovin and N. Egorshina, all from the Moscow Section of the Artists' Union, formed the first creative group since the Twenties, the "Group of Eight".[7] Advancing no aesthetic programme, united only by their personal relations, they had but one aim – the organisation of joint exhibitions.

The Italian journal *Quaderni Milanesi* wrote in 1962 of artists working in a different totalitarian régime: "Fidelity to culture was intrinsically anti-Fascist. The painting of still-lifes with bottles or the writing of hermetic verse were in themselves a protest."[8] This sentence defines precisely the chief internal impulse of these Soviet artists. The craving for culture, the urge to re-forge the broken links of time, to break the interdictions and to bridge the artistic traditions of past and present – all this was a form of protest against the cultural vacuum of Socialist Realism and left its mark on the stylistic quests of artists of diverse beliefs. In this the "Group of Eight" was exemplary.

The group had only three exhibitions in all, the last one in May 1966. The slight Cubist distortions of its portraits, the restrained Expressionism of its townscapes, the search for semi-abstract ornamentation, the peeps into the intimate corners of everyday life, the careful play with the stylistic forms of the turn of the century or of the Twenties – all this made the Group of Eight extraordinarily reminiscent of those Italian artists of the Thirties who had refused to adopt the Fascist ideology: the Corrente group, the Rome school, Giorgio Morandi, the early Guttuso, Mucchi and Levi. I am convinced that none of these Soviet artists had ever seen the work of their Italian predecessors, while some of them had no idea that they had even existed. Their stylistic affinities were due not to influence or borrowing, but to the similar social conditions in which both groups were forced to work. In the event these Soviet artists were not expelled from this ideological milieu, even though they showed that it was alien to them, and somehow or other their links with it persisted. For they were unable to find in themselves the strength to break away and attain an untarnished level of consciousness so as to express with their own voice and in their own language the confused creative ferment within them. Only the works of Weisberg – white forms on white backgrounds – and of Birger – streams of luminous colour dissolving forms within themselves – gave adequate artistic expression to this internal uncertainty, the blankness of the canvas yet to be filled.

The artists of this group can legitimately be regarded as having made the most extreme departure from Socialist Realism within the normal context of Soviet art. Other colleagues opposed to standard Socialist Realism continued to paint thematic paintings for official exhibitions – the feats of the Red Army, Komsomol members at work on building sites, the labour of the Soviet people – and to put up monuments to dead heroes. But they did this not with the insincere heartiness of Socialist Realism but in the generalised and monumentalised forms of modern art, permeated with drama and the dour pathos of struggle. But this was enough to close the doors of galleries and purchasing committees to their works.

All the time that it existed the opposition movement within official art was under implacable pressure both from above and from below. The all-powerful élite of Socialist Realism (the higher echelons of the Union of Soviet Artists and the Ministry of Culture, and the entire membership of the USSR Academy of Arts) retained all its key positions in artistic life. It reduced the level of its political activities only for a time, because of its direct complicity with the crimes of the Stalin régime.[9] Meanwhile the Union of Soviet Artists, particularly in the provinces, was numerically dominated by a conservative grey mass of artists who had received the apt nickname of "dry-brushmen", since their basic art form was the portrait, in dry-brush technique, of Soviet leaders and members of the Politburo. Their pictures embellished all the towns, villages and hamlets of the Soviet Union at holiday time and, at any other time, the walls of every state establishment. In the execution of these very profitable commissions they expended the last grains of their professional expertise and talent. The artistic leadership relied on them for the fulfilment of its policy, and they were the source from which the leadership renewed its members. The very existence of a gifted younger generation, which was free-thinking albeit within the confines of realism, was a threat to both the élite and the rank and file of the Artists' Union.

The year 1962 saw the culmination of the opposition movement and simultaneously the beginning of its decline, as it was of the whole brief "Khrushchev liberalisation". In November of that year, in the Manège (the capital's largest gallery), a large exhibition opened to commemorate the thirtieth anniversary of the Mos-

cow Section of the Artists' Union. The planning of this exhibition was the most unfettered in thirty years. Its focal point (from the point of view of the interest evoked) was the work of several young artists, notably Andronov, Nikonov, Weisberg and Birger. It was also the first showing in decades of some "moderate" artists of the Twenties – Shterenberg, Drevin, Falk, Tyshler and others (things had not gone so far as to permit the display of works of the extreme Revolutionary Avant-garde, such as Malevich and Tatlin). And it was here that the orthodox upholders of Socialist Realism chose to launch their counter-attack on the new movement. After the exhibition had already opened, some members of the progressive circle around the artist and teacher, Eli Belyutin, were invited to take part. Then, unexpectedly, Ernst Neizvestny, Vladimir Yankilevsky (then starting his search in the field of Conceptual art) and a number of artists experimenting with abstract form, none of whom were members of the Moscow Section of the Artists' Union, were also invited to take part. Suspecting nothing they submitted their works and were accorded two small rooms on the first floor. Next day the leadership of the Moscow Section of the Artists' Union and of the USSR Academy of Arts brought Khrushchev himself to the exhibition.

The head of state received explanations from the new president of the Academy, V. Serov, a total obscurantist and reactionary whose aim was to show what ideological liberalisation had led to, how the sacred principles of realism were being besmirched in the work of young painters and how the country's money was being spent on harmful daubings. His comments hit home: Khrushchev, who understood nothing of art, saw in the exercises of the young painters only charlatanism and pornography. In a speech alleged to be scatalogical in parts he harangued Neizvestny and some of the other artists present and excoriated their work in the language of the farmyard. Subsequently the artists, together with other members of the liberal creative intelligentsia, were subjected to wide-ranging criticism and denunciation.

Fortunately Stalinism was now a thing of the past. Nobody was declared an enemy of the people, arrested or even sacked. After a short-lived hysterical campaign in the press there came an unexpected lull. Everybody seemed to have gone back to their places. However in the bowels of the Party and state apparatus a new machine was silently set in motion for the total suppression of creative freedom. Slowly and systematically, without unnecessary noise or bloodshed, by means of secret instructions, administrative decrees and telephone calls, it methodically embarked on a reshuffling of the human pack. Liberal editors, teachers, members of various artistic councils and boards, adjudicators were quietly moved to less responsible posts and replaced by old Stalinist ideologues dragged out of temporary oblivion. As a result, by the end of the Sixties all artists with an inclination towards opposition were deprived of any opportunity to receive commissions, sell their work or exhibit, and their names vanished from the pages of Soviet newspapers, books and catalogues.

Under the impact of this slow but constant pressure the official opposition movement gradually ebbed. Most of its members were obliged to compromise with ideology and submerge their work in the ocean of Socialist Realism. The most talented among them (Weisberg, Birger, Sidur, Neizvestny), however, refused to compromise and were thrown overboard from the official artistic life of the country, being left to survive alone or join forces with a new phenomenon in Soviet art – the *unofficial* opposition.

The corrupting influence of "bourgeois ideology"

The main stream of the unofficial opposition flowed not in normal Soviet channels but quite outside them. It was formed by artists who from the very start had renounced all contact with the Soviet artistic ideology. The eldest among them were artists following individual paths who had arrived at a nonconformist position each in his own way, whether through experience of the Soviet labour camps (like Boris Sveshnikov or Lev Kropivnitsky) or because of the influence of their teachers or the specific circumstances of their lives (Oscar Rabin and Vladimir Nemukhin). But the majority of them were, in the Khrushchev era, still at school or first-year students at art colleges. This meant that their creative talents were brought to maturity in the most favourable period in the

fifty years of Soviet history.

As soon as the Iron Curtain had been raised a little, the cultural vacuum created in the country over the long years of Stalin's rule had started to suck in the atmosphere on the other side. In the wake of the new state policy of widening links with foreign countries, Moscow and Leningrad witnessed in a brief space of time (1956–63) a series of important foreign exhibitions, including art exhibitions. Among them were an exhibition to commemorate Picasso's seventy-fifth birthday (1957), an exhibition of German graphics (1958), exhibitions of modern English, French, Belgian and American art, an exhibition of the art of the people's democracies (i.e. of East Europe), of Fernand Léger, and others. But, as always, the country's rulers understood the widening of cultural links as merely the extension of Soviet ideology abroad. Against an influence in the opposite direction they deployed an efficient enough propaganda apparatus of mis-information and non-information. But this time the effect was the opposite of that desired: the stock of Socialist Realism hardly rose at all in the art world of the West, whereas Western culture, formerly only glimpsed through chinks in the Iron Curtain, became for the wider Soviet intelligentsia a light in the darkness, a beacon of freedom and a model for imitation.

The interest in foreign exhibitions which was manifested in the Soviet Union at the end of the Fifties can only be compared with the excitement surrounding important football matches. Many thousands of people spent whole nights in long queues in order to get into the galleries in the morning. The exchange of opinions around the pictures expanded into mass discussions, which sometimes ended in the arrest of the most active "defenders of modernism" (for instance, in Leningrad during the Picasso exhibition in 1957). Young people imbibed all kinds of information about modern art; any book or magazine with even inferior reproductions of modern masters, or merely one word about their work, instantly vanished from the shops. Large numbers of people, who had only recently thought Shishkin and Repin the unsurpassed summits of world painting, suddenly realised that art as a whole and modern art in particular was something different from that which Soviet propaganda had

for decades been criticising so harshly. The result of this change in social awareness was a serious, sensitive and sharply responsive audience of interested consumers of art, which did not and could not exist in the Stalin years. It was this audience that created the fertile ground in which the unofficial art of the Soviet Union soon sprouted.

The stimulus for this movement and at the same time its catalyst was the Sixth World Festival of Youth and Students in Moscow in the summer of 1957. Three two-storey pavilions in the Sokolniki Park of Culture housed an enormous exhibition of over four and a half thousand works by young artists of fifty-two countries. For the first time in three decades Russian artists saw the living art of the twentieth century, inhaled the vital atmosphere of its quests and innovations. In a specially equipped studio they were able to observe how foreign painters – young Abstract artists, Tachistes, neo-Expressionists – created their works, and even to work alongside them for a few hours. It was here that many of them first discovered each other's existence, made their first creative contacts and began to hope for a better future. These few days of contact with freedom were enough for budding Russian artists to discover within themselves a creative potential which until then had been suppressed by their training in Socialist Realism, a potential they had never suspected. They began, as Vladimir Nemukhin has said of himself, "to recognise in foreign artists their own selves and their own strivings".[10]

Anatoli Zverev, who was starting work at that time, is a typical example. In the studio of the Festival exhibition he saw his first Tachiste (the American, Garry Colman) and watched him splash paint onto his canvases in a state of total emotional abandon. Zverev adopted this method, but not in order to express the impulses of his unconscious in abstract conjunctions of colour, like the Tachistes. He continued to paint from nature, but now the creative process became for him a short and concentrated act of volition, in which consciousness was disconnected and the brush was allowed to follow the path prompted by the artist's innermost powers of perception. Zverev thus created a specific style in which figurative and abstract elements were combined. The hurried brush-

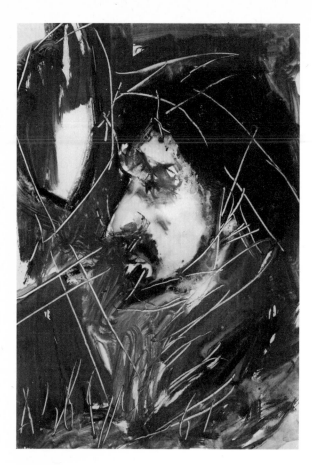

Anatoli Zverev
100
PORTRAIT OF AN ARTIST 1961
Gouache
59 × 41 cm
Private collection

strokes and squirts of paint on his canvases gave rise to typically realistic images disclosing aspects of the models which could in no way be expressed by the method of realistic copying.

Alas, in the traditional language of totalitarian propaganda all this experimentation was dubbed "the corrupting influence of reactionary bourgeois ideology". Gifted pupils were excluded from art colleges for "formalism" (one of the first victims being Zverev himself), while prospective candidates were put through still tighter ideological filters. Thus by excluding them from artistic life, the Soviet system forced these artists to become unofficial. They worked as loaders, hospital attendants, doorkeepers, nightwatchmen, while in their own homes they painted, drew and sculpted according to their own conception of free creativity. And now

they sought creative contacts and joined together in small groups. One such group was formed at the end of the Fifties in the workers' village of Lianozovo, near Moscow, around Oscar Rabin and his teacher Evgeni Kropivnitsky. Another was formed in Moscow in the flat of the art historian I. I. Tsirlin. There were many of them in Moscow and Leningrad, and the case of Tsirlin perhaps illustrates best the character and aims of most of these groups.

Ilya Tsirlin took an active part in the artistic life of the capital immediately after returning from the Second World War. He was sincerely convinced of the advantages of socialist culture, wrote orthodox articles and books unmasking American Modernists and praising Bulgarian Socialist Realism, and he came to prominence in the Soviet artistic hierarchy as chairman of the critics' section of the Moscow Artists' Union of Cinematography, and director of the book section in the important publishing house Iskusstvo (Art). But during the changes after Stalin's death he underwent a profound internal development, as did many intellectuals of his generation. It would have been impossible to call the artists who gathered in his flat a creative organisation or a circle. Tsirlin simply told them about contemporary art, showed them reproductions and gave material help to those who needed it, while in his flat they were able to show one another their work. In the late Fifties one of the central newspapers printed an article with the typical title *Dvurushnik* ("Double-dealer") denouncing Tsirlin as a secret apologist of abstractionism and an enemy of socialist culture. After this he was removed from all his posts and a year later he died of a heart attack.

Such groups and individual artists were the seedbeds of a new cultural micro-climate which, like blisters in metal, threatened to destroy the monolith of official Soviet culture which had been built up over the decades. They were a threat because their work found increasing support from increasingly wide circles of the intelligentsia, in which there was growing a largely passive resistance to official artistic ideology and policy. High ranking scientists (mainly physicists), who could afford to disregard the vociferations of the Ministry of Culture and the other controlling institutions, began arranging semi-secret exhibitions of unofficial art in their institutes. In this setting there

appeared collectors who began to buy the works of young artists. Soon their work started to attract the attention of foreigners – correspondents, diplomats and tourists. And so much had the psychological climate changed by now that the artists even fostered these dangerous contacts, although it was still not clear whether the consequences would be as serious as in the recent past: indictment for dreadful state crimes not excluding espionage. Information about the new movement seeped out into the foreign press and by the beginning of the Sixties privately-owned galleries in London, Rome and Paris had begun to organise exhibitions of some of their work. The growing atmosphere of openness made them less susceptible to persecution by the authorities and the growing interest in their work also created a market, which gave a very small number of them the chance to sell and thereby concentrate more on their work.

Although in Russia their exhibitions were very few in number and lasted only for a few days or hours (for as a rule they were closed as soon as they were discovered), although under the state monopoly of art the commercial demand was extraordinarily limited, and although the names of these artists appeared in the press mainly in satirical articles branding them as parasites and agents of capitalism, all this created for them the semblance of a professional life and implanted the hope that with time they would get through to a wider audience.

But in the mid-Sixties a curtain of absolute silence closed over them. Soviet society again tried to rid itself of this undesirable element, partly by blanketing them in silence and thus tacitly declaring that they did not exist, and partly by freezing them completely out of the official system. To understand how this was done one must first know how that system works and who it is that controls it.

The Soviet art establishment

The whole of artistic life in the Soviet Union, from top to bottom, is strictly controlled by three basic institutions: the Union of Soviet Artists, the Academy of Arts of the USSR, and the Ministry of Culture of the USSR. Formally independent of each other, these organisations are closely linked by the system of party control, since they come directly below the central party organ, the Central Committee of the Communist Party, and together form a unified and efficient mechanism of control.

From the moment of its foundation the Union of Soviet Artists has had several functions. Firstly there is its *ideological* function. Every new member has to accept the Union's code which rules that, among other things, a member must in his works adhere strictly to the principles of Socialist Realism, assist in educating the workers in the spirit of communism, further the building of socialism in the USSR, etc, etc. Disagreement with these conditions deprives the artist of his candidature, while violation of them can lead to expulsion. In the Soviet Union this places him in a peculiar position, owing to the second, *juridical* function of the Union – since only membership of the Union gives the artist the legal right to work in his profession (just as a university diploma confers this right on a gynaecologist or a dentist). Being outside the Union of Soviet Artists also deprives him of the ability to practise because of its third, *economic* function: it and the Ministry of Culture are the only official bodies empowered to commission art works and to distribute the material rewards. Private selling of any kind, including the sale by an artist of his own work, is illegal. Finally, the Union has a fourth, *controlling*, function. It appoints adjudicators of works submitted for exhibition and it publishes two of the three chief art journals in which the critics' section practises its artistic policy.

The original creation of the Union had caught the Soviet artist in an ideological snare: acceptance of the principles of Socialist Realism became a condition of membership of the Union, and membership became in turn a condition of being able to practise professionally. But even this system of control turned out to be insufficient, because the leadership of the Union (which came to include over ten thousand painters, graphic artists, sculptors, craftsmen and designers) is formally elective, and under the pressure of the mass of creative workers its understanding of Socialist Realism has sometimes seemed elastic to the powers that be. This was one of the reasons for the later creation of the second basic institution – the Academy of Arts of the USSR.

The Academy came into being in 1947 and the limited number of its highly paid members formed the élite of Socialist Realism – portraitists of the party leaders and eulogists of the "unprecedented achievements" of Stalinist socialism. In the last twenty-five years its composition and ideology have changed little. Its present president, N. Tomsky, made his career with monuments to Comrade Stalin with which he flooded the country. Currently the Academy of Arts of the USSR controls all the important art institutes and schools in the country, where the adepts of Socialist Realism explain to future artists the reactionary essence of the art of Kandinsky, Malevich, Picasso, and all modern art. Together with the Ministry of Culture it also controls all artistic research, museum work, and publishing.

The Ministry of Culture of the USSR is the third mainstay on which control of Soviet artistic life rests. It controls all the art museums and directs their exhibitions, and through a State Purchasing Commission it controls new acquisitions (museums do not have their own resources for this purpose). Ministry bureaucrats and Academicians dominate all exhibition selection committees, editorial boards in the publishing houses and the leadership of the Union of Soviet Artists, and thus exercise ideological control over all creative activity in the USSR.

Control of artistic institutions can thus be summarised as follows. The Cultural Section of the Central Committee of the Communist Party controls all three bodies – the Ministry, the Academy and the Union (the latter being dominated by members of the former). All three bodies control the journal *Iskusstvo (Art)* and all exhibition facilities. The Union controls the journals *Tvorchestvo (Creativity)* and *Dekorativnoe Iskusstvo SSSR (Decorative Art in the USSR)* and a commissioning body known as the *Khudozhestvenny Fond* (Artistic Fund). The Ministry controls the newspaper *Sovetskaya Kultura (Soviet Culture)*, the State Hermitage and the State Russian Museum (both in Leningrad), the State Purchasing Commission, and the Institute for the History of Art. Finally, the Academy controls the following educational institutions: the Surikov Institute (Moscow), the Repin Institute (Leningrad), the Institute of Decorative and Applied Art (Moscow), and in addition the research organisation known as the Institute for the History and Theory of the Figurative Arts.

The mere fact of an artist falling out of this system of control is regarded by the state as theoretically impossible and, if it actually takes place, as wholly reprehensible, since the state continually proclaims its monolithic quality, the unanimous popular approval of its policies and the necessity of implacable struggle against all deviations. Every step in the creative life of a nonconforming artist is liable to be regarded as a crime. If he is not an employee of the state or a member of the Moscow Section of the Artists' Union his "antisocial" behaviour can come under the severe Soviet laws on "parasitism", as a result of which he may be expelled from his native town or forced to give up his artist's brush for the spade of an unskilled worker. Supposing he paints not the façades of swank new buildings but the dingy life of the working-class suburbs, not the optimistic smiles of Soviet people but his concept of the principles governing the construction of the human body; in such a case he can be accused of distorting Soviet reality, making propaganda for an alien ideology, or of condoning amorality and producing pornography. Supposing that, to keep body and soul together, he sells his work to a foreigner, in that case he will start to look fearfully at his telephone (if he has one) or at the suspicious air-vent in the ceiling (it might be bugged), and hasten to turn his canvases to the wall if a stranger comes. Any concierge, co-sharer of a communal flat, caretaker or policeman might inform the relevant organs of his semi-underground existence, and then. . . . For the older generation at least, who began their artistic careers in an atmosphere still heavy with fear and suspicion, the dots would have a very real and threatening meaning.

The search for a way out – the "fantastic realism" of Sveshnikov

In Stalin's time the Soviet artistic establishment was bedecked with the old Avant-garde's revolutionary slogans, left over from the Twenties, about the class nature of art, its duty to the masses, its educative function, its rôle in the transformation of the world and of the consciousness of the masses,[11] and the same slogans,

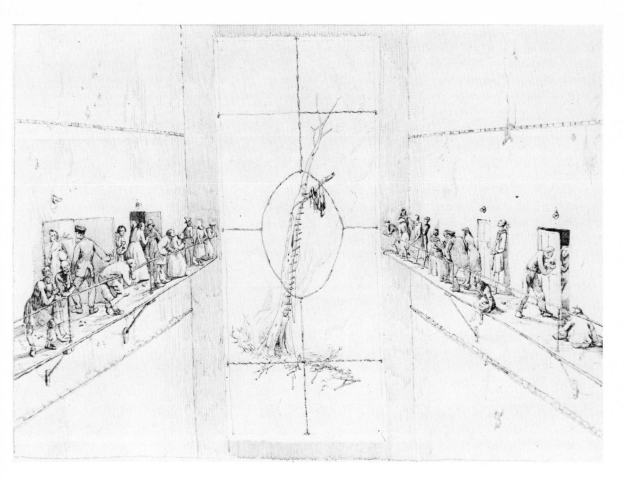

Boris Sveshnikov
101
PRISON FANTASY 19?
Indian ink on paper
28.5 × 38 cm
Private collection

somewhat tarnished, decorate it still. But the artists who in the Fifties began their search for a way out of the cul-de-sac of official ideology deeply suspected the official establishment. They escaped from it into the values of another tradition which led them to look within themselves and explore their own internal world – in which, nevertheless, they discovered spectres of the reality that surrounded them.

"As an artist, I am very much bound up in life, I cannot just paint out of nothing. For me to paint is to experience reality. This reality, naturally, undergoes a change of form," says Boris Sveshnikov of himself. Sveshnikov started to "experience reality" earlier than the other painters of his generation. At the beginning of 1946, as a youth of eighteen, he was accused of plotting against Stalin and sent to the con-

centration camps of the far north, where he spent eight years and where he started drawing secretly at night.

On the islands of the Gulag Archipelago life continued in close proximity to death and every stroke, every drawing, might have been his last. "That was absolutely free art," recollects Sveshnikov, "I received my bread ration and painted what I wanted. Nobody directed me. Nobody took any interest in me." In those conditions it was worth painting only what mattered.

At that time in the Soviet Union a neophyte painter, like Sveshnikov before his arrest, could hardly have heard much about Surrealism. But the world of Stalin's camps was in fact governed by an irrational logic, a logic of the absurd, in which black became white, the

tragic became everyday, and human became animal. This world covered enormous territories of Russia, undiscovered, disembodied, unknown except to its inhabitants, but the irrational horror which it radiated fettered the country, formed the nerve and pivot of its existence, turning the state of Socialism Triumphant into an enormous suburb of the prison metropolis. This world existed in real space, but in an unreal time which could stop for decades, move back by hundreds of years or move forward by thousands into a kind of post-apocalyptic epoch. It formed Sveshnikov's consciousness. And the figurative structure of Sveshnikov's works is based on this dislocation between space and time.

In the real space of the northern landscapes (in his camp drawings), of Moscow backyards, waste plots and cemeteries, the dead exist side by side with the living. On snowy plains – interspersed with wooden fences, wretched buildings and copses of stunted pine trees – fairy-tale castles rise, crinolined ladies and be-wigged cavaliers are frozen in the gallant movements of an ancient minuet, while through the windows of twentieth-century communal flats we glimpse the pullulation of swarming non-human (pre- or post-anthropoid) forms of life. In this dislocated world human life is revealed in all its porcelain brittleness and sorry defence-lessness (not for nothing did the rich concentration-camp folklore throw up the apt definition of a prisoner on the point of dying as "skinny, tinny and transparent"). The artist conveys this heartache with the gothic fragility of his line, the translucent instability of his pointillist colour and the absorbed detachment of his people.

In his work Sveshnikov pursues what he personally has seen and experienced of reality, rather than a rational conception of the absurdity of human existence. At first glance his works seem close to Surrealism, but they derive from, and are imbued with, an inner reality of a kind which has never before been the subject of art. What in the Twenties had been invented in the garrets of Montmartre was actually seen by Sveshnikov twenty years later – in Stalin's camps of the Forties.

At the time when the unofficial art movement was coming into being in the Soviet Union, the underground writer and subsequent camp inmate Andrei Sinyavsky (Abram Tertz) wrote in his essay "What is Socialist Realism?": "I place my hopes in an art of the phantasmagoric, with suppositions instead of objectives, and the grotesque in place of realism. That would correspond to the modern spirit more accurately than anything else. Let the exaggerated images of Hoffman, Dostoevsky, Goya and Chagall and the arch-socialist Mayakovsky, and many other realists and non-realists, teach us how to be truthful with the aid of absurd fantasy."[12] Later developments fully confirmed his prognosis. The feeling of the fantastic quality of surrounding life turned out to be typical not only of the former labour-camp prisoner Sveshnikov but, in varying degrees, of dozens of other nonconformist artists who began their work outside the barbed wire. It is no exaggeration to say that the whole movement more or less began with phantasmagoric art, or, if a more learned definition is called for, "fantastic realism".

Oscar Rabin and the grotesque

The social roots of this phenomenon can easily be surveyed. It arose in reaction to the system of aesthetic, ethical and rational values of official culture. These were impossible simply to ignore or reject: in the first post-Stalin years the atmosphere was still too dense with ideological proscriptions and left too few openings for access to the living culture of our time. It was possible only to recoil from them, to oppose them. These artists opposed total Socialist Realism with a realism not of description but of understanding, they opposed the shallow optimism of its progress into a bright future with the artistic traditions of the past (which Soviet ideology had been busy uprooting for decades), and they opposed its banal materialism with sincere religious feeling, its party and national loyalty, its rationalism and collectivism, with the personal, the intimate, the spiritual and the metaphysical. The contrast between these systems of values was so great that, when they were superimposed in one and the same work, they inevitably created a world of the grotesque and the fantastic, toppled as it were, off the axis of time. Opposition to official culture left its mark on the styles of the majority of nonconformist artists of the older generation.

Oscar Rabin, one of the best-known of them, fills his pictures with the *realia* of Soviet life: slogans, banknotes, identity-cards, newspapers with typical headlines: "Forward to the Dawn in the Name of the Happiness of the People", "Feeling of Fellowship", "Indifference is Contra-indicated", and so on. These he reproduces not in order to "fill the gap between art and life", and not for the sake of affirming the artistic worth of objects of mass culture, as Jasper Johns has done with the American flag or Andy Warhol with soup tins. Instead he juxtaposes exclamatory aspects of official life with the *realia* of Soviet life that accompany them. Placed cheek by jowl with saucepans, tins of preserve, vodka-bottles, dried-up bits of herring and other everyday objects they lose their pompous complacency and acquire a more genuine character of the malevolent grotesque. Here we are dealing with the unmasking of stock-phrases of official culture, the belittling of their stale enthusiasm, rather than with their affirmation as aesthetic values. This points to a certain didacticism in Rabin's work, but the essence of his art lies elsewhere.

Rabin's reality is the barrack huts of the settlement of Lianozovo where the workers of this Moscow suburb are obliged to live and where the artist spent his youth. It is the slums surrounding the railway station, where he worked as a loader after his expulsion from the art institute. This lopsided, unobtrusive world,

Oscar Rabin
102
THE REFLECTED CHURCH 1968
Oil on canvas
81 × 109 cm
Alexander Glezer – Russian Museum in Exile

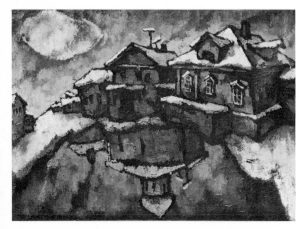

rushing forward to no great achievements, a world of simple things with its cosy asymmetry, its lumpy unevenness, its habitual decrepitude, is always warmed in his pictures by a human presence: smoke rises from chimneys, crooked little windows emit a golden glow, hinting at the cosiness of life inside. In the picture shown here some tumbledown cottages in a sleepy corner of the suburb are shown reflected in an enormous puddle. They themselves are real enough, but the reflection takes the form of an ancient little church, evidently one which used to stand on the spot but was razed to make way for these hovels. And it as if they can still see it in their sleep. It represents the world of the past and its vain attempts to maintain a foothold in the present, trying to find a hiding-place behind the façade of Soviet life which denies the possibility of its existence under socialism with bombastic slogans and meaningless newspaper headlines. It is fantastic not so much by virtue of an external grotesqueness, though Rabin often resorts to the grotesque in his work, as because of the unexpectedness of its invasion into the carefully scrubbed and washed chocolate-box world of Socialist-Realist culture, rather as a simple old peasant-woman seems an unreal fantasy when glimpsed amid the grand marbles and bronzes of the Moscow metro.

Nostalgia for the past and religion

Vyacheslav Kalinin paints Moscow life in the juicy colours of the artists of the beginning of the century (particularly Kustodiev), while exploiting the poetic irrationality of a Chagall. Like Rabin, he paints the vanishing world of his childhood, the world which used to seethe just beyond the Kremlin walls on the opposite bank of the Moscow River. This merry, shabby world of the people, existing somewhere in the artist's spacious memory and the drunken daydreams of its inhabitants, may be somewhat coarse and primitive, but on the other hand it is unfettered and natural, it sparkles with genuine life and humour and in no way lets itself be docketed by a faceless official ideology.

Nostalgia for a destroyed national culture, for the vanishing traditional forms of popular life, is typical of the artist living in a cultural vacuum. It is precisely this feeling which has

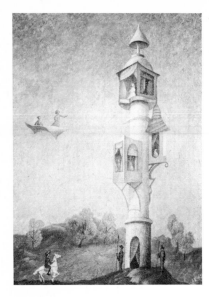

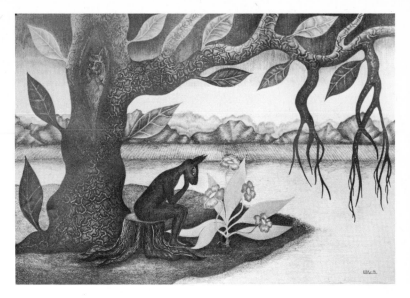

Alexander Kharitonov
103
FLYING CARPET 1962
Oil on canvas
75 × 55.5 cm
Private collection

Valentina Kropivnitskaya
104
THE ISLET 1974
Pencil on paper
43 × 61 cm
Alexander Glezer – Russian Museum in Exile

prompted many artists to create their own world far removed from contemporary life and rooted in other times and places.

The work of Alexander Kharitonov and Valentina Kropivnitskaya is perhaps an extreme expression of the trend I have called fantastic realism, since the world of their art is filled with an atmosphere not of the surrealistic absurd, but of the fairy tale, which so often deputises for the spiritual deficiencies of real life.

The poetic world of Kharitonov follows the age-old laws of truth, goodness and beauty. The spaciousness of his pictures arises from the soft shimmer of colour which he applies to his canvases with a complex method akin to that of pointillism. In places this shimmer thickens to form the ghostly outlines of people, trees, flowers, angels and saints. There are no conflicts here, except of the type: "The king is reading a book but the queen is angry because she does not want to drink tea alone" (the artist's title for one of his pictures).

Kropivnitskaya, in her drawings, unfolds a kindred world inhabited by endearing donkey-like beings. But for all the abstractness, the other-worldliness of these works, they still echo reality. The ingredients are those of the fairy-tale dream – ordinary objects, feelings and ideas which are normally suppressed by official culture or replaced by surrogates: icons, churches (genuine ones, not the monuments of art which are shown to tourists), compassion, pity, love and the phenomena of the spiritual world as elements of a different reality from that defined as "the highest product of matter" or, alternatively the "emanations of a diseased psyche".

Another aspect of this trend is represented by Edward Zelenin and Nikolai Vechtomov, who approach pure Surrealism in their work. "If time and space are endless, then the existence of many forms is possible. . . . My problem is to create a convincing impression of the existence of particular forms in specific space," says Vechtomov. Whereas these forms are abstract in Vechtomov, Zelenin more often than not borrows his forms from the life around him. Usually they are the little churches and bell-towers of the ancient Russian provincial town of Vladimir, where he lived and worked before emigrating to the West in the autumn of 1975. His works differ from classical Surrealism by his intuitive following of certain principles closer to American Super-realism (intuitive because Zelenin could hardly have heard of this trend in the provinces). Thus a certain sim-

plicity of colour in his fantastic compositions is due to the laws of colour simplification in the popular press.

Dmitri Plavinsky likewise began work at the end of the Fifties with fantastic scenes, but he soon abandoned direct representation. Plavinsky has defined his main theme fairly precisely as "the object in its travel through time", and his basic task as "the expression of what the object carries through time, that is, a certain degree of spirituality". Plavinsky does not simply reproduce objects but compresses them into a dense impasto of colour, leaving them to exist in it in the form of imprints, abstract patterns or even in their natural form. Russian folding icons, scraps of ecclestiastical brocade,

pages of ancient books and documents, the patterned forms of old keys, the imprints of plants, fish skeletons, shells are here seen as the relics of other epochs, antediluvian fossils excavated by the artist from the ossified strata of historical time. A brilliant draughtsman, he continues this theme by figurative means in the proper sense in his drawings and enormous etchings, where whimsical forms of organic life arise out of a cobweb of the finest strokes creating a feeling of universal decrepitude and collapse. Even the abstract patterns in his works often braid themselves into a whimsical version of old Slavonic calligraphy. His graphic works and relief-collages, which it would be difficult to call painting in the traditional sense, are

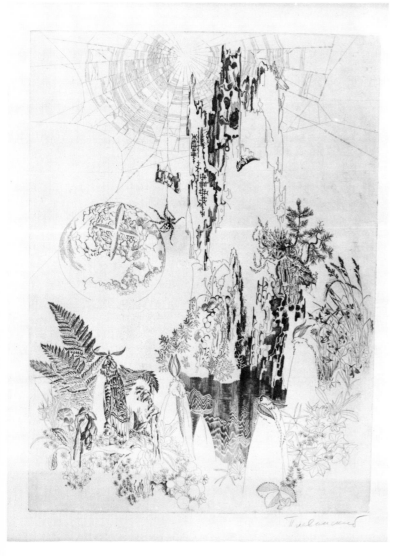

Dmitri Plavinsky
105
THE BUTTERFLY 1969
Etching
64 × 49 cm
Alexander Glezer –
Russian Museum in Exile

imbued with the nostalgic atmosphere of a vanishing culture.

The Moscow art-scholar and critic, E. Barabanov, describing the September 1975 exhibition of unofficial Moscow artists, commented: "In almost every other picture, regardless of the age and aesthetic orientation of the artist, one can see, whether directly or indirectly, Christian subjects or elements or motifs derived from Christian ritual. Cupolas, crosses, haloes, crucifixions, crowns of thorns, little churches, icons, together and separately, in season and out, roam from picture to picture."[13]

This phenomenon deserves particular attention, since it is far from uniform. The majority of artists (including Rabin, Plavinsky, Kharitonov and Kropivnitskaya) employ ecclesiastical images as symbols – bearers of values of the traditional semi-legal culture which is being discarded. However, for many of them religious emotion has also become an artistic subject in its own right. Since the permitted forms of religious life and access to them are so exiguous, art is often the only way of making contact with the spiritual: it becomes a means of acquiring religious understanding, thus transforming itself into a metaphysical act. Thus the work of Otari Kandaurov is at first sight similar to a variety of Surrealism, but the artist considers himself to be the initiator and sole representative of a creative method which he calls "metarealism" and which he defines as "a method of plastic meditation, in which the object shines, so to speak, through a spiritual light".

Art for its own sake

To become an unofficial artist in the Soviet Union it is not necessary to turn directly to forbidden themes or subjects, such as religion or aspects of Soviet life that are normally brushed under the carpet. It is enough simply to try to work as an artist in the traditional sense, that is, to strive for perfection in painting as an activity not harnessed to social tasks. The language of Soviet ideology possesses an impressive arsenal of derogatory labels for this kind of activity: "bourgeois aestheticism", "militant individualism", "distraction of the awareness of the masses from the real problems of the time", "escapism", "the preaching of ideological emptiness", and the like. As a result artists of the most diverse tendencies are pushed out of official culture and into the sphere of unofficial art, such as the semi-abstractionist, Vladimir Nemukhin, the portraitist Boris Birger, the analytic Vladimir Weisberg and the refined Dmitri Krasnopevtsev.

For the last fifteen years Nemukhin has confined his work to collages of playing cards in which he strives to create a closed aesthetic system, one in which the rôle of the cards is not only decorative but associative. Appearing sometimes as real objects, at others as their simulacra, they re-create the mysterious world of the shadows of the past which lives in the deepest layers of human memory.

At the moment one of the most influential unofficial artists is Weisberg. In his early portraits and still-lifes (late Fifties to early Sixties) one could still recognise traces of the influence of such diverse masters as Cézanne, Modigliani, Seurat, Falk perhaps, and Giorgio Morandi, with whom he has a special affinity and with whom he is sometimes compared. For the last ten years his work has concentrated on the depiction of white forms on a white background (often china on a white tablecloth), in which objects are present only for the affirmation of the painting's intrinsic worth. Weisberg is the kind of artist who tries to construct a rational *summa* of all the experience of world art in which to found his artistic system. In his long theoretical work, "The Classification of the Basic Aspects of Artistic Perception" (regrettably only published in summary form)[14], Weisberg divides works of art into three categories, of which the highest includes "the creative apogee of many artists, usually at the end of their life", when the painting's structure is built on the "non-recognition of the pigmentation of large areas which nevertheless are governed by a structural scheme", while the composition is built on the "balance between recognition and non-recognition, with the emphasis on the latter". Certainly Weisberg himself strives to approach this category. The simple forms and endlessly complex colour of his still-lifes merely hint at their real prototypes. They require long contemplation, during which the viewer's recognition in them of real forms in real space alternates with the disappearance of this similarity, when the pure laws of composition and colour begin to operate. (Similar problems, although

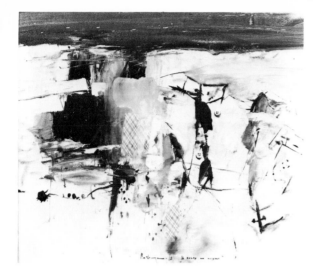

Vladimir Nemukhin
106
THE GAME ON THE BEACH 1973
Acetate tempera and collage on paper
51 × 59 cm
Alexander Glezer –
Russian Museum in Exile

Vladimir Weisberg
107
STILL-LIFE WITH THREE WHITE CUBES 1975
Oil on canvas
53 × 53 cm
Private collection

in a different artistic system, occupy Edward Steinberg, who represents the second generation of unofficial artists.)

Formally Weisberg is still a member of the Union of Soviet Artists, but his still-lifes hardly ever appear in official Soviet exhibitions. This does not mean, however, that the genre has no place in Socialist-Realist culture. On the contrary – in such exhibitions one can see one's fill of cups, tumblers, table-cloths, but only as direct reproductions of reality, multiplying the visible content of the world but in no way deepening it aesthetically. In other words they are essentially devoid of the artistic quality of the painting of our era. This is precisely why artists of Weisberg's calibre are gradually levered out of official art into the artistic semi-underground: if Weisberg's still-lifes are planted among that vast acreage of banality, the officially approved paintings immediately reveal their total aesthetic hollowness. In this respect the creative career of the artist Boris Birger is very revealing.

Birger, like Weisberg, once belonged to the "Group of Eight". At that time his works were formal experiments (he later destroyed most of his pre-1964 works himself), and the Soviet press started calling him "one of the leading young Soviet artists". With time he began to look at nature more closely, to analyse and communicate the highly complex relations between objects and light, not however with the hedonism of an Impressionist but with a spirituality akin to that of Rembrandt. Working from Rembrandt's experiments with light he developed a most complicated technique of multi-coloured strokes in which every millimetre of the canvas was covered with several pigments. From his formal experiments he progressed to an ever deeper understanding of nature, and among Moscow's painters it would be difficult to name a more subtle portraitist and discoverer of the inner life of things. But no sooner had Birger attained a level greatly superior to normal Soviet aesthetic standards than he was accused of "formalism", expelled from the Moscow Section of the Artists' Union and prevented from exhibiting.

It is interesting to note that the style of Birger's latest works (since 1974) has begun to show elements of fantastic realism. He has begun to create populous compositions in which

real people, his friends and the subjects of his portraits, wear crowns or dunces' caps and gorgeous apparel, and raise goblets at feasts in an atmosphere of joy and goodwill in which the painter himself appears to be both the creator and a participant. Thus, in his time, Rembrandt dressed the beggars of Amsterdam in the clothes of Biblical kings and prophets and transferred them from reality into the world of the imagination.

Abstraction, Constructivism, and Kinetics

All the artists so far referred to belong more or less to the realm of figurative art; and the works of the majority of them in one way or another reveal elements of the grotesque, phantasmagoria and fantasy. The unofficial art movement in the USSR began with them and was dominated by them until at least the mid-Sixties. But it is difficult to be absolutely sure of the chronological priority of the movement because concurrently with it painters like Masterkova, Lev Kropivnitsky, Kulakov and others were beginning their quest for abstraction. Nevertheless in the evolution of the unofficial movement the appearance of this separate trend must be seen as a second stage. When it began, non-representational art still had no firm hold in society: artists did not yet possess a genuine formal, plastic and material culture, such as would have been created by a school and a tradition, and there existed no wide audience of consumers capable of assimilating such art. The younger Muscovite and Leningrad intelligentsia took a greedy interest in Jackson Pollock, Georges Mathieu and Robert Motherwell. But they were nonplussed by their own abstract artists because they could not find in them what it was they had sought, and sometimes found, in "fantastic realism", namely a direct link between the deep social and spiritual developments of the time and their interpretation through art.

It is interesting to note in this connection that many artists who began with Classical Abstractionism somehow went through that stage very quickly and either returned to a figurative style (Zverev, Nemukhin, Yakovlev) or turned to the ideas of Pop art or Conceptualism (L. Kropivnitsky, Yankilevsky, and others). In this respect the work of Masterkova is a rare exception, being an example of consistent Abstractionism evolving from freely expressionistic forms to stricter structural ones.

It was not just general cultural circumstances, linked with the process of involving specific areas of society in modern artistic culture, which produced and sustained these trends in the USSR – it was also circumstances specific to Russian society. As early as the Forties the theory of relativity – and cybernetics – had been declared by Stalin's guardians of ideological purity to be idealistic, reactionary and conducive to Fascism. This denial of widely-recognised truths soon resulted in the catastrophic backwardness of Soviet science, including nuclear physics. Einstein and Viner had to be partly rehabilitated.

At the end of the Fifties there was a similar situation in the realm of industrial design, which until then had been regarded in the Soviet Union as another invention of bourgeois pseudo-science, whose aim was to drag formalism in by the back door. A few liberals managed to convince the authorities that the lamentable quality of Soviet industrial production, some of it beginning to be exported, was a direct result of neglect of the rules of design which, if adopted, would cure the ills of socialist production. For the sake of caution, the enormous All-Union Research Institute for Technical Aesthetics was built in Moscow in 1960, with departments in Leningrad, Tbilisi, Kiev, Erevan, Novosibirsk and other towns. Its theoretical section was to work out the rules of design and practical sub-departments were to apply them to the production of machines, refrigerators, domestic equipment and so on. In these circumstances the interest shown in the heritage of the Soviet Avant-garde of the Twenties was natural, and the journal *Decorative Art in the USSR* even contrived to print a few articles about the theories of the early Russian Constructivists and Productivists. The ghost of the once disgraced cybernetics and of Hiroshima became for many representatives of the creative intelligentsia a kind of shield behind which they were able to get on with their work free from ideological overseers. (For instance, in the Soviet Union in the Sixties this shield made possible the birth of a school of structural and semiotic linguistics which is now one of the best in the world.)

In Moscow the same shield covered the early

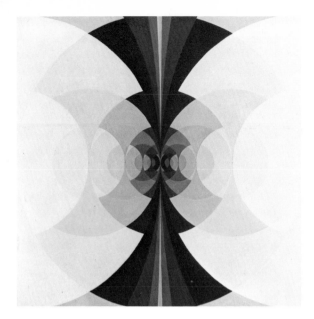

Francisco Infante
108
MEDIEVAL SPAIN 1963
Tempera on cardboard
24 × 24 cm
Private collection

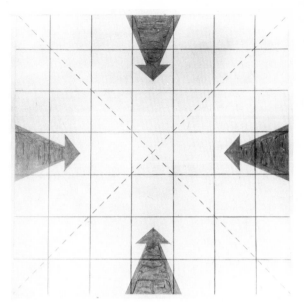

Erik Bulatov
109
ENTRANCE 1973
Crayon on paper
26 × 26.5 cm
Alexander Glezer – Russian Museum in Exile

activity of an artistic group, *Dvizheniye* ("Movement"), organised by Lev Nussberg and including over ten young artists (Infante, Grigoryev, Bystrova, Bitt, Grabenko and others). They strove for an art of synthesis uniting artistic elements such as form, colour, light, sound, rhythm and movement. They put their purely aesthetic experiments across as investigations in the realms of design, material formation and the re-ordering of the material environment. In the mid-Sixties, having obtained the support of the Komsomol organisation, they managed to arrange two or three semi-public exhibitions of their work in youth clubs. They displayed suspended, mobile and fixed constructions, futuristic plans for towns and industrial landscapes. All this was lit by spotlights which changed colours and accompanied by music from concealed tape-recorders. Many exhibits were reminiscent of, and some were literal repetitions of, the constructions and projects of Pevsner, Gabo, Tatlin and other Russian Constructivists of the Twenties.

What the group was doing was turning directly to the Soviet Revolutionary Avant-garde at the stage where this movement's development had been violently cut short, and in unofficial art it was unique in so doing. However, there was an enormous gap between the revolutionaries of the Twenties, with their ideas of the transformation of all human life through art, and Soviet bureaucrats striving to improve the quality of refrigerators being sold to Arab countries. The ideas of Nussberg met with neither the approval of the leaders, nor the stormy enthusiasm of the art audience inside the country, for the majority of whom any idea of revolutionary reform – in the sphere of art as much as in any other – had long since been discredited. Subsequently the group tried to broaden their aesthetic quest by including elements of dance, performance and improvisation in their work in the spirit of the Western "happening", but it appears that "Movement" as a separate group has now ceased to exist.

Conceptual and Pop art

It is difficult to regard unofficial art in the Soviet Union, even in its most modern forms, as a renascence of the traditions of the Russian Revolutionary Avant-garde. But it would also

be wrong to look at it as only the product of superficial borrowing and the mere assimilation of the concepts and styles of recent Western trends. It was formed partly under the influence of foreign exhibitions and the seeping in of artistic information from the West, certainly, but also by a reversion to traditional national sources, and these were by no means confined to the achievements of the Revolutionary Avant-garde.

In Moscow there came into existence the private studio of Eli Belyutin, who gave his countless pupils practical lessons in the application of the newest creative concepts. It is fairly difficult to explain the existence of a free workshop of this kind under the Soviet régime. Both artist and scholar, Belyutin taught in the Moscow Polygraphic Institute and shared with his wife, N. Moleva, the authorship of weighty but thoroughly orthodox works on the history of art education in Russia. Most probably the

authorities simply turned a blind eye to the existence of the workshop, though it is also possible that they attempted to use it for various ideological provocations (for instance, it was Belyutin's circle that was invited to take part in the lamented Manège exhibition, where they were held up to Khrushchev as examples of the aesthetic and moral decay of modern youth).

In any case the studio played a vital rôle. In the words of Vladimir Yankilevsky, a pupil of Belyutin: "He opened my eyes to the number of expressive possibilities available; he taught not art but the language of art, which enabled me to make a speedy choice."

Yankilevsky is now regarded as one of the leaders of Conceptual art in the Soviet Union. He is indeed interested in concepts – not those of formal creation, but those of human existence and the possibilities of expressing them in art. Of himself he says: "The problem which has always vexed me is the problem of man as a

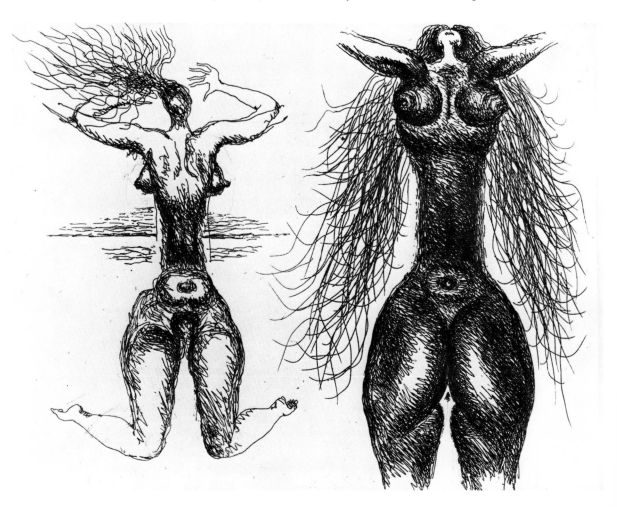

being in the universe. Not on the science-fiction level, but on that of becoming aware of his place in the cosmos, of first causes and consequences, the search for man as a single being containing male and female elements, how these elements are embodied in men and women, and how they unite in a single being. And how man in his development is constantly reflected in the background of eternity."

For the resolution of these problems Yankilevsky turned to the form of a triptych uniting both painting and relief, the content of which is revealed in the tensions and interactions between the various parts. As a preliminary the artist works out his ideas in long series of graphic works which detail and analyse the themes and aspects which are later synthesised in his large triptychs. One of Yankilevsky's constant themes is that of the destruction of indivuality, the conversion of man into robot when he becomes part of the social mechanism.

Ilya Kabakov
III
FACES WITH DOUGHNUT 1967
20 × 28.5 cm
Private collection

Vladimir Yankilevsky
110
FROM THE ALBUM "ANATOMY OF THE SENSES" 1972
Indian ink on paper
Alexander Glezer – Russian Museum in Exile

For this reason his triptychs and drawings are often dominated by machine forms reminiscent of the early work of Marcel Duchamps, Francis Picabia or Malevich. However the deeply existential content of his work derives not from the assembly-line aesthetics of the Soviet Avantgarde, nor from the social mechanicism of certain Western leftists of the beginning of the century, but from such Russian artists as Kandinsky or Filonov (allowing, of course for the stylistic differences between them and him).

The graphic works of Ilya Kabakov also have a high cerebral content, while attaining a simplicity of draughtsmanship which recalls visual aids, plans and diagrams. In addition they are often peppered with explanatory notices naming the object depicted ("Apple", "Teapot", "Tumbler"), the person ("Nikolai Admovich Borev", "Alexander Alexandrovich Koss"), the scene of the action ("Here is where they studied") and so on. But Kabakov regards objects of mass culture "in the light of the laws of a higher artistic tradition, that is, the laws of three-dimensional space, symmetry, and the natural interactions between the objects depicted." His "serious" attitude to deliberately frivolous things fills his work with gentle humour and irony. This merry Pop art also has its Russian precursor: M. Larionov in his pre-Revolutionary works began the introduction into "high" art of frivolous notices and simplifications of that type. On the other hand it is difficult to imagine that unofficial art could (like American Pop art) take a positive attitude to the objects of a mass culture which in the Soviet Union is thoroughly impregnated with ideology. All that one can do with them is – as Rabin does – strip them of the pompous clothes of ideology, or – as Kabakov does – mock them and thus reinstate them in their original forms. But Kabakov becomes completely serious in his large compositions, where he places real objects in space of a realistic, illusory (as in mirror images) or stylised kind, experimenting with the complex relations between them.

Lev Kropivnitsky began his work in exile in 1953, having fought at the front and then served nine years in labour camps. Living amid the sands of Kazakhstan he naturally had no idea of what was taking place in modern art outside the Soviet Union, but even his earliest works were done in the spirit of Abstract Expressionism.

[103]

Back in Moscow he turned to Figuration, then back to Abstraction and then relatively recently to a classical variant of Pop art.

"The Pop art born on Russian soil was produced not by a superabundance of objects but, on the contrary, by their gradual disappearance."[15] Alexander Glezer thus defines the Russian character of this phenomenon. The young Evgeni Rukhin (one of the most active dissident artists, who died in Leningrad in the summer of 1976 in mysterious circumstances) often put into his Pop-art compositions fragments of old furniture, imitations of icons and other elements of a vanishing life-style. Essentially, in other words, he was doing the same as Rabin, Plavinsky, Nemukhin and other "fantastic realists' were with their more traditional resources. Cultural nostalgia affects Russian unofficial art as a whole from its traditional to its most radical, avant-garde forms. This seems to me to be the main difference between contemporary Russian art and leftist art in the West, the sentiment of which aims at the destruction of existing culture and the breaking of its traditional norms and forms.

Geological changes

It should be borne in mind, however, that everything I am describing here and what has been written on the subject before amounts only to fragments of a great process of geological change that is now taking place in the Soviet Union, fragments selected for what seems to be their significance and distributed according to trends that seem to be indisputable. One such unarguable trend is the constant expansion and deepening of the creative and spiritual processes in art. We can only see the tip of this iceberg, the bulk of which is hidden in the turbid depths of Soviet society. But suddenly in its lowest levels there take place some unseen changes, the iceberg rises slightly and we can begin to make out the powerful mass below. Here is just one example.

On 15 September 1974 a group of Moscow artists went out onto a suburban waste-plot to show their works to the public. This exhibition, organised by Oscar Rabin, Alexander Glezer, Evgeni Rukhin and others, was immediately dispersed with the aid of plain-clothes policemen, bulldozers and water-cannon. The scandal which erupted in the world press and the insistent demands of the artists forced the authorities to permit for the first time in forty years an open display of unofficial art, and on 29 September the artists had the chance to display their works for four hours in the Moscow park of Izmailovo. The following year, another such exhibition was permitted and arranged, this time in the Bee-keeping Pavilion of the Exhibition of Economic Achievements in Moscow. The increase in the number of participants in these exhibitions was extraordinarily revealing: only fourteen artists had gone out to the patch of Moscow waste-ground, bringing with them thirty or forty works. In the Izmailovsky Park seventy artists displayed some two hundred works. In the exhibition of 1975 eight hundred works were shown by one hundred and forty-four Moscow artists. It can be said without fear of exaggeration that the majority of artists now working in the Soviet Union are in opposition to official Socialist Realism, an unnatural hybrid obtained (as in the biological experiments of the Stalinist Academician Lysenko) by grafting a narrowly understood realistic tradition in art onto the mighty trunk of totalitarian ideology.

But the important thing will be not just the quantitative expansion of this process, but, one hopes, its deepening in quality. In the latest exhibitions trends are evident, which have appeared in the last five or six years. Only a few unofficial artists of the older generation have taken part in them. Young people have predominated, with a different attitude to their work and to life around them. It is too soon to evaluate these phenomena from an aesthetic point of view, to number them and line them up in a historical row. I shall simply quote an eye-witness description of some of the things which took place in 1975 in the Bee-keeping Pavilion of the Exhibition of Economic Achievements:

". . . Here in the corner, under a notice which says 'quiet, experiment in progress', conceptualist artists are sitting in an enormous nest of branches, hay and leaves. They are 'hatching an egg', and allow spectators to take their places for a time (this exhibit was banned on the third day). Here also there is red calico on the walls with even lines of protruding threads: '24 knots in memoriam' – an impudent paraphrase of the sacred number of propaganda. At the front and above the whole hall there soar seven enormous

canvases by V. Linitsky (b. 1934), including his 'Apocalypse', a fanciful and vivid improvisation on themes from the Revelation of John the Divine. Here also are two works by A. Kurakin (b. 1947) – the large 'Turin Shroud of Christ', with the text of the Easter *troparion*, and his 'Portrait of Judas'. Further on there are the severe geometrical abstractions of O. Yakovlev (b. 1948), the dynamic compositions of P. Belenko (b. 1938), the bright and harmoniously-coloured still-lifes of M. Odnoralov (b. 1944), and the expressive formulae of symbols unified by colour of M. Shpindler (b. 1931).

"In another corner a group of hippy artists is sitting on the floor. Their manifesto, the tapestry entitled 'The Hippy Flag', was banned from the exhibition by the censorship, which saw in its crossed-out frontier post and its notice 'The Country without Borders' a particularly frightening rebellion. In protest these boys and girls took all their drawings down from the walls, including the symbolic 'Selfportrait' by I. Kamenov (b. 1955), a canvas filled with the long-haired head of a hippy. Helmeted homunculi fuss round the head, one cutting its hair with garden shears, another hammering rivets into its lips, while a third repaints one eye red with a house-painter's brush. This 'Selfportrait' only appeared some days after the opening of the exhibition.

"In the central gallery are the artists here termed 'avant-garde'. Their exhibition has also been truncated by the censorship: the two shirts of G. Sapgir, on which were written the sonnets 'Spirit' and 'Body', are missing. However that most naturalistic item, 'Overcoat of the Artist M. I. Odnoralov' by M. Roginsky (b. 1931) and L. Bruni (b. 1950), with its red scarf and the bottle of kefir in the pocket, *is* here: a Conceptualist replica of the Museum exhibits known to everybody from their childhood. Next to it are the meditative compositions of N. Alexeyev (b. 1953) and the severe canvas of R. Zanerovsky (b. 1930) with its black and white circles. A little further on are S. Volokhov's bright collages striving for sensationalism, and, as if to contrast with them, the neo-Suprematist 'Compositions' of A. Yulikov (b. 1943), which are purged of all neo-Expressionist emotions and literariness. Still further are the Pop-art experiments of S. Borodochev and A. Dryuchin (b. 1949)."[16]

From this description it may seem that the younger generation of Russian unofficial artists are at the moment more concerned with the destruction of traditional cultural values than with their creation or preservation. This conclusion would only be partly true. Here is one more example.

In one exhibition of this sort the Moscow artist A. Melamid exhibited a tin can. At first sight he was doing what one of the founders of Pop art, Andy Warhol, had done decades earlier. However the same tin, exhibited in Moscow and New York, acquires a different, even an opposite aesthetic connotation. For the artist in New York (or any other city in the free world) such an act is a protest against the established values of modern élite culture. But the Moscow artist tries, by such an act, to defend and assert what for his consciousness has become a part of twentieth-century culture, a tradition seen by Soviet ideology as élitist, anti-democratic and individualistic, and therefore banned. And in the Soviet Union the artist is ready to defend this tradition not only against artistic criticism, but against the police, the KGB and bulldozers. Let us also recall all those crosses, cupolas, icons and the like which, according to the same writer, were present in "almost every other picture" at the exhibition.

It is therefore necessary to be very cautious in coming to conclusions about the direction unofficial art is now taking in the Soviet Union and what forms it would adopt under normal creative conditions. At the moment these conditions are still far from normal. The recent authorisation of a few exhibitions of unofficial artists is due on the one hand to enormous pressure from below, and on the other to the attention of the Western public to this process in the conditions of détente. Owing to these conditions the Soviet régime is forced to conceal its fangs behind a façade of moderation. But despite this façade it possesses an arsenal of weapons with which to render impossible the life of an artist who does not submit to ideological prescription.

This explains the fact that in recent years artists have also begun to emigrate from the Soviet Union, along with the writers, academics and intellectuals who constitute the biggest exodus from the country since 1920. They are leaving a country which impales them on the

dilemma of either serving an alien ideology or leading a semi-clandestine existence with the constant threat of a trial. There are too many to name them all, but they include L. Zbarsky, Oleg Kudryashov, Y. Krasny, L. Shteinmets, Mikhail Shemyakin, Vasili Sitnikov, Lydia Masterkova, Edward Zelenin, Victor Kulbak, Ernst Neizvestny. With each year the list is growing longer. But alas, totalitarian régimes have never been concerned at the loss of creative talents from their countries. On the contrary, it makes those countries easier to govern.

Notes

[1] *Iskusstvo kommuny (The Art of the Commune)*, 30 March 1919.

[2] *Iskusstvo (Art)*, 1937, no. 6 (July), p. 8.

[3] The Museum of New Western Art was organised on the basis of the collections made before the Revolution by the famous Russian collectors S. Shchukin and I. Morozov and nationalised in 1918. At the end of the last century Shchukin and Morozov were among the first to buy the works of the Impressionists, Cézanne, Van Gogh, Gauguin, and later Matisse, Picasso and others. Their collection is to this day considered one of the most important and richest collections in the world of Western art from the Impressionists to 1914. After the closure of the museum, its exhibits were due to be offered for sale abroad and it was only Stalin's death that prevented this. At the moment the collection is divided between the State (Pushkin) Museum of Fine Arts in Moscow and the State Hermitage in Leningrad.

[4] *Voprosy teorii sovetskogo izobrazitel'nogo iskusstva (Problems in the Theory of Soviet Figurative Art)*, Moscow, 1950, pp. 29–30.

[5] The centralised sale of art treasures began immediately after the Revolution and by the end of the Twenties began to involve the Hermitage. By the middle Thirties the greater part of the best works in this most important of museums had been sold, including such widely known masterpieces as the altar-pieces "The Last Judgment" by Van Eyck, Raphael's "Donna Alba", Titian's "Venus in front of a Looking-glass", Rembrandt's "Head of a Warrior", and many others. The majority of these masterpieces are now in the Mellon collection of the Washington National Gallery.

[6] The State (Pushkin) Museum of Fine Arts was founded in 1912 as the Moscow University Museum of Sculpture. After the Revolution it was augmented with works from nationalised collections and became the second most important collection of classical Western painting in the Soviet Union after the Hermitage (Perugino, Cranach, Rembrandt, Poussin, Ingres, and others).

[7] The title is conventional, since the members of the group changed and its numbers varied from seven to nine.

[8] "Dialogo con Guttuso sulla pittura", in *Quaderni Milanesi*, 1962, nos. 4–5, p. 22.

[9] Among all the artists active under Stalin only one was tacitly made the scapegoat for the crimes of the régime – Alexander Gerasimov, the Stalinist portraitist, who until 1957 was never replaced as President of the Academy of Arts of the USSR and was in fact an all-powerful dictator in the sphere of art. Crimes here means not just the implementation of ideological decrees in the cultural sphere, as listed above, but mendacious political denunciations as a result of which many prominent Soviet artists (including A. Drevin, K. Istomin, V. Ermolaeva, G. Klutsis) were convicted or in some cases died in concentration camps, or the appropriation of their property and the like, which in any law-abiding state would have been a punishable crime. In an atmosphere of anticipated change the men in power feared possible retribution and this held them back. It was typical that Gerasimov's death in 1963 was marked only by a brief obituary in the journal *Ogonyok* over just two signatures, those of his former assistants. (Lately his name has again been appearing in official documents among the classics of Socialist Realism.)

[10] This, like all the subsequent quotations from Soviet unofficial artists, is taken from the personal archive of Alexander Glezer.

[11] "Together with the scientist the artist must become a psycho-engineer, a psycho-constructor," wrote the important Futurist theoretician S. Tretyakov in *LEF*, 1923, no. 1, p. 202. Later Stalin literally repeated this utterance, by a man who had rotted at his behest in the concentration camps, as the fundamental definition of the function of a writer in a socialist state: "A writer is an engineer of human souls."

[12] *Fantastichesky mir Abrama Tertza (The Fantastic World of Abram Tertz)*, Inter-language Literary Associates, 1967, p. 446.

[13] E. Barabanov, "The September exhibition of Moscow painters in 1975", in *Vestnik russkogo khristianskogo dvizheniya (The Herald of the Russian Christian Movement)*, 1975, p. 241.

[14] *Simpozium po strukturnomu izucheniyu znakovykh sistem*, ("Symposium on the structural study of sign systems"), AN SSSR (Academy of Sciences of the USSR), Moscow, 1962, pp. 134–6.

[15] A. Glezer, *Evgeni Rukhin, Russky muzey v izgnanii* (Russian Museum in Exile).

[16] Barabanov, *op. cit.*, pp. 234–5.

The Struggle to Exhibit

Alexander Glezer

When asked about the development of their work and the seminal influences on it, practically all the founder members of the nonconformist movement of Russian artists refer back to the International Art Exhibition at the Sixth World Festival of Youth and Students in Moscow, held in Gorky Park in the summer of 1957. The several thousand pictures and sculptures on display gave young Soviet painters their first opportunity of seeing contemporary Western art in all its variety, and for those who had matured enough to strike out on an independent, uncensored path, it served as a kind of catalyst, accelerating the pace of their artistic self-determination. Numerous other exhibitions of foreign painting which were held throughout Khrushchev's rule and ended with it had the same effect – American and French art shown as part of those countries' exhibitions at Sokolniki Park, the Yugoslav primitives, and the Fernand Léger one-man exhibition at the Pushkin Museum of Fine Arts. The Russian intelligentsia, too, starved of genuine values, gave budding Russian artists their attention and maintained a genuine interest in them. This can be seen from the private exhibitions which were frequent towards the end of the 1950s. The composer A. Volkonsky organised a showing in his own home of water-colours by the seventy-year-old Evgeni Kropivnitsky. The celebrated pianist Sviatoslav Richter introduced Muscovites to the paintings of Dmitri Krasnopevtsev. Exhibitions of the works of Oscar Rabin, Dmitri Plavinsky, Vladimir Nemukhin and Lydia Masterkova were held in the apartment of the art historian Ilya Tsirlin.

These private exhibitions were followed by others in scientific research institutes and club premises. In 1960 Ernst Neizvestny showed in the Druzhba workers' club, as did Vladimir Yakovlev in the following year. In 1962 Neizvestny and Vladimir Yankilevsky exhibited at Moscow University. The Belyutin Studio group staged a show in the Zhdanov district teachers' training college, with U. Sooster, Neizvestny, B. Zhutovsky, Yankilevsky, V. Galatsky and others exhibiting. Just a few days after this, on 1 December 1962, Khrushchev made his notorious attack on modern painters at the exhibition to mark the thirtieth anniversary of MOSK – the Moscow Section of the Artists' Union – held in the capital's biggest exhibition hall, the Manège.

Many people thought Khrushchev's anger an aberration, an emotional outburst by an exuberant and self-willed despot. The facts of the matter were less straightforward. The jealous guardians of pure Socialist Realism – the dogmatic academicians and party culture watch-dogs – were worried about the re-birth between 1956 and 1962 of a genuine art, which was supposed to have been buried for ever in the days of Stalin. If it had been only the unrecognised nobodies of underground painting going to the devil, that would have been neither here nor there. What worried them was that even in MOSK, an official body subject for decades to strict discipline, there had emerged irresponsible liberals who were forgetting that weakness on the ideological front was unthinkable. These liberals had gradually infiltrated the MOSK hierarchy, until eventually they wormed canvases by artists long condemned for "formalism" (S. Drevin, R. Falk, A. Osmerkin, A. Shevchenko and R. Shternberg) into the MOSK anniversary exhibition. They also made hanging room available for young experimental Artists' Union members like Neizvestny, N. Andronov and P. Nikonov. So the conservatives decided it was time to put

down those who had deviated from the canons of Socialist Realism. The Stalinist academicians, headed by the President of the USSR Academy of Arts, A. Serov, were confident of total and absolute victory – they had years of experience in conspiracy. They offered the Belyutin Studio artists a transfer of their exhibition from the training college to the Manège, there to be seen not by the general public, but in private by VIPs. And they did not err in their calculations. Khrushchev was the main VIP concerned and his furious reaction was just what they had anticipated.

Khrushchev's tirade gave the signal for a full-scale witch-hunt against modernists. Three days later a general meeting of the Academy of Arts unanimously condemned the formalist tendencies seen at the MOSK thirtieth anniversary exhibition. Academician Deineke, who had himself once been accused of formalism at the end of the 1940s but had recanted, said: "There once existed Kandinsky and Falk. They are artists we can live and work quite well without, and create our own art."

The triumphant ideologues of Socialist Realism redoubled their attacks on 17 December, when party and government leaders met representatives of literature and art, while the pressure was kept up in articles in *Sovetskaya kultura (Soviet Culture)*, *Izvestia*, *Literaturnaya gazeta (Literary Gazette)* and other newspapers, and at sundry meetings of the Artists' Union. Numbers of artists were condemned – A. Tyshler, V. Weisberg, B. Birger, N. Yegorshina, V. Sidur and V. Lemport. Writers and art historians – Ilya Ehrenburg, Yuri Nagibin, Lev Kopelev, A. Kamensky and V. Kostin – were harshly criticised for supporting "formalism". But impressive as this witches' sabbath seemed – it lasted several months – it was no longer able to halt the liberation of art from its rusty fetters. The painters, with few exceptions, refused to surrender and continued their free activity as before. In any case, the wrath of the orthodox fell exclusively on those who were members of the Artists' Union. But a large group of talented artists had sprung up outside the Union establishment, and their work aroused more and more interest both in the USSR and in the West.

Anatoli Zverev's one-man show in Paris and Oscar Rabin's in London, organised unofficially

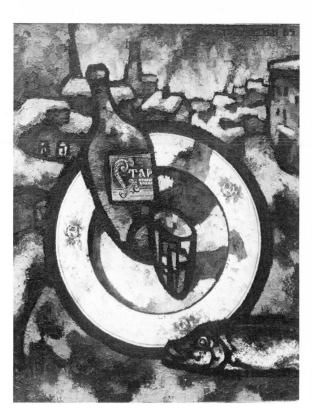

Oscar Rabin
112
STILL-LIFE WITH DISH AND VODKA 1965
Oil on canvas
100 × 80 cm
Alexander Glezer – Russian Museum in Exile

in 1964 and 1965, caused consternation among those who thought the Russian Avant-garde had been buried once and for all. An entire feature article was devoted to the London exhibition by *Sovetskaya kultura*, which accused Oscar Rabin of slandering and distorting Soviet reality. The author of the article, V. Olshevsky, wrote: "It is hardly surprising that Rabin's canvases found the appropriate customer . . . they migrated to England, to London's Grosvenor Gallery. The exhibition was accompanied by a strident press and a specially-printed catalogue – it was yet another of those exhibitions that blacken Soviet art and give employment to sundry specialists on our artistic gutters. Oscar Rabin found himself dragged into an ideological arena known to the West as 'a great experiment in Russian art', no less [a reference to the book by Camilla Grey, *The Great Experiment*, about Russian art of the 1920s, including Kandinsky, Malevich, Tatlin, Lisitsky and

Chagall]. Now the wheel has come full circle: political capital is made out of random bourgeois scribblings on canvas and what is called the sensitive soul of the individual pursuing paranoid visions, or maybe just a half-litre of vodka."

But the article had no effect, for it was precisely in 1965, three years after the scandal at the Manège, that exhibitions began to be staged in scientific research institutes, such as the large Kurchatov Institute of Atomic Physics, in Academician Kapitsa's Physics Institute at the Institute of Hygiene and Occupational Health, and at the Institute of Biochemistry.

It must be emphasised at this point that the movement of "left-wing" artists was not a homogeneous one; it was neither united nor organised, nor did its members have many ideas in common on the purpose of art. The artist Nikolai Vechtomov once remarked: "All that unites us is a lack of freedom. Our philosophies and attitudes to art are so different that if we could all show our works we should become enemies." There was an interesting group of MOSK members – Weisberg, Birger, Andronov, Egorshina and others – whose ambition was to expand the framework of official Socialist Realism and blur its edges; then there was the "avant-garde" – Neizvestny, Ilya Kabakov, Vladimir Yankilevsky, Ullo Sooster, Boris Zhutovsky and A. Brusilovsky – whose art had the

Vladimir Yakovlev

113
PORTRAIT WITH FLOWER 1974
Oil on cardboard
48.5 × 68 cm
Alexander Glezer – Russian Museum in Exile

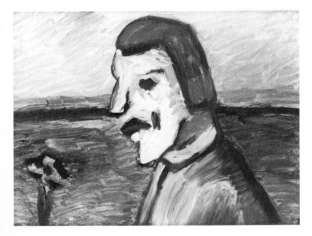

backing of critics in Italy, France, Poland and Czechoslovakia and therefore achieved a certain reputation; and there was also the loosely knit Moscow group, consisting of Boris Sveshnikov, Oleg Tselkov, Anatoli Zverev, Dmitri Plavinsky, Alexander Kharitonov, Vasili Sitnikov and Vladimir Yakovlev. At the end of the 1950s someone also coined the phrase "the Lianozovo group", after the village near Moscow where Rabin and the Kropivnitskys lived. Its members – Oscar Rabin, Lydia Masterkova, Vladimir Nemukhin, Valentina Kropivnitskaya, Nikolai Vechtomov and Lev Kropivnitsky – were the most uncompromising fighters for the emancipation of creative activity. They had no desire to "stretch Socialism Realism" with the backing of "progressive" art experts from either West or East. They wanted only to paint as they saw fit and exhibit their pictures.

It was they who in the mid-1960s became dissatisfied with exhibitions in private homes and clubs, which were generally of brief duration and lacked invitation cards or any other form of advertising and as a result were seen by few people. (That indeed may well have been why the authorities pretended not to notice them.)

I made the acquaintance of the Lianozovites and other unofficial painters in December 1966, felt impelled to help them, and offered to arrange an exhibition in the Druzhba workers' club on the street called Chaussée Entuziastov, whose manager was an acquaintance of mine. This exhibition by twelve non-conformists (Oscar Rabin, Vladimir Nemukhin, Evgeni Kropivnitsky, Valentina Kropivnitskaya, Lev Kropivnitsky, Dmitri Plavinsky, Anatoli Zverev, Lydia Masterkova, Edward Shteinberg, Nikolai Vechtomov, Olga Potapova and Vorobyev) opened on 22 January 1967 and caused a sensation. For this was the first occasion on which it had been possible to get tickets printed and thus give the show wide publicity. To a Westerner this says very little – tickets are never a problem. But in the USSR getting invitation cards or anything else printed is no simple matter – the printers accept only texts that have been approved in writing by the censorship. The censor would never have given his imprimatur to invitations to an exhibition by unofficial artists. Subterfuge was the only way. The censorship – known officially in Moscow as

Glavlit – was submitted invitations to an opening without any mention of the names of the artists involved. The censors overlooked this omission, and once the invitations were received back from the printer the artists' names were typed in. Because of the publicity, and despite a twenty-degree frost, a queue gathered in the street outside the club. In two hours the pictures were seen by two thousand people, including Moscow writers, poets and art historians, and foreign diplomats and correspondents.

The foreigners, of course, were briskly followed in by their state security tails. This was inevitable. Every diplomat and journalist in the USSR has his KGB shadow. If he so much as drives along an unfamiliar route, one that leads neither to his embassy nor to his office or home, a Volga falls in behind with a few narks from the Lubyanka. In this case they were faced with an exodus to the suburbs of not just two or three, but thirty cars with foreign number-plates.

I was soon called to the club manager's office, where I found a puce-faced KGB major ensconced in the manager's chair. "This exhibition is a put-up job by the CIA!"

"I put it up myself," I objected.

"Then you must be a blind tool in the hands of the CIA," he insisted.

The deputy leader of the Culture Section of the Moscow Party Committee, Pasechnikov, and the Section's arts inspector, Abakumov, arrived. Abakumov shouted: "A typical provocation! Before the day's out all the Western radio stations will be whooping about these underground artists, and how they're breaking through and organising themselves despite all the obstacles!"

That day they thought it best not to close the exhibition but, as Pasechnikov put it, to "suspend viewing temporarily". He promised that on the 24th, as we had intended, there should be a discussion of the pictures open to public and art critics alike. It was a lie. The very next morning the Moscow Party Committee set up a special action group to deal with the exhibition. It was rumoured that its orders came direct from the Central Committee of the Soviet Communist Party. And on the afternoon of 24 January that exalted body decided to close the exhibition for good, without appeal.

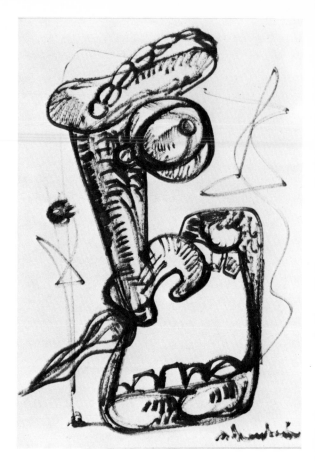

Ernst Neizvestny
114
ABSTRACT 19?
Ink on paper
43 × 30 cm
Grosvenor Gallery collection

The Druzhba club was telephoned immediately and the Party secretary of the firm which owned it summoned the *druzhinniki* (volunteer vigilantes) and told the artists to get out and take their pictures with them. The vigilantes yelled: "We'll smash their pictures and throw them out in the street!"

But there was no need. A lorry drove up to the back entrance – God forbid that suspicions should be aroused in advance – pictures and painters were embarked on it and disembarked at their homes under vigilante escort, to make sure they stayed put. The Druzhba club manager was dismissed and blacklisted, so that the lowest of management jobs were in future closed to him. (After many difficulties he eventually found a niche in theatre administration.)

The closure of the exhibition was severely

criticised in the West, but the Moscow press was silent for a long time. It was months later, on 26 May, that *Moskovsky Khudozhnik (Moscow Artist)* printed two articles about the January exhibition in the same issue. One was headed "How to be worthy of the honourable title of artist in the land of the Soviets", and the other, "No distortion of Soviet reality". The articles described the exhibition as "private enterprise", although none of the artists had tried to sell anything. It was also labelled "political and subversive in the strictest sense of the word".

That same month the Georgian Artists' Union held an exhibition of my collection in Tbilisi, and even had a catalogue printed. The inhabitants of Tbilisi were flabbergasted: "We'd never have thought such a thing could happen in Russia! You've actually got some real art!"

The exhibition in the Georgian capital was seen by students of the Georgian College of Art, writers, musicians, and leading Georgian artists. Two young Tbilisi painters brought their own pictures and asked us to hang them, too, in solidarity with the Russian painters who were being persecuted. On the fifth day the KGB, acting on orders from Moscow, closed the exhibition down.

At about this time the Moscow Party organisation issued an instruction to the effect that in future all exhibitions in the capital were to be inspected and approved by MOSK. That organisation had never before involved itself with unofficial painters. It did not want the responsibility. Nor did it wish to be associated with scandals. The easy way out was to say: "They're not members of the Union. We don't know what they're doing. We don't approve of their work, but we're not responsible for it." Now it was being obliged to be responsible. And since MOSK could not approve of exhibitions hostile to Socialist Realism, the party's ingenious instruction deprived the nonconformists of the last loophole for exhibiting their work in their own country.

On 10 March 1969, nonetheless, the artists made one final attempt to meet their public, this time at the Institute of World Economics and International Relations. The exhibitors were Oscar Rabin, Boris Sveshnikov, Vladimir Nemukhin, Dmitri Plavinsky and Lev Kropivnitsky. But a mere forty-five minutes after the

opening the secretary of the local Party organisation ordered them to take their paintings away, on the pretext that the hall was needed for a meeting.

For five years after that, despite many exhibitions abroad, all efforts by the modernists to communicate with individual art-lovers at home proved fruitless. The greatest success was achieved by Oleg Tselkov. His one-man show at the Architects' Centre in 1971 lasted fifteen whole minutes before being closed. Unofficial painters had been driven against a solid and apparently unscalable wall.

Their problems were not material ones. Little known beginners, those who had not yet found their feet or developed their artistic talent, had their troubles, as they do everywhere. But established artists did well enough. Some made a perfectly satisfactory living from book and newspaper illustrations. Others sold their paintings independently – that is bypassing official channels. Their customers were mainly foreigners, since few Soviet citizens have the means to buy works of art, and in any case buying paintings by those the state frowns on can be risky. But though they lived well by Soviet standards, were able to work – at least most of them – in studios converted from basements or attics, and enjoyed a reasonable standard of living, most unofficial artists never felt fulfilled. Pictures were sold and bought and disappeared into unknown foreign parts. There would be exhibitions and articles in the press from time to time in France, the USA, Germany, Switzerland, Italy or Denmark. In America a whole book was published on unofficial Soviet art. All this was encouraging and good for morale. But as the years passed the utter hopelessness of exhibiting in Russia depressed them more and more.

People who do not know the USSR find it hard to believe – some refuse to believe – that the country where Socialism is alleged to have triumphed needs to ban showings of Surrealist works by Nikolai Vechtomov, primitives by Vyacheslav Kalinin, fantasy landscapes by Valentina Kropivnitskaya, abstracts by Lydia Masterkova, the Conceptualist compositions of Ilya Kabakov or the Pop-art works of Evgeni Rukhin.

But what matters to the authorities, forcing them to grapple with and endeavour to eradi-

cate eternally mutinous modern art, is neither subject-matter nor style. The crux of the matter is something different and much more important. The Soviet Union is, after its own fashion, a "religious" state, professing a unique, militant and intolerable "religion" – Marxism-Leninism, whose embodiment in literature and art is Socialist Realism. Whoever denies the dogmas of Socialist Realism is deemed to reject the state religious ideology in favour of a bourgeois philosophy – which is both apostasy and a crime. However often unofficial artists stress that they are aloof from politics, demonstrating and underlining the non-ideological nature of their work, every article about them in the Soviet press invariably accuses them of denying Soviet ideals and propagating bourgeois ideology. It is the independence of these free artists that infuriates the Communist hierarchy, though the present policy of détente and peaceful co-existence obliges them to act with an eye to Western opinion. From time to time, nevertheless, they falter and show their true face – as occurred on 15 September 1974, on the outskirts of Moscow.

The idea of an exhibition in the open air, in a park or by the river, had occurred to Oscar Rabin as far back as the end of 1969, when he realised that the prospects for exhibitions in clubs and institutes had reached vanishing point. Nobody backed him at the time. Most artists were all but exhausted after nearly twenty years of skirmishing with the state apparatus and feared that a sortie with their pictures into the open air would be regarded as an outright challenge.

But by 1974 a great deal had changed. Independent young artists had appeared in Leningrad as well as Moscow – Evgeni Rukhin, Yuri Zharkikh, and others. They joined forces with other young artists – Edward Zelenin, Vitali Komar, Alexander Melamid, Nadezhda Elskaya, Alexander Rabin and others – who, heedless of the consequences, had set their hearts on exhibiting in their own country. They supported the idea of an open-air exhibition wholeheartedly. Furthermore, the general campaign against dissidents of all kinds was gathering momentum and it seemed inevitable that unofficial art would again come under fire sooner or later.

Three days after Solzhenitsyn was expelled in February 1974, Oscar Rabin remarked: "Now he's off their hands they're free to turn against us." The next few months showed how right he was. In the second half of February the state security organs, sometimes acting openly and sometimes through the police, started their campaign against the most active of the nonconformists.

Twice, while Evgeni Rukhin was away from home, the windows of his apartment were smashed. The policeman who was called to the scene told Rukhin's wife in so many words: "If your husband stayed at home instead of traipsing off to Moscow to see his disreputable friends, those windows would still be in one piece." Another Leningrader, Yuri Zharkikh, was seized by KGB men in the street and taken to the local security headquarters, where they tried both the stick and the carrot to make him turn state's evidence. Alexander Rabin in Moscow had a similar experience, a three-hour interrogation by experts. Once Rabin was detained by police and accused of stealing someone's watch in church; for weeks on end he received telephone calls night and day from strangers asking him to lend them *The Gulag Archipelago* or using threatening and offensive language. When Melamid and Komar were showing their paintings to some friends in Melamid's apartment the police burst in, took all the spectators to headquarters and subjected them to abusive and humiliating interrogation.

These provocations and others like them all had the same purpose – to intimidate the nonconformists, liquidate unofficial art and put an end once and for all to free creativity. But unexpectedly the plan misfired. The nonconformists, longing for contact with the home audience and realising that to put up with police bullying any longer was tantamount to suicide, took the initiative. On 2 September they despatched a letter to the Moscow City Council, informing it that they planned to hold an exhibition of their paintings on 15 September 1974 in the open air, on a patch of waste-land.

In London, Paris or New York such an exhibition would be part of the everyday scene, like student stunts or workers' demonstrations. But in the USSR students who had demonstrated peacefully in defence of the Soviet constitution by the Pushkin Monument were accused of disturbing public order and rusti-

cated, while the ringleaders were tried and sent to labour camps and lunatic asylums. The same thing had happened to some young poets who got into the habit of gathering by the monument to the proletarian poet Mayakovsky in Mayakovsky Square to read their own (uncensored) poetry. Police and vigilantes scattered them and again the leaders were tried.

In the authorities' view, therefore, the painters' letter to the Moscow Council amounted to a direct provocation and was seen as a challenge. Furthermore it contained an ultimatum demanding an immediate answer, so that the sluggish Soviet apparatus for once had to move fast if it wanted to do anything. The letter was despatched on 2 September and on the 5th its authors were summoned to the City Council. The unfortunate officials had been unable to discover any regulation banning exhibitions in the open air. Accordingly N. Sukhinich, who received the artists, neither permitted nor prohibited anything: he merely advised them to refrain from putting their plan into action. But advice is not an order, it can be either heeded or ignored. The nonconformists, of course, ignored it, typed out their invitations, and sent them to friends and acquaintances at home and abroad.

The authorities too were busy. Moscow City officials, fearing to take responsibility, had shirked a decision, but the Moscow City Party Committee, a far more powerful organisation, was another matter. The head of its culture division, Yagodkin, decreed unambiguously (on his own initiative, or so said the official story put about later through the foreign press) that the activities of the rebels were to be crushed by whatever means seemed appropriate.

So at twelve noon on 15 September, on the outskirts of Moscow near the intersection of Profsoyuznaya and Ostrovityanov Streets in Cheremushki, on a bare patch of waste-land drenched in the grey autumn rain, the confrontation duly took place. Why, one may ask, did the artists choose this unappealing site for their show instead of, say, the river-bank or a park, as Rabin had originally suggested? The answer is that they wanted to avoid the authorities' catch-all regulation about "disturing public order". On waste-land there is neither pedestrian nor vehicular traffic, there is nothing to disturb. In the event, however, this consideration did not embarrass Yagodkin's subordinates in the persons of Knigin, head of the propaganda section of the Cheremushki District Committee, who was in overall charge of the proceedings, and deputy chairman Petin of the District Committee, who headed the "pacification" operation. As the artists arrived on the waste-lot with their canvases and tripods, they were met by police in mufti disguised as workers doing voluntary Sunday work. The angry "workers", hooting and booing, pitched into the artists, threw them to the ground, twisted their arms and snatched their pictures away, slinging them into dump trucks which then disappeared into the distance. Despite the "workers'" numerical advantage, however, the artists resisted, and it was at this point that some bulldozers were brought into action. One of them ran over two pictures by Oscar Rabin with its heavy tracks and proceeded to pursue the artist himself. Oscar seized the upper jaw of its grab arm and hung there, drawing up his legs to avoid being crushed by the lower jaw. He was rescued from the fury of the bulldozer-driver by the "workers" who seized him and threw him into an undisguised police Volga. Rukhin was dragged into another. In forty minutes it was all over. The spectators were scattered by

Paintings damaged by the authorities' bulldozers during the First Autumn Open-air Exhibition, held in Moscow on 15 September 1974

ice-cold jets of water. Two or three Western journalists, apart from being soaked to the skin, had their teeth knocked in by the "proletarians", who celebrated their famous victory with a bonfire on which they burned three pictures.

Four participants in the exhibition (Oscar Rabin, Evgeni Rukhin, Alexander Rabin and Nadezhda Elskaya) were arrested. Many who had come to look were detained and fined for disturbing public order. All the precautions had proved useless – this violation would no doubt have applied even in the depths of the forest. But contrary to the expectations of those who planned this pogrom and despite the outward appearance of victory, the operation proved a failure. Western journalists had actually been eye-witnesses to this act of savagery and news of it was instantly flashed right round the world, together with photographs. World public opinion naturally took the side of the artists. They themselves were bloody but unbowed. On the following day they sent the Soviet government an open letter, which said:

"Twenty-four artists from Moscow, Leningrad, Pskov and Vladimir planned to hold their autumn exhibition in the open air on 15 Sep-

tember. They gave the Moscow City Council advance notice of their intention in a letter despatched on 2 September. Moscow Council officials, headed by K. A. Sukhinich, failed to give the artists any indication that the spot they had chosen for the showing of their pictures, on waste-land far from any city streets, was unsuitable or forbidden. Yet at twelve noon on 15 September the artists and numerous spectators were met at the exhibition site by police in civilian clothes with dump trucks and bulldozers. The artists' pictures were taken away and their arms twisted and dislocated. The bulldozer-drivers literally chased artists and spectators. One bulldozer-driver, after running over pictures by Oscar Rabin knocked the painter off his feet, and another ploughed into a confused crowd of people. Water-cannon scattered artists and spectators with powerful jets of water. Eighteen pictures were mutilated and burned by uncontrolled young thugs. Five artists were detained by the police, who to our surprise took a most active part in the assaults on artists and the destruction of their works.

"We demand an investigation of these events, which are a disgrace to our country, the punish-

Spectators at the Second Autumn Open-air Exhibition in the Izmailovsky Park, Moscow on 29 September 1974

ment of those responsible and the return of the surviving pictures. We also inform you that in two weeks' time, on Sunday 29 September, in the same place, we shall re-erect the open-air exhibition of our pictures which was sabotaged by mischief-makers.

"We ask you to remind the police and other guardians of public order that they are there not to encourage barbarism and hooliganism, but to defend others from it – in this case spectators, artists and works of art."

Almost immediately the unfortunate waste-lot, henceforth a landmark in Russian art history, was hurriedly planted with young saplings, while the Culture Division of the Moscow City Council was directed to start negotiating with the nonconformists. It was obviously out of the question to bring in the bulldozers again while the world was watching.

For ten tense days Council officials, headed by Mikhail Shkodin, the first deputy chairman of the Culture Division, offered conditions which they knew would be unacceptable, hoping to force the artists' action committee into some rash act and blame them for failure to reach a compromise acceptable to both sides. But this strategy failed and just two days before the nonconformists' ultimatum was due to expire, permission for the second exhibition was granted.

"The Second Autumn Open-air Exhibition", as our typewritten invitations called it, opened as planned on 29 September 1974 in the Izmailovsky Forest Park on a vast green grassy meadow. This time there were seventy or more painters who covered the meadow with about two hundred of their works, some on easels, some propped up on the ground with sticks. The spectators came in their thousands – perhaps ten or fifteen thousand of them altogether – and filed in an endless stream past the pictures. They were obliged to walk several abreast, it was hard for them to get a good look, so from time to time the artists would raise the pictures above their heads – to rapturous applause. In the general holiday atmosphere the unsmiling ever-vigilant faces of the stool pigeons and informers were particularly conspicuous. But nobody was afraid of them today.

Thus the police offensive against the nonconformist painters, which had reached its climax with the onslaught of the bulldozers,

Pictures displayed at Izmailovsky Park on 29 September 1974

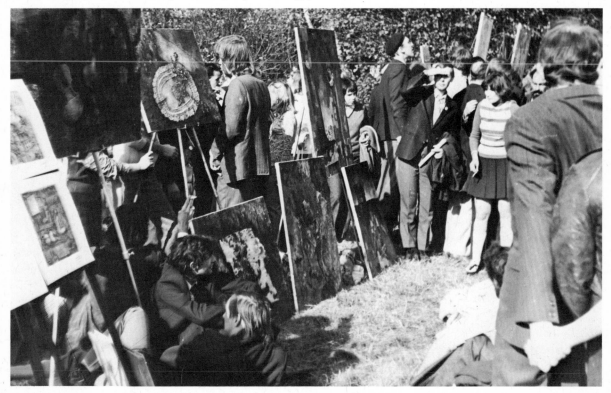

was unexpectedly turned into a nonconformist victory. Four hours of freedom at the Izmailovsky Park demonstrated the pointlessness of persecuting the opponents of Socialist Realism and proved that public opinion in Russia had not yet been thoroughly cowed, that even the long-suffering Soviet intelligentsia were still capable of passive protest by turning up to view the works of the rebels. Needless to say, it was a bitter setback for the authorities. But there was no question of them quitting the field. The attack was switched, for the moment, to the pages of the press.

Less than a month later *Vechernyaya Moskva (Moscow Evening News)*, the organ of the Moscow City Party Committee, printed two articles within five days of each other, on 18 and 23 October, attacking the nonconformists. One, "Chronicle of the People", was by USSR People's Artist F. Reshetnikov, and the other, "How the Mirage Evaporated", was by N. Rybalchenko. The People's Artist wrote: "Here in Moscow we have seen trash substituted for art before, at the beginning of the century [meaning Kandinsky, Malevich, Lisitsky, Tatlin and so on]. This kind of work, it seems to me, is in its very essence directed against the people." Rybalchenko meanwhile singled out Rabin who, he wrote, "knows what he is trying to say and knows how to say it, he inoculates others with malice and infects them with his own cold, cheerless view of life. Life in all its fullness is his enemy." He concluded: "Analysing the majority of these works, one is forced to diagnose their authors' spiritual collapse, or rather, evil intent resulting from their hostility to reality and Russian national culture."

But the artists ignored these diatribes in the press and, inspired by their September victory, were in confident mood. They applied to reserve exhibition space for December in Moscow and Leningrad, and in both cities they were granted it. In Moscow, however, they then refused to make use of it in protest against the persecution of some of those who had organised and taken part in the Izmailovsky Park exhibition. Three of these, V. Pyatnitsky, R. Pennonen and A. Paustovsky, had been committed to mental hospitals, and two youngsters had been called up for military service in the Altay. The police forced Alexander Kalugin to give an undertaking to paint no more abstract pictures.

Under threat of being sent to a mental hospital, Sergei Bordachev was compelled to sign a promise not to participate in any more exhibitions. I myself was taken by KGB men to the Lubyanka. There I learned of the existence of an unpublished Decree of the USSR Supreme Soviet, dated 25 December 1972, according to which the KGB is entitled to summon any Soviet citizen and issue a warning to this effect: we regard your actions as hostile to the state, and unless you put a stop to them, you'll finish up in court. If it does come to a court action, this warning is regarded as evidence ("we warned him, but he hasn't learned his lesson"). In accordance with this Decree I was duly warned:

"There is only a hair's breadth in your case between being a law-abiding citizen and a criminal. Stop organising provocative exhibitions, stop telling foreign journalists about them, stop creating anti-Soviet situations [they meant a press conference I had held in my apartment on 16 September to draw attention to the arrests of artists the day before]. Otherwise you'll be sentenced for anti-Soviet activity."

Ignoring this threat, I summoned another press conference to tell Western correspondents about this secret decree and the KGB's accusations against me. On the same evening, as I was on my way home, I was attacked by three men in plain clothes who knocked me to the ground and kicked me, shouting:

"Filthy Yid! Go home to your stinking Israel!"

In Leningrad, meanwhile, the exhibition opened as planned on 22 December in the Gaas Culture Palace and lasted for four days. People queued for hours in freezing weather to see the works of fifty hardly known painters who had not dared to emerge before in Leningrad's harsher ideological climate. Leningrad had been ruled with an iron fist for many years by the First Secretary of the Leningrad Regional Party, Tolstikov, who made no concessions to literature or art. And although it was some years since Tolstikov had become Soviet Ambassador to China, the party apparatus he had trained was still vigilant. It was not like Moscow, where if you arrested some little-known artist or closed an exhibition the Western press was likely to come buzzing about your ears. Since there are

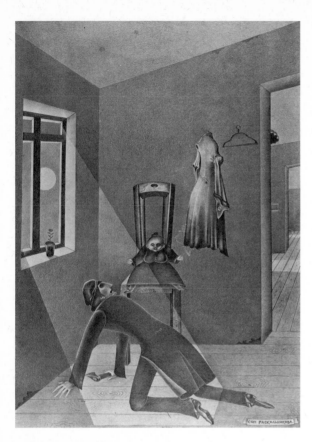

Mikhail Shemyakin

115
RASKOLNIKOV'S DREAM 1966
Pencil on paper
57 × 41 cm
Private collection

no Western journalists in Leningrad the punitive organs can afford to be high-handed. In Leningrad in December 1964 an exhibition of works by four artists (M. Shemyakin, V. Ovchinnikov, V. Ufland and O. Lyagachev) which had opened at the Hermitage by permission of the Director, was not only closed and the pictures confiscated – to be returned to their owners a whole six months later – but the KGB also took the visitors' book and abstracted from it the names of those who had made favourable remarks about the exhibition. Many of these people lost their jobs, many others were reprimanded. The dismissals went as high as the Director of the Hermitage himself, Academician Artamonov. Few people heard of this even in Moscow, let alone abroad.

But the Gaas Palace exhibition went off peacefully. Even the press kept silent about it.

Evidently the authorities hoped the artists would be satisfied, that it would be "all quiet on the artistic front", and that once the West had forgotten the bulldozers some unobtrusive but dependable means might be found of crushing the last more or less organised echelon of dissidents. But they miscalculated. The nonconformists did not ease the pressure, but strove to consolidate their gains, to turn the precedents established in the fight for this exhibition into something less ephemeral.

In mid-January 1975 Leningraders and Muscovites told foreign journalists that they planned to hold a joint exhibition. This did not suit the authorities at all, and Moscow's culture officials immediately made a counter-move. They suggested an exhibition in the very near future of Muscovites only (to split them from Leningrad) and of only the best known of them (to split the old guard from some fifty young painters who had surfaced in September at the Izmailovsky Park). This exhibition did in fact open in the Bee-keeping Pavilion at the Exhibition of Economic Achievements on 18 February. But four days earlier ninety-nine painters from Moscow, Leningrad, Tbilisi, Vladimir and Pskov also sent the Soviet Culture Minister, Demichev, an open letter demanding a joint exhibition of all artists regardless of domicile, age or reputation, without any pre-selection committee and with free access for all who might wish to see it.

The Minister did not answer the letter. But on 10 March *Vechernyaya Moskva*, pursuing its special interest in unofficial art, printed an article by the editor-in-chief of the journal *Tvorchestvo (Creation)*, Y. Nekhoroshev, ridiculing the modernists and peppering them with insulting epithets. "The avant-garde is choking with bourgeois mortification," he wrote. "That is why its art is doomed to vegetate like a plant in a cellar without sunlight and fresh air." Pillorying Oscar Rabin for his "frenziedly erotic representation of the female form", Yakovlev for "hypocritical primitivism", Kandaurov for banality, and many for unoriginality, Y. Nekhoroshev crowned his arguments with a quotation from Maxim Gorky: "What have they to do in life's battle? We see them nervously and furtively slinking away from it as best they can, hiding in murky corners of mysticism, in the preciousness of hastily plagiarised

aestheticism. Sadly and hopelessly they wander in the labyrinths of metaphysics, twisting and turning in the poky paths of religion cluttered with centuries of lies, accompanied everywhere by the bane of triviality, by the hysteria of cowardice, by ineptitude and scurrility; and everything they touch is showered with pretty-pretty words, cold and void of meaning, whose echo is hollow and funereal . . .'' The writer of the article added: ''And that just about sums up the modernists.''

But even in this lamentable article a ray of light seemed to shine through. Occasionally, wrote Nekhoroshev, pictures like these ought to be shown to the general public, to enable it to see with its own eyes that the emperor has no clothes. The artists, of course, wanted nothing better. Their idea for the last twenty years had been: revile us, criticise us, but let us communicate with the public. Could this be the dawn of a new cultural policy? Evidently it could, how else could such a suggestion have got into the press? The optimists maintained that Nekhoroshev's idea must have had the approval of Comrade Demichev himself, and that the way was clear to an All-Union exhibition of modern art.

These hopes were dashed. The Minister still gave no answer to the letter and soon it dawned on the artists that *Vechernyaya Moskva* had simply been playing cat and mouse. As a protest the artists of several cities organised a week of exhibitions at the end of March in seven private apartments in Moscow. They repeated the performance a month later, and had plans for an open-air show in Leningrad on 25 May. But though the authorities suffered private exhibitions, if with an ill grace, an extensive public showing of modernist works was not to be tolerated in any circumstances. This time the strategy did not include bulldozers. A week before the due date *Moskovskaya Pravda*, the organ of the Moscow Party Committee, published an article by art expert I. Gorin under the explicit heading, ''There is no third way''. The author labelled the nonconformists as ''art charlatans'' and confidently proceeded to elucidate: ''Seeing these artistically incompetent works, these talentless daubs, this triviality, these pretensions to a new language of art, and seeing too the praise the bourgeois media heap on the Soviet avant-garde, it is perfectly obvious that

the real stakes are neither art nor freedom of expression, but politics and the confrontation of two ideologies, the Communist and the bourgeois.'' And further: ''Many so-called avant-garde artists claim to avoid ideology, choosing some third way. But it is obvious to everyone that there is no such way. In actual fact these artists are not innocently playing at 'art for art's sake', but actively preaching bourgeois ideology.'' Gorin concluded: ''We must not allow hostile ideology to penetrate into our midst in the guise of innovation and creative inquiry.''

Practical steps were taken to back up the threats implicit in Gorin's article. First of all Oscar Rabin, the undisputed leader of the nonconformists and the only man capable of uniting the majority of them in times of crisis, was expelled from the Amalgamated City Committee of Moscow Artists and Draughtsmen. This union, a branch of the capital's Union of Culture Workers, comprises book, magazine and poster designers who for one reason or another are not members of the Artists' Union. Membership of the City Committee entitles them to be without a regular job: once they have completed their commissioned work, illustrations for a book of poems or whatever it might be, they are free to paint their own pictures if they like. That is why such well-known unofficial painters as Vladimir Nemukhin, Dmitri Plavinsky, Valentina Kropivnitskaya, Edward Shteinberg and others joined it. Oscar Rabin's expulsion meant that he could at any time be declared an idler, a parasite with no settled job, and therefore forcibly provided with one by the courts so as to make it impossible for him to paint.

Alexander Rabin received an anonymous letter threatening his life if he took his pictures to the exhibition in Leningrad. Then, although he had been exempted from military service years before on health grounds, he was summoned to a fresh medical examination which, to nobody's surprise, found him perfectly fit for two years' service in the Soviet Army.

The Leningrad authorities did not waste time either. Yuri Zharkikh, Alexander Leonov and Alexander Ovchinnikov, who formed the local artists' action group, were summoned to KGB headquarters and warned that anybody who brought his pictures out into the streets on

25 May would be prosecuted under Paragraph 3 of Article 190 of the Soviet penal code – "taking mass action without the knowledge of the authorities". The promised penalty for disobedience was three years in a labour camp. Several bold spirits nevertheless tried to put their plan into action on 25 May, only to be prevented from leaving their homes.

Then, unaccountably, it was announced a week later that the exhibition would take place after all – in the autumn, opening on 15 September 1975. What was the reason for this abrupt about-face? Why was the exhibition banned, creating yet another scandal, and then permitted? What was the significance of 15 September, the anniversary of the Moscow bulldozer pogrom? It is hard to say – the actions of Soviet leaders by no means always follow a logical pattern. But a reasonable theory would be that within three months the authorities hoped to have intimidated some artists and flattered others, so that in the end few could be found to participate even in an authorised show. A month before the September exhibitions in Moscow and Leningrad, as it was, the weekly *Ogonyok* published a lengthy article headed "The False Values of Abstractionism" by Academician Nalbandian, a People's Artist of conservative and, for that matter, Stalinist views, pouring scorn and obloquy on the avantgarde. He was roused to fury, he wrote, by what he called the "forgeries" of Shteinberg and Tyapushkin, the primitives of Yakovlev, the "surrealist symbols" of Nemukhin, and especially by the bourgeois spleen and muckraking of their guiding spirit, Oscar Rabin, that "uncrowned Godfather of the Soviet avantgarde". The modernists, wrote Nalbandian, rejected their motherland and everything man held sacred, displayed "snobbish indifference to the achievements and struggle of the people", and "expressed personal pessimism about today's reality and lack of faith in the shining future".

Unfortunately the machinations of the authorities proved successful, in that the joint exhibition the avant-garde had campaigned for did not come off. Seventy-eight Leningraders had an exhibition in the Nevsky District House of Culture from 10 to 21 October, while Muscovites staged a separate ten-day show in a pavilion of the Exhibition of Economic Achievements on 21 September. The painters of the Caucasus, the Baltic states, Vladimir and Pskov had no part in either. It was therefore far from a victory. On the other hand, the situation did not seem all that bad and the artists remained optimistic.

However, in February 1976 the modernists of Leningrad went once more to the City Council to discuss matters connected with a further exhibition, only to be told in so many words that there would be no more independent exhibitions. They were to try the Artists' Union – any who were accepted could show their pictures on the same footing as the other members. In Moscow the City Artists' Committee had also promised to set up a painting section and bragged to the nonconformists about how it would organise their exhibitions, but then it retreated and went back on its promises.*

Nevertheless the City Council did stage an exhibition some three months later, from 11 to 18 May 1976. It was a very local affair with only seven artists represented – Vladimir Nemukhin, Dmitri Plavinsky, Dmitri Krasnopevtsev, Otari Kandaurov, Alexander Kharitonov, Vyacheslav Kalinin and Nikolai Vechtomov – and may well have been no more than a white-washing operation for the benefit of world opinion. But it was a sign of the times and undoubtedly owed its staging to the changed climate of opinion prevailing since the now famous bulldozer show.

Looking back on this turbulent period of two and a half years it is clear that a major change has taken place since the original exhibition. For things can now never return to the pre-September 1974 situation. In the first place the artists have shattered the wall of silence that used to surround Soviet unofficial art. Its existence has become known at home as well as abroad. More exhibitions were held in one year

* Events since the time of writing these words have proved me wrong. In the early summer of 1976 the City Artists' Committee did indeed establish a painting section and invited all the nonconformists to join with the exception of Oscar Rabin and his son Alexander. After this, members of the Ministry of Culture were heard to boast that "unofficial art" had ceased to exist, since all the artists were now "official". When, however, an exhibition containing their work was held in Paris in November the Soviet embassy protested to the Director of the Palais des Congrès (where it was being held) that it was an "anti-Soviet provocation". Thus it would seem that official attitudes have hardly changed and that the acceptance of the nonconformists into the City Committee had as its aim either a desire to deceive world opinion or else the bringing of the nonconformists under closer control – or both. *A.G.*

(apart from semi-clandestine ones in institutes and clubs) than in the previous twenty. Secondly, it has become clear that the nonconformist movement is much more broadly based than its founders and old guard imagined. They were joined by about fifty young painters in the Izmailovsky Park, and some fifty more unknowns emerged in December 1974 in Leningrad. Letters and telegrams from the Caucasus and the Baltic republics testify that independent art has taken root all over the country. Thirdly, and perhaps most importantly, those in authority who attempted in February 1974 to annihilate uncensored art are now compelled to think again. Direct suppression using the KGB, the police and finally bulldozers has not worked. Undoubtedly other methods will be tried, up to and including measures designed to force the nonconformists to emigrate. In the last year and a half alone Ernst Neizvestny, Lydia Masterkova, Vasili Sitnikov, Edward Zelenin and Victor Kulbak, to name only the best known, have left the USSR.

But equally undoubtedly the vast majority of artists will not leave, neither will they surrender or retreat, or renounce their freedom of self-expression. Only a mass terror, like Stalin's, could eradicate them now, and that is out of the question in the present international atmosphere. A genuine culture has been rekindled after decades of burial, and it is only a matter of time before its independence is acknowledged and accepted.

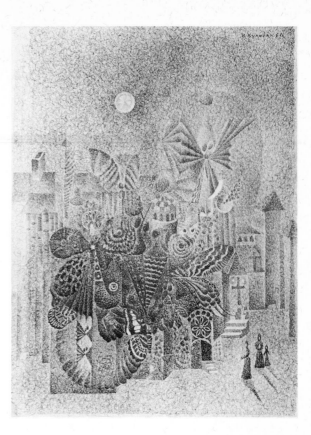

Victor Kulbak
116
NIGHT 1967
Pencil on paper
40 × 31 cm
Alexander Glezer – Russian Museum in Exile

Postscript

An interview with Alexander Kalugin obtained by a Moscow journalist in the summer of 1976.

Q: Information has recently filtered through to the West to the effect that the Soviet authorities are relaxing their policy towards representatives of unofficial art, so-called "avant-gardists". Do you share this opinion?

A: No, I do not. I cannot name a single well-known unofficial artist in our country whose position has changed for the better in the sense of his official social standing; that is to say, the overwhelming majority of such artists are still not members of the Artists' Union, and that means that they may at any moment be subjected to the cruellest repressions as "parasites" or "asocial elements". You do not have to look very far for examples. During the last year several exhibitions of unofficial art were held in Moscow. The authorities did not break up the exhibitions, but immediately after the first of them – the famous Izmailovsky Park exhibition – had closed, the repressions began. These hardly affected the "older generation" (as they are called) of "avant-gardists", artists like Rabin, Rukhin or Masterkova (perhaps because they are well known in the West). But the younger generation of artists (including myself) were the targets of the severest of measures: some were incarcerated in psychiatric hospitals, expelled from establishments of higher education, compulsorily recruited for army service or simply sacked from their jobs. As for myself, soon after the exhibition, the police came to my wife's apartment, where I live, threatened me and obtained a signed statement from me promising not to paint "abstract pictures" (although it is difficult to call my work abstract). Nevertheless, this does not surprise me: in a recent issue of the journal *Ogonyok* – "Spark" – an article by the Soviet artist Nalbandian, printed immediately after a poem by Yevtushenko about a progressive Japanese political lady artist, branded *all Soviet unofficial artists to a man* "abstractionists".) If I disobeyed they threatened to have me put away in a psychiatric hospital. It was then announced to me that I was forbidden to live in my wife's apartment (!) since I was not registered to reside at that address.

Q: Nevertheless you went on exhibiting your work in people's homes after the Izmailovsky Park exhibition, did you not?

A: In the winter of 1974–75 I was put in a psychiatric hospital. My work was taken to an exhibition while I was there without my knowledge. In the spring I was discharged, but I have continued exhibiting. One thing must be taken into account here. After the Ismailovsky Park exhibition, which was visited by many Western correspondents, a number of exhibitions were held in private apartments. Hardly any Western correspondents came to these exhibitions, which therefore did not provoke what the authorities regarded as an "unhealthy fuss". The participants amounted to several dozen young artists. You can understand why the authorities nowadays are unwilling to use open repressions against several dozen relatively united people.

Perhaps it was the absence of open, mass repressions against artists that led Iosif Kiblitsky to announce that a new era in the authorities' attitude to unofficial artists had begun. In my opinion, there has been no change at all in their attitude. The repressions will continue; the KGB has not stopped compiling dossiers on us, and the authorities are not offering us premises to use for exhibitions.

Q: Your words about foreign correspondents not visiting recent exhibitions in private apartments may be taken as meaning that the exhibitions have not been enjoying very much success with the Western public.

A: That is true. Igor Golomshtok was right in what he said in his article in *Kontinent* about the Western public's attitude to our "avant-gardism" (which is the term the Soviet press uses when it talks about us). The exhibitions of our pictures Glezer has brought out of Russia to Western Europe have also demonstrated this attitude very clearly.

Q: Are private exhibitions by "avant-gardists" popular with Soviet citizens?

A: It is impossible to judge. The vast majority of Soviet citizens know absolutely nothing about the existence of such exhibitions. How can they possibly know? If Western radio stations are the only ones to report the fact . . . And the majority of those who do know about them don't go to see them, fearing for their own personal safety: KGB men are constantly to be found on duty outside the apartments where

these exhibitions take place. There remain the few dozen dissidents who make a habit of visiting such exhibitions. It is difficult, of course, to judge the real extent to which avant-garde art is popular from these few dozen people. The open-air exhibition at Izmailovsky Park was a pleasant exception; it was visited by enormous numbers of Muscovites. This was due to good advertising by Western radio stations broadcasting in Russian. However, the official reaction to that exhibition by the Moscow press was truly incredible. In an abusive review of the exhibition, the paper *Vechernyaya Moskva* incidentally described me as an imitator of Salvador Dali who painted in the "ancient Chinese manner" (in our country such absurdities in reviews by "plain-clothes art critics" are considered quite natural).

Q: Are private exhibitions in apartments the only opportunity for you and artists like you to show your work?

A: Yes, for the moment. So in this sense we are doomed to have no mass audience in our own country.

Q: How do you earn your living? How do you survive?

A: I refuse to get a job as a matter of principle. I am an artist and my business is painting. The authorities don't regard people like me as artists; they demand that we engage in "socially useful labour". Many of my friends who are unofficial artists or writers are forced to work as caretakers and nightwatchmen – anything to avoid giving the authorities any more grounds for repressions. But I do not wish to resort to a compromise of that kind. The only honest, acceptable source of income for myself, in my opinion, is income derived from the sale of my pictures. Unfortunately, though I have no permanent place of residence, and consequently I not only have nowhere to paint, I have nowhere even to show my work to prospective buyers. To a Western artist, even the least popular Western artist, such a situation may seem surrealistic, but, believe it or not, I make barely enough money from selling my pictures to keep me from starving to death – and I have a wife and daughter into the bargain. Even by the wretched, beggarly standard of living in the Soviet Union today I fall into the category of the lowest of beggars.

Q: Are you the rule or the exception?

A: I have, at least, some reputation in the West, and having a reputation in the West is a decisive factor when it comes to the matter of security. Most of the unofficial artists of my generation have no such reputation, and they live in even worse conditions and are victims of even greater persecution.

Q: Who buys your work?

A: Mainly foreigners, most of them Americans. I am grateful to fate that my work appeals to the Americans, the most culturally advanced people in the world, a nation with a subtle feeling for modern art.

Q: What are your average earnings from the sale of your pictures?

A: You had better address that question to my wife. For the reasons I have already mentioned my pictures sell in sporadic waves. It's either all or nothing. When it's "nothing" we get into debt. When we manage to sell some, all the money goes towards paying off the debts.

Q: What phenomena in Russian and world culture have influenced your work?

A: Artistically, the first and most striking influence was Malevich. Then I think I developed as an artist under the influence of Filonov, Klee, Chagall, and later Bosch and Dionysius. I love rock and folk music. I like nothing better than working to the sound of, say, Emerson, Lake and Palmer, Bob Dylan or Arlo Guthrie. But it is almost impossible to get hold of records like these in Russia. But that's not the worst of it. Far more tragic is the fact that we have no information at all about artistic life in the West or what is really happening in world culture at the present time.

Biographical Notes on the Artists

Pyotr Belenok

Born Kurogod, Kiev region, 1938. Graduated from the Kiev Art Institute in
1963. A sculptor by profession. In 1967 moved to Moscow, where he came into
contact with unofficial artists.

Exhibitions
1974 USSR, Moscow. Izmailovsky Park, *Second Autumn Open-air Exhibition.*
1976 France, Montgeron. Russian Museum in Exile.
1976 USSR, Moscow. Artists' Union, *Experimental Exhibition.*

Boris Birger

Born Moscow, 1923. Fought at the front from 1941–5. Graduated from the
Moscow Surikov Art Institute in 1951. Between 1957 and 1962 participated
in almost all the major official exhibitions of Soviet Art, although also member
of mildly reformist "Group of Eight". Exhibited at famous Manège
exhibition in 1962 and after Khrushchev's visit was expelled from the Soviet
Artists' Union (though later reinstated) and deprived of the chance to exhibit
his work. In 1968 he was expelled from the Artists' Union a second time.

Exhibitions
1954 USSR, Moscow. *Exhibition of the Works of Young Moscow Artists.*
1961 USSR, Moscow. *Exhibition of the "Nine".*
1962 USSR, Leningrad. *Exhibition of the "Eight".*
1962 USSR, Moscow. The Manège. *Exhibition to Mark the 30th Anniversary
 of MOSK (Moscow Section of the Artists' Union).*

Galina Bitt

Born Moscow, 1946. Graduate of the Textile Institute in Moscow and has
worked as a designer. Active member of the *Dvizheniye* (Movement) Group
of kinetic artists.

Exhibitions
1965 USSR, Leningrad. Architects' Club, *Exhibition of Kinetic Art.*
1965 Czechoslovakia, Prague. Viola Gallery, *Drawings by Young Moscow
 Kinetic Artists and E. Neizvestny.*
1966 USSR, Moscow. Cultural Club, Kurchatov Institute of Atomic Energy,
 Exhibition of Kinetic Art.
1966 West Germany, Heidelberg and Munich. *New Aspects of Soviet Painting.*
1974 West Germany, Krefeld. Museum Hans Lange, *Movement Group –
 Moscow 1962–72.*

William Brui

Born in Leningrad, 1946. Studied at the Leningrad Academy of Arts from 1958 to 1960, then from 1963 with painters of the generation of the Russian Avant-garde of the 1920s. Emigrated in 1970 and settled in Paris in 1971.

Exhibitions
1972 France, Paris. Salon Alexandre, one-man show.
1972 France, Paris. Cité Internationale des Arts, one-man show.
1974 Switzerland, Geneva. Galerie Anton Meyer, one-man show.
1975 USA, Elmira. Arnot Art Museum, one-man show.

Erik Bulatov

Born Sverdlovsk, 1933. Attended Moscow Art College 1947–52, graduated from the Surikov Art Institute in 1958. Also studied as a private pupil under Favorsky.

Exhibitions
1967 USSR, Moscow. *World Festival of Youth and Students.*
1967 USSR, Moscow. One-man show in a coffee house.
1973 France, Paris. Galerie Dina Vierny, *The Russian Avant-garde, Moscow 1973.*

Francisco Infante

Born in the Volga region, 1943. Graduated from the Moscow Regional College of Art and then worked as a teacher of drawing. An active member of the *Dvizheniye* (Movement) Group of kinetic artists since its inception.

Exhibitions
1964 USSR, Moscow. Youth Club, Marinskaya Street, *Towards a Synthesis of Art Forms.*
1965 USSR, Leningrad. Architects' Club, *Exhibition of Kinetic Art.*
1965 Czechoslovakia, Prague, Louny, Brno. *Moscow Kinetic Art.*
1965 Czechoslovakia, Prague. Viola Gallery, *Drawings by Young Moscow Kinetic Artists and E. Neizvestny.*
1965 Italy, Aquila. *Present Alternatives II.*
1966 USSR, Moscow. Cultural Club, Kurchatov Institute of Atomic Energy, *Exhibition of Kinetic Art.*
1966 USSR, Moscow. Cultural Club, Kurchatov Institute of Atomic Energy, *Kinetic Theatrical Performance – Metamorphoses.*
1966 West Germany, Heidelberg and Munich. *New Aspects of Soviet Painting.*
1974 West Germany, Krefeld. Museum Hans Lange, *Movement Group – Moscow 1962–72.*

Ilya Kabakov

Born Dnepropetrovsk, 1933. Graduated in 1951 from the Moscow Art School and in 1957 from the Surikov Art Institute. Member of the Soviet Artists' Union in his capacity of book-illustrator.

Exhibitions
1962 USSR, Moscow. *Exhibition of the Belyutin Studio Group,* Bolshaya Kommunisticheskaya Street.
1965 Italy, Aquila. *Present Alternatives II.*

1966 Poland, Sopot-Poznan. Nineteenth Festival of Fine Arts, *Sixteen Moscow Artists*.
1967 Italy, Rome. Galleria il Segno, *Fifteen Young Moscow Painters*.
1969 Italy, Florence. Galleria Pananti, *The New School of Moscow*.
1970 Switzerland, Lugano. Museo Belle Arti, *New Tendencies in Moscow*.
1970–71 Switzerland, Zurich. Galerie Renée Ziegler, *Six Soviet Artists*.
1970 West Germany, Cologne. Galerie Gmurzynska, *The Russian Avant-garde in Moscow Today*.
1973 France, Paris. Galerie Dina Vierny, *The Russian Avant-garde, Moscow 1973*.
1974 West Germany, Bochum. Bochum Museum, *Progressive Tendencies in Moscow 1957–70*.
1975 USSR, Moscow. Bee-keeping Pavilion of the Exhibition of Economic Achievements, *Twenty Moscow Artists*.
1975 Austria, Vienna. Künstlerhaus, *The Russian February 1975 in Vienna (Glezer Collection)*.
1975 West Germany, Braunschweig. Kunstverein, *Russian Nonconformist Artists (Glezer Collection)*.
1975 West Germany, Freiberg. Kunstverein, *Russian Nonconformist Artists (Glezer Collection)*.
1975 West Germany, West Berlin. Kunstamt Charlottenburg, *Russian Nonconformist Artists (Glezer Collection)*.
1975 Austria, Vienna. Galerie Christian Brandstätter, *Seven from Moscow, (Glezer Collection)*.
1976 France, Montgeron. Russian Museum in Exile.
1976 West Germany, Konstanz. Kunstverein, *Russian Nonconformist Artists (Glezer Collection)*.
1976 West Germany, Saulgau. Stadtgalerie "Die Fähre", *Russian Nonconformist Artists (Glezer Collection)*.
1976 West Germany, Esslingen. *Alternatives (Glezer Collection)*.

Vyacheslav Kalinin

Born Moscow, 1939. Graduated from the Abramtsevo College of Art and Manufacture, Khotkovo, near Moscow in 1963.

Exhibitions
1962 USSR, Moscow. Pedagogical Institute.
1965 USSR, Moscow. Kurchatov Institute of Physics.
1967 USSR, Tbilisi. Georgian Artists' Union, *Paintings and Drawings (Glezer Collection)*.
1967 Italy, Rome. Galleria il Segno, *Fifteen Young Moscow Painters*.
1969 Italy, Florence, Galleria Pananti, *The New School of Moscow*.
1969 West Germany, Stuttgart. Galerie Behr, *The New School of Moscow*.
1970 Switzerland, Lugano. Museo Belle Arti, *New Tendencies in Moscow*.
1971 Denmark, Copenhagen. Københavns Kommunes Kulturfond, *Ten Artists from Moscow*.
1974 West Germany, Bochum. Bochum Museum, *Progressive Tendencies in Moscow 1957–70*.
1975 USSR, Moscow. Bee-keeping Pavilion of the Exhibition of Economic Achievements, *Twenty Moscow Artists*.
1975 Austria, Vienna. Künstlerhaus, *The Russian February 1975 in Vienna (Glezer Collection)*.
1975 West Germany, Braunschweig. Kunstverein, *Russian Nonconformist Artists (Glezer Collection)*.
1975 West Germany, Freiburg. Kunstverein, *Russian Nonconformist Artists (Glezer Collection)*.
1975 West Germany, West Berlin. Kunstamt Charlottenburg, *Russian Nonconformist Artists (Glezer Collection)*.

1976 France, Montgeron. Russian Museum in Exile.
1976 West Germany, Konstanz. Kunstverein, *Russian Nonconformist Artists (Glezer Collection)*.
1976 West Germany, Saulgau. Stadtgalerie "Die Fähre", *Russian Nonconformist Artists (Glezer Collection)*.
1976 France, Mulhouse. *Second European Print Biennale.*
1976 USSR, Moscow. City Committee of Graphic Artists, *Exhibition of Seven Artists.*
1976 England, London. Parkway Focus Gallery, *The Religious Movement in the USSR (Glezer Collection)*.
1976 West Germany, Esslingen. Kunstverein, *Alternatives (Glezer Collection)*.
1976 USA, St Louis. Convention of the American Association for the Advancement of Slavic Studies, *New Art from the Soviet Union.*

Alexander Kalugin

Born 1949. He is a graduate of a secondary art college and lives in Moscow.

Exhibitions
1972 USA, Albuquerque. University of Albuquerque, one-man show.
1974 USSR, Moscow. Izmailovsky Park, *Second Autumn Open-air Exhibition.*
1976 France, Montgeron. Russian Museum in Exile.

Otari Kandaurov

Born Kemerovo, 1937. Studied at Moscow Art School and at the Graphic Art faculty of the Moscow State Pedagogical Institute.

Exhibitions
1967 Italy, Rome. Galleria il Segno, *Fifteen Young Moscow Painters.*
1970 USSR, Dubna. Institute of Nuclear Physics, one-man exhibition.
1970 Switzerland, Geneva. Versoix, L'atelier du soleil, *Panorama of Slavonic Painting.*
1970 Switzerland, Lugano. Museo Belle Arti, *New Tendencies in Moscow.*
1971 Denmark, Copenhagen. Kφbenhavns Kommunes Kulturfond, *Ten Artists from Moscow.*
1975 USSR, Moscow. Bee-keeping Pavilion of the Exhibition of Economic Achievements, *Twenty Moscow Artists.*
1975 West Germany, West Berlin. Kunstamt Charlottenburg, *Russian Nonconformist Artists (Glezer Collection)*.
1976 France, Montgeron. Russian Museum in Exile.
1976 England, London. Parkway Focus Gallery, *The Religious Movement in the USSR (Glezer Collection)*.
1976 West Germany, Esslingen. Kunstverein, *Alternatives (Glezer Collection)*.
1976 USA, St Louis. Convention of the American Association for the Advancement of Slavic Studies, *New Art from the Soviet Union.*

Alexander Kharitonov

Born Moscow, 1931. He has received no specialised artistic training.
He considers his teachers to have been the artists Dubinin and Krasilnikov, especially the latter.

Exhibitions
1965 USSR, Karpov. Institute of Physics, one-man exhibition.

Alexander Kharitonov

1967 France, St-Restitut, Drôme. Galerie ABC, Maison de la Tour, *New Painting from the USSR*.
1967 USA, New York. Gallery of Modern Art, *A Survey of Russian Painting, Fifteenth Century to the Present*.
1970 Switzerland, Lugano. Museo Belle Arti, *New Tendencies in Moscow*.
1970 Switzerland, Zurich. Kunstgalerie Villa Egli-Keller, *Alexei Smirnov and the Russian Avant-garde from Moscow*.
1971 Denmark, Copenhagen. Københavns Kommunes Kulturfond, *Ten Artists from Moscow*.
1974 France, Grenoble. Musée de Peinture et de Sculpture, *Eight Painters from Moscow*.
1975 USSR, Moscow. Bee-keeping Pavilion of the Exhibition of Economic Achievements, *Twenty Moscow Artists*.
1976 France, Montgeron. Russian Museum in Exile.
1976 USSR, Moscow. City Committee of Graphic Artists, *Exhibition of Seven Artists*.
1976 England, London. Parkway Focus Gallery, *The Religious Movement in the USSR (Glezer Collection)*.

Dmitri Krasnopevtsev

Born Moscow, 1925. Graduated in 1955 from the Surikov Art Institute in Moscow. Has worked for about twenty years as a graphic artist doing cinema advertisements for "Reklamfilm".

Exhibitions
1967 USSR, Tbilisi. Georgian Artists' Union, *Paintings and Drawings (Glezer Collection)*.
1967 USA, New York. Gallery of Modern Art, *A Survey of Russian Painting, Fifteenth Century to the Present*.
1967 France, St-Restitut, Drôme. Galerie ABC, Maison de la Tour, *New Painting from the USSR*.
1970 Switzerland, Lugano. Museo Belle Arti, *New Tendencies in Moscow*.
1974 France, Grenoble. Musée de Peinture et de Sculpture, *Eight Painters from Moscow*.
1974 West Germany, Bochum. Bochum Museum, *Progressive Tendencies in Moscow 1957–70*.
1975 USSR, Moscow. Bee-keeping Pavilion of the Exhibition of Economic Achievements, *Twenty Moscow Artists*.
1975 Austria, Vienna. Künstlerhaus, *The Russian February 1975 in Vienna (Glezer Collection)*.
1975 West Germany, Braunschweig. Kunstverein, *Russian Nonconformist Artists (Glezer Collection)*.
1975 West Germany, Freiburg. Kunstverein, *Russian Nonconformist Artists (Glezer Collection)*.
1975 West Germany, West Berlin, Kunstamt Charlottenburg, *Russian Nonconformist Artists (Glezer Collection)*.
1976 France, Montgeron. Russian Museum in Exile.
1976 West Germany, Konstanz. Kunstverein, *Russian Nonconformist Artists (Glezer Collection)*.
1976 West Germany, Saulgau. Stadtgalerie "Die Fähre", *Russian Nonconformist Artists (Glezer Collection)*.
1976 USSR, Moscow. City Committee of Graphic Artists, *Exhibition of Seven Artists*.
1976 France, Paris. Salon des Réalités Nouvelles.
1976 West Germany, Esslingen. Kunstverein, *Alternatives (Glezer Collection)*.

Valentina Kropivnitskaya

Born Moscow, 1924, into a family of artists – her parents were Olga Ananyevna Potapova and Evgeni Leonidovich Kropivnitsky, who later became Oscar Rabin's teacher. Kropivnitskaya worked in her district art studio and learned from her father. She is married to Oscar Rabin (*q.v.*).

Exhibitions

1966 Poland, Sopot-Poznan. Nineteenth Festival of Fine Arts, *Sixteen Moscow Artists*.
1967 USSR, Moscow. Druzhba Club, Chaussée Entuziastov.
1967 USSR, Tbilisi. Georgian Artists' Union, *Paintings and Drawings (Glezer Collection)*.
1967 Italy, Rome. Galleria il Segno, *Fifteen Young Moscow Painters*.
1969 Italy, Florence. Galleria Pananti, *The New School of Moscow*.
1969 West Germany, Stuttgart. Galerie Behr, *The New School of Moscow*.
1970 Switzerland, Lugano. Museo Belle Arti, *New Tendencies in Moscow*.
1970–71 Switzerland, Zurich. Kunstgalerie Villa Egli-Keller, *Alexei Smirnov and the Russian Avant-garde from Moscow*.
1971 Denmark, Copenhagen. Kφbenhavns Kommunes Kulturfond, *Ten Artists from Moscow*.
1974 West Germany, Bochum. Bochum Museum, *Progressive Tendencies in Moscow 1957–70*.
1974 USSR, Moscow. Izmailovsky Park, *Second Autumn Open-air Exhibition*.
1975 USSR, Moscow. Bee-keeping Pavilion of the Exhibition of Economic Achievements, *Twenty Moscow Artists*.
1975 Austria, Vienna. Künstlerhaus, *The Russian February 1975 in Vienna (Glezer Collection)*.
1975 West Germany, Braunschweig. Kunstverein, *Russian Nonconformist Artists (Glezer Collection)*.
1975 West Germany, Freiburg. Kunstverein, *Russian Nonconformist Artists (Glezer Collection)*.
1975 West Germany, West Berlin. Kunstamt Charlottenburg, *Russian Nonconformist Artists (Glezer Collection)*.
1975 Austria, Vienna. Galerie Christian Brandstätter, *Seven from Moscow (Glezer Collection)*.
1976 France, Montgeron. Russian Museum in Exile.
1976 West Germany, Konstanz. Kunstverein, *Russian Nonconformist Artists (Glezer Collection)*.
1976 West Germany, Saulgau. Städtgalerie "Die Fähre", *Russian Nonconformist Artists (Glezer Collection)*.
1976 France, Mulhouse. *Second European Print Biennale*.
1976 England, London. Parkway Focus Gallery, *The Religious Movement in the USSR (Glezer Collection)*.
1976 West Germany, Esslingen. Kunstverein, *Alternatives (Glezer Collection)*.
1976 USA, St Louis. Convention of the American Association for the Advancement of Slavic Studies, *New Art from the Soviet Union*.

Lev Kropivnitsky

Born Tyumen, 1922. Is the brother of Valentina Kropivnitskaya. In 1939 became a student at the Moscow Institute of Decorative and Applied Art, where he studied, except for the war years, until 1946. In 1946 he was arrested and spent nine years in the labour camps.

1958 USA, San Francisco. *Exhibition of Soviet Artists*.
1964 USSR, Moscow. Institute of Labour Hygiene, one-man exhibition.
1966 Poland, Sopot-Poznan. Nineteenth Festival of Fine Arts, *Sixteen Moscow Artists*.

1967 USSR, Moscow. Druzhba Club, Chaussée Entuziastov.
1967 USSR, Tbilisi. Georgian Artists' Union, *Paintings and Drawings (Glezer Collection)*.
1967 Italy, Rome. Galleria il Segno, *Fifteen Young Moscow Painters*.
1967 USA, New York. Gallery of Modern Art, *A Survey of Russian Painting, Fifteenth Century to the Present*.
1969 Italy, Florence. Galleria Pananti, *The New School of Moscow*.
1969 USSR, Moscow. Institute of World Economics and International Relations.
1970 Switzerland, Lugano. Museo Belle Arti, *New Tendencies in Moscow*.
1971 Norway, Oslo. *Ten Artists from Moscow*.
1971 Denmark, Copenhagen. Københavns Kommunes Kulturfond, *Ten Artists from Moscow*.
1974 West Germany, Bochum. Bochum Museum, *Progressive Tendencies in Moscow 1957–70*.
1975 Austria, Vienna. Künstlerhaus, *The Russian February 1975 in Vienna (Glezer Collection)*.
1975 West Germany, Braunschweig. Kunstverein, *Russian Nonconformist Artists (Glezer Collection)*.
1975 West Germany, Freiburg. Kunstverein, *Russian Nonconformist Artists (Glezer Collection)*.
1975 West Germany, West Berlin. Kunstamt Charlottenburg, *Russian Nonconformist Artists (Glezer Collection)*.
1976 France, Montgeron. Russian Museum in Exile.
1976 West Germany, Konstanz. Kunstverein, *Russian Nonconformist Artists (Glezer Collection)*.
1976 West Germany, Saulgau. Stadtgalerie "Die Fähre", *Russian Nonconformist Artists (Glezer Collection)*.
1976 West Germany, Esslingen. Kunstverein, *Alternatives (Glezer Collection)*.

Victor Kulbak

Born Moscow, 1946. Studied at the Moscow Art School and the Moscow Polygraphic Institute. From 1968 to 1972 he held five one-man exhibitions in Moscow, but they were all closed after two or three hours. In 1975 he emigrated to Sweden and is at present living in Paris.

Exhibitions
1975 Sweden, Helsingborg. Briiska Galleriet, one-man show.
1976 Sweden, Bro. City Library, *Swedish Painters*.
1976 Sweden, Goteborg. Galerie A.E., *Swedish Painters*.
1976 Sweden, Stockholm. Grafikhuset Futura, one-man show.
1976 Sweden, Malmö. Galerie Leger, one-man show.
1976 Sweden, Viken. City Library, one-man show.
1976 Norway, Oslo. Galerie 27, one-man show.
1976 France, Montgeron. Russian Museum in Exile.
1976 France, Paris. Salon des Réalités Nouvelles.
1976 West Germany, Esslingen. Kunstverein, *Alternatives (Glezer Collection)*.

Alexander Makhov

Born Moscow, 1944. A graduate of the Moscow Art School.

Exhibitions
1968 USSR, Moscow. Kurchatov Institute of Atomic Energy, one-man show.
1976 France, Montgeron. Russian Museum in Exile.

Lydia Masterkova

Born Moscow, 1929. Started drawing at the age of twelve, then studied at the Moscow Secondary Art School under Mikhail Perutsky (1943–6). Entered the Moscow Art College in 1946 and studied there until 1950, when it was closed down for "left deviationism". Turned to abstract painting in 1957 and has remained an abstractionist ever since. Emigrated from the Soviet Union in 1976. Now living in Paris.

Exhibitions
1966 Poland, Sopot-Poznan. Nineteenth Festival of Fine Arts, *Sixteen Moscow Artists.*
1967 USSR, Moscow. Druzhba Club, Chaussée Entuziastov.
1967 USSR, Tbilisi. Georgian Artists' Union, *Paintings and Drawings (Glezer Collection).*
1967 Italy, Rome. Galleria il Segno, *Fifteen Young Moscow Painters.*
1967 USA, New York. Gallery of Modern Art, *A Survey of Russian Painting, Fifteenth Century to the Present.*
1967 France, St-Restitut, Drôme. Galerie ABC, Maison de la Tour, *New Painting from the USSR.*
1974 West Germany, Bochum. Bochum Museum, *Progressive Tendencies in Moscow 1957–70.*
1974 USSR, Moscow. Cheremushki, *First Autumn Open-air Exhibition.*
1975 USSR, Moscow. Izmailovsky Park, *Second Autumn Open-air Exhibition.*
1975 USSR, Moscow. Bee-keeping Pavilion of the Exhibition of Economic Achievements, *Twenty Moscow Artists.*
1975 Austria, Vienna. Künstlerhaus, *The Russian February 1975 in Vienna (Glezer Collection).*
1975 West Germany, Braunschweig. Kunstverein, *Russian Nonconformist Artists (Glezer Collection).*
1975 West Germany, Freiburg. Kunstverein, *Russian Nonconformist Artists (Glezer Collection).*
1975 West Germany, West Berlin. Kunstamt Charlottenburg, *Russian Nonconformist Artists (Glezer Collection).*
1976 France, Montgeron. Russian Museum in Exile.
1976 West Germany, Saulgau. Stadtgalerie "Die Fähre", *Russian Nonconformist Artists (Glezer Collection).*
1976 West Germany, Esslingen. Kunstverein, *Alternatives (Glezer Collection).*
1976 Austria, Vienna. Künstlerhaus, *The Russian February 1976 in Vienna.*

Ernst Neizvestny

Born Sverdlovsk, 1925. After finishing secondary school volunteered to serve in the Soviet army. Was severely wounded at the Czechoslovak border and thought dead, but was saved and taken to a hospital in Bratislava and then Brno. After convalescence attended the Academy of Art in Riga and in 1954 graduated from the Surikov Art Institute in Moscow. Worked for a time as a founder in the Urals. Commenced making sculptures in the Fifties and came to prominence in the early Sixties. Emigrated 1976, now living in Zurich.

Exhibitions
1954 USSR, Moscow. *Young Moscow Artists.*
1957 USSR, Moscow. *Sixth World Festival of Youth and Students.*
1958 USSR, Moscow. *Exhibition to mark "Forty Years of the Komsomol".*
1961 USSR, Moscow. Druzhba Club, one-man show.
1961 USSR, Moscow. *Exhibition of the "Nine".*
1962 USSR, Moscow. *Exhibition at Moscow University* (jointly with Y. Yankilevsky).

1962 USSR, Moscow. *Exhibition of the Belyutin Studio Group*, Bolshaya Komunisticheskaya Street.

1962 USSR, Moscow. Manège, *Exhibition to Mark the 30th Anniversary of MOSK (Moscow Section of the Artists' Union)*.

1964 England, London. Grosvenor Gallery, *Drawings* (one-man show).

1964 Austria, Vienna. Zentral Buchhandlung, *Drawings* (one-man show).

1965 Yugoslavia, Belgrade. Museum of Belgrade, *Drawings* (one-man show)

1965 England, London. Grosvenor Gallery, *Drawings* (one-man show).

1965 Italy, Aquila. *Present Alternatives II*.

1965 Czechoslovakia, Prague. Viola Gallery, *Drawings by Young Moscow Kinetic Artists and E. Neizvestny*.

1965 Switzerland, Geneva. Palais des Expositions, *Drawings*.

1965 Czechoslovakia, Usti na Orlici and Most. *Drawings and Graphics by Young Soviet Artists*.

1965 Czechoslovakia, Prague. Capek Brothers Gallery, *Works by Neizvestny and Yankilevsky*.

1966 France, Paris. Galerie Lambert, *Drawings*.

1966 Poland, Sopot-Poznan. Nineteenth Festival of Fine Arts, *Sixteen Moscow Artists*.

1968 England, London. Grosvenor Gallery, *Sculpture – From the Human Form*.

1969 France, Paris, Musée d'Art Moderne, *Animation–Research–Confrontation*.

1969 Italy, Florence. Galleria Pananti, *The New School of Moscow*.

1969 Italy, Montecatini. Galleria La Barcaccia, one-man show.

1970 West Germany, Cologne. Galerie Gmurzynska, *The Russian Avant-garde in Moscow Today*.

1970 Switzerland, Lugano. Museo Belle Arti, *New Tendencies in Moscow*.

1971 Italy, Rome. Galleria Il Gabbiano, one-man show.

1972 Israel, Tel Aviv. The Tel Aviv Museum, *Etchings*.

1972 Italy, Rome, Galleria Anthea, *Neizvestny and Other Soviet Artists*.

1973 West Germany, Dortmund. Museum am Ostwall, *Russian Opposition Art, The Graphics of the Avant-garde*.

1974 West Germany, Bochum. Bochum Museum, *Progressive Tendencies in Moscow 1957–70*.

1975 USA, New York. The New York Cultural Center, *Drawings and Prints by Ernst Neizvestny 1965–74*.

1975 Austria, Vienna. Künstlerhaus, *The Russian February 1975 in Vienna (Glezer Collection)*.

1975 West Germany, Braunschweig. Kunstverein, *Russian Nonconformist Artists (Glezer Collection)*.

1975 West Germany, Freiburg. Kunstverein, *Russian Nonconformist Artists (Glezer Collection)*.

1975 Germany, West Berlin. Kunstamt Charlottenburg, *Russian Nonconformist Artists (Glezer Collection)*.

1976 France, Montgeron. Russian Museum in Exile.

1976 West Germany, Konstanz. Kunstverein, *Russian Nonconformist Artists (Glezer Collection)*.

1976 West Germany, Saulgau. Stadtgalerie, "Die Fähre", *Russian Nonconformist Artists (Glezer Collection)*.

1976 England, London. Parkway Focus Gallery, *The Religious Movement in the USSR (Glezer Collection)*.

Ernst Neizvestny

Vladimir Nemukhin

Born Moscow, 1925. Began drawing as a child. In 1942 met the painter, P. E. Sokolov, a pupil of Malevich, and Pavel Kuznetsov, both of whom became his teachers. For many years he worked full-time in a factory, painting in his spare time, but in 1956 he stopped working and in 1957 entered

Vladimir Nemukhin

the Surikov Art Institute. He was soon expelled, however, for his unorthodox ideas. For many years he worked as a decorator while continuing to paint, but for the last ten years he has been able to make his living from painting. He was married for some years to Lydia Masterkova *(q.v.)*.

Exhibitions

1965 USA, San Francisco. Arleigh Gallery, *The Fielding Collection of Russian Art.*

1966 Poland, Sopot-Poznan. Nineteenth Festival of Fine Arts, *Sixteen Moscow Artists.*

1967 USSR, Moscow. Druzhba Club, Chaussée Entuziastov.

1967 USSR, Tbilisi. Georgian Artists' Union, *Paintings and Drawings (Glezer Collection).*

1967 Italy, Rome. Galleria il Segno, *Fifteen Young Moscow Painters.*

1967 USA, New York. Gallery of Modern Art, *A Survey of Russian Painting, Fifteenth Century to the Present.*

1967 France, St Restitut, Drôme. Galerie ABC, Maison de la Tour, *New Painting from the USSR.*

1969 Italy, Florence. Galleria Pananti, *The New School of Moscow.*

1969 USSR, Moscow. Institute of World Economics and International Relations.

1969 West Germany, Frankfurt. Galerie Interior, *The New School of Moscow.*

1969 West Germany, Stuttgart. Galerie Behr, *The New School of Moscow.*

1970 Switzerland, Lugano. Museo Belle Arti, *New Tendencies in Moscow.*

1970 Switzerland, Zurich. Kunstgalerie Villa Egli-Keller, *Alexei Smirnov and the Russian Avant-garde from Moscow.*

1970 USSR, Moscow. Edmund Stevens' Villa, *Open-air Exhibition.*

1971 Denmark, Copenhagen. Kφbenhavns Kommunes Kulturfond, *Ten Artists from Moscow.*

1974 West Germany, Bochum. Bochum Museum, *Progressive Tendencies in Moscow 1957–70.*

1974 France, Grenoble. Musée de Peinture et de Sculpture, *Eight Painters from Moscow.*

1974 USSR, Moscow. Cheremushki, *First Autumn Open-air Exhibition.*

1974 USSR, Moscow. Izmailovsky Park, *Second Autumn Open-air Exhibition.*

1975 USSR, Moscow. Bee-keeping Pavilion of the Exhibition of Economic Achievements, *Twenty Moscow Artists.*

1975 Austria, Vienna. Künstlerhaus, *The Russian February 1975 in Vienna (Glezer Collection).*

1975 West Germany, Braunschweig. Kunstverein, *Russian Nonconformist Artists (Glezer Collection).*

1975 West Germany, Freiburg. Kunstverein, *Russian Nonconformist Artists (Glezer Collection).*

1975 West Germany, West Berlin. Kunstamt Charlottenburg, *Russian Nonconformist Artists (Glezer Collection).*

1975 Austria, Vienna. Galerie Christian Brandstätter, *Seven From Moscow (Glezer Collection).*

1976 France, Montgeron. Russian Museum in Exile.

1976 West Germany, Konstanz. Kunstverein, *Russian Nonconformist Artists (Glezer Collection).*

1976 West Germany, Saulgau. Stadtgalerie "Die Fähre", *Russian Nonconformist Artists (Glezer Collection).*

1976 USSR, Moscow. City Committee of Graphic Artists, *Seven Artists.*

1976 France, Paris. Salon des Réalités Nouvelles.

1976 West Germany, Esslingen. Kunstverein, *Alternatives (Glezer Collection).*

Lev Nussberg

Born Tashkent, 1937. Graduated from the Moscow Regional College of Fine Art in 1958. Worked in a film studio, then in various publishing houses. Was a teacher of drawing for a while. The founder, chief organiser and chief theoretician of the *Dvizheniye* (Movement) Group of kinetic artists. Emigrated in 1976, now living in Paris.

Exhibitions
1963 USSR, Moscow. Central House of Workers in the Arts, *Exhibition of Ornamentalists*.
1964 USSR, Moscow. Youth Club, Marinskaya Street, *Towards a Synthesis of Art Forms*.
1965 USSR, Leningrad. Architects' Club, *Exhibition of Kinetic Art*.
1965 Czechoslovakia, Prague, Louny, Brno. *Moscow Kinetic Art*.
1965 Italy, Aquila. *Present Alternatives II*.
1965 Czechoslovakia, Prague. Viola Gallery, *Drawings by Young Moscow Kinetic Artists and E. Neizvestny*.
1966 USSR, Moscow. Kurchatov Institute of Atomic Energy, *Exhibition of Kinetic Art*.
1966 USSR, Moscow. Kurchatov Institute of Atomic Energy, *Kinetic Theatrical Performance – Metamorphoses*.
1966 Yugoslavia, Zagreb. International Exhibition of Kinetic Art, *"New Tendencies"*.
1966 West Germany, Heidelberg and Munich. *New Aspects of Soviet Painting*.
1966 USSR, Leningrad. House of Culture of the Leningrad Soviet, *Kinetic Dramatic Sketches "Black and White"*.
1966 USSR, Leningrad. Kinetic street decorations and structures to mark the fiftieth anniversary of the Revolution.
1966–7 USSR, Moscow. Moscow Artists' Union, *Seventh Exhibition of Young Moscow Artists*.
1967 USSR, Kazan. University of Kazan, *First Student Kinetic Seminar on Problems of Colour and Music*.
1967 USSR, Moscow. Permanent Exhibition of Soviet Achievements, Erection of a Kinetic Complex entitled "Galaxy".
1967 USSR, Leningrad. Construction of a Kinetic Model – the "Cybertheatre".
1968 West Germany, Kassel. *Documenta*.
1969 USSR, Kazan. University of Kazan, *Second Student Kinetic Seminar on Problems of Colour and Music*.
1969 USSR, Moscow. Central Exhibition Hall (formerly The Manège), *Fifty Years of the Soviet Circus*.
1969 West Germany, Nuremberg. *The Nuremberg Biennale*.
1969 Italy, Florence. Galleria Pananti, *The New School of Moscow*.
1969 Switzerland, Berne. *Plans and Projects in the Art World*.
1969 USSR, Odessa. *Third Soviet Conference on Problems of Synthesising "Colour, Music and Light", Display by the Movement Group*.
1970 England, London. *International Exhibition of Kinetic Art*.
1974 West Germany, Krefeld. Museum Hans Lange, *Movement Group – Moscow 1962–72*.

Dmitri Plavinsky

Born Moscow, 1937. Attended a secondary school specialising in art and later graduated from the Moscow Regional Art College. Both a painter and a lithographer.

Exhibitions
1957 USSR, Moscow. *Third Exhibition of Young Moscow Painters*.

Dmitri Plavinsky

1957 USSR, Moscow. Sixth World Festival of Youth and Students, *Exhibition of Young Soviet Painters.*
1957 USSR, Moscow. Sixth World Festival of Youth and Students, *Exhibition of Painters from the International Studio.*
1958 USSR, Moscow. Moscow University, One-man Show.
1958 USSR, Moscow. *Fourth Exhibition of Young Moscow Painters.*
1959 USSR, Moscow. *Fifth Exhibition of Young Moscow Painters.*
1960 USSR, Moscow. Central House of Workers in the Arts, *Exhibition of Diploma Students from the Moscow Regional Art College.*
1961 USSR, Moscow. Central House of Workers in the Arts, *Exhibition of Diploma Students from the Moscow Regional Art College.*
1964 England, London. Grosvenor Gallery, *Aspects of Contemporary Soviet Art.*
1965 USA, San Francisco. Arleigh Gallery, *The Fielding Collection of Russian Art.*
1966 Poland, Sopot-Poznan. Nineteenth Festival of Fine Arts, *Sixteen Moscow Artists.*
1967 USSR, Moscow. Druzhba Club, Chaussée Entuziastov.
1967 USA, New York. Gallery of Modern Art, *A Survey of Russian Painting Fifteenth Century to the Present.*
1967 Italy, Rome. Galleria il Segno, *Fifteen Young Moscow Painters.*
1967 France, St-Restitut, Drôme. Galerie ABC, Maison de la Tour, *New Painting from the USSR.*
1969 West Germany, Stuttgart. Galerie Behr, *The New School from Moscow.*
1969 USSR, Moscow. Institute of World Economics and International Relations.
1970 USSR, Moscow. Edmund Stevens' Villa, *Open-air Exhibition.*
1970 West Germany, Cologne. Galerie Gmurzynska, *The Russian Avant-garde Today.*
1970 Switzerland, Geneva. Versoix, L'atelier du Soleil, *Panorama of Young Slavonic Painting.*
1970 Switzerland, Lugano. Museo Belle Arti, *New Tendencies in Moscow.*
1970 USSR, Dubna. Scientists' Club of the Nuclear Research Institute, One-man Show.
1970 Switzerland, Zurich. Kunstgalerie Villa Egli-Keller, *Alexei Smirnov and the Russian Avant-garde from Moscow.*
1971 Denmark, Copenhagen. Kφbenhavns Kommunes Kulturfond, *Ten Artists from Moscow.*
1974 West Germany, Bochum. Bochum Museum, *Progressive Tendencies in Moscow 1957–70.*
1974 France, Grenoble. Musée de Peinture et de Sculpture, *Eight Painters from Moscow.*
1975 USSR, Moscow. Bee-keeping Pavilion of the Exhibition of Economic Achievements, *Twenty Moscow Artists.*
1975 Austria, Vienna. Künstlerhaus, *The Russian February 1975 in Vienna (Glezer Collection).*
1975 West Germany, Braunschweig. Kunstverein, *Russian Nonconformist Artists (Glezer Collection).*
1975 West Germany, Freiburg. Kunstverein, *Russian Nonconformist Artists (Glezer Collection).*
1975 West Germany, West Berlin. Kunstamt Charlottenburg, *Russian Nonconformist Artists (Glezer Collection).*
1976 France, Montgeron. Russian Museum in Exile.
1976 West Germany, Konstanz. Kunstverein, *Russian Nonconformist Artists (Glezer Collection).*
1976 USSR, Moscow. City Committee of Graphic Artists, *Seven Artists.*
1976 France, Mulhouse. *Second European Print Biennale.*
1976 West Germany, Esslingen. Kunstverein, *Alternatives (Glezer Collection).*
1976 USA, St Louis. Convention of the American Association for the Advancement of Slavic Studies, *New Art from the Soviet Union.*

Oleg Prokofiev

Born Moscow, 1928. Son of the composer, he spent his early childhood in Paris, then returned to the USSR in 1936. Studied art history at the Moscow Regional Art College and published a number of books on the art of India and South-East Asia. Also studied painting under R. Falk 1949–52 but did not paint full-time until he emigrated to England in 1971. Is now a resident of London.

Exhibitions
1967 USSR, Moscow. *Spring Exhibition of Young Moscow Artists.*

(Prokofiev has had later exhibitions of work painted in the West.)

Alexander Rabin

Born Lianozovo, near Moscow, 1951. Son of Oscar Rabin and Valentina Kropivnitskaya. One of the organisers of the open-air exhibition at Cheremushki that was bulldozed.

Exhibitions
1974 USSR, Moscow. Cheremushki, *First Autumn Open-air Exhibition.*
1974 USSR, Moscow. Izmailovsky Park. *Second Autumn Open-air Exhibition.*
1975 USSR, Moscow. Bee-keeping Pavilion of the Exhibition of Economic Achievements, *Twenty Moscow Artists.*
1975 West Germany, West Berlin. Kunstamt Charlottenburg, *Russian Nonconformist Artists (Glezer Collection).*
1976 France, Montgeron. Russian Museum in Exile.
1976 England, London. Parkway Focus Gallery, *The Religious Movement in the USSR (Glezer Collection).*
1976 West Germany, Esslingen. Kunstverein, *Alternatives (Glezer Collection).*

Oscar Rabin

Born Moscow, 1928. Orphaned at the age of four, he was later adopted by the painter Evgeni Kropivnitsky, whose daughter, Valentina Kropivnitskaya *(q.v.)* he eventually married. He spent 1946–8 in Riga, studying music and drawing at the Academy of Arts there, and then moved to Moscow. He studied for a time at the Surikov Art Institute, but was expelled for his unorthodox views. Until 1958 Rabin worked as a loader on the railways and on various construction sites. Then, until 1967, he combined painting with work in an arts and design centre, and since 1967 he has earned a living by painting alone. He is the moving spirit behind the "Group of Lianozovo", so named for the settlement just outside Moscow where he now lives.

Exhibitions
1957 USSR, Moscow. Sixth World Festival of Youth and Students, *Exhibition of Young Soviet Painters.*
1964 England, London. Grosvenor Gallery, *Aspects of Contemporary Soviet Art.*
1965 England, London. Grosvenor Gallery, one-man show.
1965 USA, San Francisco. Arleigh Gallery, *The Fielding Collection of Russian Art.*
1966 Poland, Sopot-Poznan. Nineteenth Festival of Fine Arts, *Sixteen Moscow Painters.*
1967 USSR, Moscow. Druzhba Club, Chausée Entuziastov.
1967 USSR, Tbilisi. Georgian Artists' Union, *Paintings and Drawings (Glezer Collection).*
1967 USA, Chicago. Vincent Price Gallery, *Sixty Years of Russian Art.*

1967 Italy, Rome. Galleria il Segno, *Fifteen Young Moscow Painters*.
1967 USA, New York. Gallery of Modern Art, *A Survey of Russian Painting, Fifteenth Century to the Present*.
1967 France, St-Restitut, Drôme. Galerie ABC, Maison de la Tour, *New Painting from the USSR*.
1969 Italy, Florence. Galleria Pananti, *The New School of Moscow*.
1969 USSR, Moscow. Institute of World Economics and International Relations.
1969 West Germany, Frankfurt. Galerie Interior, *The New School of Moscow*.
1969 West Germany, Stuttgart. Galerie Behr, *The New School of Moscow*.
1970 Switzerland, Lugano. Museo Belle Arti, *New Tendencies in Moscow*.
1970 Switzerland, Zurich. Kunstgalerie Villa Egli-Keller, *Alexei Smirnov and the Russian Avant-garde from Moscow*.
1971 Denmark, Copenhagen. Kφbenhavns Kommunes Kulturfond, *Ten Artists from Moscow*.
1973 France, Paris. Galerie Dina Vierny, *The Russian Avant-garde – Moscow 1973*.
1974 West Germany, Bochum. Bochum Museum, *Progressive Tendencies in Moscow 1957–70*.
1974 France, Grenoble. Musée de Peinture et de Sculpture, *Eight Painters from Moscow*.
1974 USSR, Moscow. Cheremushki, *First Autumn Open-air Exhibition*.
1974 USSR, Moscow. Izmailovsky Park, *Second Autumn Open-air Exhibition*.
1975 USSR, Moscow. Bee-keeping Pavilion of the Exhibition of Economic Achievements, *Twenty Moscow Artists*.
1975 Austria, Vienna. Künstlerhaus, *The Russian February 1975 in Vienna (Glezer Collection)*.
1975 West Germany, Braunschweig. Kunstverein, *Russian Nonconformist Artists (Glezer Collection)*.
1975 West Germany, Freiburg. Kunstverein, *Russian Nonconformist Artists (Glezer Collection)*.
1975 West Germany, West Berlin. Kunstamt Charlottenburg, *Russian Nonconformist Artists (Glezer Collection)*.
1975 Austria, Vienna. Galerie Christian Brandstätter, *Seven From Moscow (Glezer Collection)*.
1976 France, Montgeron. Russian Museum in Exile.
1976 West Germany, Konstanz. Kunstverein, *Russian Nonconformist Artists (Glezer Collection)*.
1976 West Germany, Saulgau. Stadtgalerie "Die Fähre", *Russian Nonconformist Artists (Glezer Collection)*.
1976 France, Paris. Salon des Réalités Nouvelles.
1976 France, Toulon. Salon International d'Art.
1976 England, London. Parkway Focus Gallery, *The Religious Movement in the USSR (Glezer Collection)*.
1976 West Germany, Esslingen. Kunstverein, *Alternatives (Glezer Collection)*.

Evgeni Rukhin

Born Saratov, 1943. Graduated in geology from the University of Leningrad, but learned painting by unofficially attending lectures at the Mukhina College of Art and Manufacture in Leningrad. Died in mysterious circumstances as a result of a fire in his studio in Spring 1976.

Exhibitions
1965 USSR, Leningrad. Leningrad University.
1967 USA, New York. Betty Parsons Gallery, one-man show.

Evgeni Rukhin

1969 USSR, Leningrad. Two-day Exhibition, *Ten Leningrad Artists*.
1970 Switzerland, Lugano. Museo Belle Arti, *New Tendencies in Moscow*.
1971 Switzerland, Zurich. Galerie La Foumière, one-man show.
1972 West Germany, Stuttgart. Württemberger Kunstverein.
1974 USSR, Moscow. Cheremushki, *First Autumn Open-air Exhibition*.
1974 USSR, Moscow. Izmailovsky Park, *Second Autumn Open-air Exhibition*.
1974 USSR, Leningrad. Gaas House of Culture, *Fifty Leningrad Artists*.
1975 Austria, Vienna. Künstlerhaus, *The Russian February 1975 in Vienna (Glezer Collection)*.
1975 West Germany, Braunschweig. Kunstverein, *Russian Nonconformist Artists (Glezer Collection)*.
1975 USSR, Leningrad. House of Culture of the Nevsky District, *Some Leningrad Artists*.
1975 West Germany, Freiburg. Kunstverein, *Russian Nonconformist Artists (Glezer Collection)*.
1975 West Germany, West Berlin. Kunstamt Charlottenburg, *Russian Nonconformist Artists (Glezer Collection)*.
1975 USA, Raleigh, North Carolina. North Carolina Museum of Art, one-man show.
1975 USA, New York. Banakh Gallery, one-man show.
1976 France, Montgeron. Russian Museum in Exile.
1976 West Germany, Konstanz. Kunstverein, *Russian Nonconformist Artists (Glezer Collection)*.
1976 West Germany, Saulgau. Stadtgalerie "Die Fähre", *Russian Nonconformist Artists (Glezer Collection)*.
1976 West Germany, Esslingen. Kunstverein, *Alternatives (Glezer Collection)*.

Valentina Shapiro

Born Moscow. Educated at the Moscow Institute of Art. Emigrated to Israel in 1972, settled in Paris in 1975.

Exhibitions
1973 Israel, Tel Aviv. One-man show.
1974 France, Paris. Galerie Katia Granoff, one-man show.
1975 France, Paris. Galerie Katia Granoff, one-man show.

Mikhail Shemyakin

Born Moscow, 1943. In 1957 entered the Repin College of Art to study painting, but was expelled two years later for "formalism". In 1964 had a one-man exhibition at the Hermitage in Leningrad, but the exhibition was closed after three days and the Director of the Hermitage dismissed for permitting it. In the same year Shemyakin was a co-founder of the "Petersburg Group" which adopted "Metaphysical Synthesis" (see pp. 155–7) as its programme. In 1971 Shemyakin emigrated and settled in Paris.

Exhibitions
1971 France, Paris. Galerie Dina Vierny, one-man show.
1972 France, Paris. Grand Palais, *The Great and the Young of Today*.

(Shemyakin has since had numerous exhibitions in the West, but almost entirely of work painted outside the Soviet Union.)

Edward Steinberg

Born Moscow, 1937. Had no formal training, but worked with Boris Sveshnikov *(q.v.)* and Oscar Rabin *(q.v.)*.

Exhibitions
1967 USSR, Moscow. Druzhba Club, Chaussée Entuziastov.
1967 USSR, Tbilisi. Georgian Artists' Union, *Paintings and Drawings (Glezer Collection)*.
1968 USSR, Moscow. Moscow Artists' Union, one-day Exhibition.
1975 USSR, Moscow. Bee-keeping Pavilion of the Exhibition of Economic Achievements, *Twenty Moscow Artists*.
1975 Austria, Vienna. Künstlerhaus, *The Russian February 1975 in Vienna (Glezer Collection)*.
1975 West Germany, Braunschweig. Kunstverein, *Russian Nonconformist Artists (Glezer Collection)*.
1975 West Germany, Freiburg. Kunstverein, *Russian Nonconformist Artists (Glezer Collection)*.
1975 West Germany, West Berlin. Kunstamt Charlottenburg, *Russian Nonconformist Artists (Glezer Collection)*.
1976 France, Montgeron. Russian Museum in Exile.
1976 West Germany, Konstanz. Kunstverein, *Russian Nonconformist Artists (Glezer Collection)*.
1976 West Germany, Saulgau. Stadtgalerie "Die Fähre", *Russian Nonconformist Artists (Glezer Collection)*.
1976 West Germany, Esslingen. Kunstverein, *Alternatives (Glezer Collection)*.

Vasili Sitnikov

Born 1915 in a village on the Don near the town of Lebedyani, moved to Moscow as a child. Graduated from a Naval Technical College in 1934. Received no specialized artistic training, but drew from early childhood onwards. During the war imprisoned for political reasons and later incarcerated in a prison psychiatric hospital. In 1975 he emigrated from the USSR.

Exhibitions
1967 USA, New York. Gallery of Modern Art, *A Survey of Russian Painting, Fifteenth Century to the Present*.
1971–72 Italy, Arezzano. Centro di Iniziative Culturali, one-man show.
1975 West Germany, West Berlin. Kunstamt Charlottenburg, *Russian Nonconformist Artists (Glezer Collection)*.
1976 France, Montgeron. Russian Museum in Exile.
1976 West Germany, Esslingen. Kunstverein, *Alternatives (Glezer Collection)*.
1976 USA, St Louis. Convention of the American Association for the Advancement of Slavic Studies, *New Art from the Soviet Union*.
1976 Austria, Vienna. Künstlerhaus, *The Russian February 1976 in Vienna*.

Boris Sveshnikov

Born Moscow, 1927. In 1946 became a student at the Moscow Institute of Decorative and Applied Art, but in his first year was arrested and sentenced for alleged anti-Soviet activity. Spent eight years in Stalin's labour camps, where he began to paint and draw scenes from camp life. After his return to Moscow was accepted as a member of the Artists' Union in the capacity of a book illustrator.

Exhibitions
1969 USSR, Moscow. Institute of World Economics and International Relations.

Boris Sveshnikov

1970 Switzerland, Lugano. Museo Belle Arti, *New Tendencies in Moscow*.
1974 France, Grenoble. Musée de Peinture et de Sculpture, *Eight Painters from Moscow*.
1974 West Germany, Bochum. Bochum Museum, *Progressive Tendencies in Moscow 1957–70*.
1975 Austria, Vienna. Künstlerhaus, *The Russian February 1975 in Vienna (Glezer Collection)*.
1975 West Germany, Braunschweig. Kunstverein, *Russian Nonconformist Artists (Glezer Collection)*.
1975 West Germany, Freiburg. Kunstverein, *Russian Nonconformist Artists (Glezer Collection)*.
1975 West Germany, West Berlin. Kunstamt Charlottenburg, *Russian Nonconformist Artists (Glezer Collection)*.
1976 France, Montgeron. Russian Museum in Exile.
1976 West Germany, Konstanz. Kunstverein, *Russian Nonconformist Artists (Glezer Collection)*.
1976 West Germany, Saulgau. Stadtgalerie "Die Fähre", *Russian Nonconformist Artists (Glezer Collection)*.
1976 West Germany, Esslingen. Kunstverein, *Alternatives (Glezer Collection)*.

Oleg Tselkov

Born Moscow, 1934. Was a pupil at the Moscow secondary school specialising in art. Studied at the Minsk Institute of Theatre Art (1945) and at the Academy of Art in Leningrad (1955). Was expelled from both of these for "formalism". Nevertheless later succeeded in graduating from the Theatre Institute in Leningrad in 1958 as a stage-designer. Has designed a number of productions and is a member of the relevant section of the Artists' Union.

Exhibitions
1965 USSR, Moscow. Kurchatov Institute of Physics, one-man show.
1970 USSR, Moscow. Central House of Architects, one-man show.
1975 USSR, Moscow. Bee-keeping Pavilion of the Exhibition of Economic Achievements, *Twenty Moscow Artists*.
1975 Austria, Vienna. Künstlerhaus, *The Russian February 1975 in Vienna (Glezer Collection)*.
1975 West Germany, Braunschweig. Kunstverein, *Russian Nonconformist Artists (Glezer Collection)*.
1975 West Germany, Freiburg. Kunstverein, *Russian Nonconformist Artists (Glezer Collection)*.
1976 France, Montgeron. Russian Museum in Exile.
1976 West Germany, Konstanz. Kunstverein, *Russian Nonconformist Artists (Glezer Collection)*.
1976 West Germany, Saulgau. Stadtgalerie "Die Fähre", *Russian Nonconformist Artists (Glezer Collection)*.

Avtandil Varazi

Born Tbilisi, 1926. In 1948 graduated from the Faculty of Architecture at the Georgian Polytechnic Institute. Simultaneously studied painting and drawing at the Georgian Academy of Arts. In 1965 took part in some all-republic exhibitions in Tbilisi, but was not given the opportunity of exhibiting his most interesting works, which are in the style of Pop-art.

Exhibitions
1967 USA, New York. Gallery of Modern Art, *A Survey of Russian Painting, Fifteenth Century to the Present*.

1975 Austria, Vienna. Künstlerhaus, *The Russian February 1975 in Vienna (Glezer Collection)*.
1975 West Germany, Braunschweig. Kunstverein, *Russian Nonconformist Artists (Glezer Collection)*.
1975 West Germany, Freiburg. Kunstverein, *Russian Nonconformist Artists (Glezer Collection)*.
1975 France, Montgeron. Russian Museum in Exile.
1976 West Germany, Konstanz. Kunstverein, *Russian Nonconformist Artists (Glezer Collection)*.
1976 West Germany, Saulgau. Stadtgalerie "Die Fähre", *Russian Nonconformist Artists (Glezer Collection)*.

Anatoli Vasiliev

Born Riga, 1940. Graduated from the Mukhina College of Art and Manufacture in Leningrad.

Exhibitions
1975 USSR, Leningrad. House of Culture of the Nevsky District, *Some Leningrad Artists*.
1975 West Germany, West Berlin. Kunstamt Charlottenburg, *Russian Nonconformist Artists (Glezer Collection)*.
1976 France, Montgeron. Russian Museum in Exile.
1976 West Germany, Esslingen. Kunstverein, *Alternatives (Glezer Collection)*.

Nikolai Vechtomov

Born Moscow, 1923. Served at the front, was taken prisoner, escaped from a concentration camp and joined partisans in Czechoslovakia during the Second World War. In 1946 became a student at the Moscow City Art College, which was closed in 1949 for alleged "formalism". In 1951 graduated from the Moscow Regional Art College and since then he has worked as a designer, while painting in his spare time.

Exhibitions
1966 Poland, Sopot-Poznan. Nineteenth Festival of Fine Arts, *Sixteen Moscow Artists*.
1967 USSR, Moscow. Druzhba Club, Chaussée Entuziastov.
1967 USSR, Tbilisi, Georgian Artists' Union, *Paintings and Drawings (Glezer Collection)*.
1967 Italy, Rome. Galleria il Segno, *Fifteen Young Moscow Painters*.
1967 France, St-Restitut, Drôme. Galerie ABC, Maison de la Tour, *New Painting from the USSR*.
1969 Italy, Florence. Galleria Pananti, *The New School of Moscow*.
1971 Denmark, Copenhagen. Københavns Kommunes Kulturfond, *Ten Moscow Artists*.
1974 West Germany, Bochum. Bochum Museum, *Progressive Tendencies in Moscow 1957–70*.
1975 USSR, Moscow. Bee-keeping Pavilion of the Exhibition of Economic Achievements. *Twenty Moscow Artists*.
1975 Austria, Vienna. Künstlerhaus, *The Russian February 1975 in Vienna (Glezer Collection)*.
1975 West Germany, Braunschweig. Kunstverein, *Russian Nonconformist Artists (Glezer Collection)*.
1975 West Germany, Freiburg. Kunstverein, *Russian Nonconformist Artists (Glezer Collection)*.
1975 West Germany, West Berlin. Kunstamt Charlottenburg, *Russian Nonconformist Artists (Glezer Collection)*.

1976 France, Montgeron. Russian Museum in Exile.
1976 West Germany, Konstanz. Kunstverein, *Russian Nonconformist Artists (Glezer Collection)*.
1976 West Germany, Saulgau. Standtgalerie "Die Fähre", *Russian Nonconformist Artists (Glezer Collection)*.
1976 USSR, Moscow. City Committee of Graphic Artists, *Seven Artists*.
1976 West Germany, Esslingen. Kunstverein, *Alternatives (Glezer Collection)*.

Vladimir Weisberg

Born Moscow, 1924. Was seriously wounded in the Second World War and invalided out of the forces as a "group three psychopaths invalid". Although not a student there, attended lectures at the Surikov Art Institute, Moscow, where he studied under Osmerkin. Works as a teacher of drawing at the Moscow College of Architecture. Is a member of the Artists' Union, and was one of the "Group of Eight", together with Boris Birger *(q.v.)* and others. Had two canvases in the celebrated exhibition at the Manège in 1962 and was accused of "pornography" on the basis of one of them, a nude.

Exhibitions
1960 USSR, Moscow. House of Artists, *Group exhibition*.
1962 USSR, Moscow. House of Artists, *Group exhibition*.
1962 USSR, Moscow. Manège, *Exhibition to Mark the 30th Anniversary of MOSK (Moscow Section of the Artists' Union)*.
1967 USSR, Tbilisi. Georgian Artists' Union, *Paintings and Drawings (Glezer Collection)*.
1967 USA, New York. Gallery of Modern Art, *A Survey of Russian Painting, Fifteenth Century to the Present Day*.
1974 USSR, Moscow. House of Artists, *Annual Spring Exhibition*.
1975 Austria, Vienna. Künstlerhaus, *The Russian February 1975 in Vienna (Glezer Collection)*.
1975 West Germany, Braunschweig. Kunstverein, *Russian Nonconformist Artists (Glezer Collection)*.
1975 West Germany, Freiburg. Kunstverein, *Russian Nonconformist Artists (Glezer Collection)*.
1975 West Germany, West Berlin. Kunstamt Charlottenburg, *Russian Nonconformist Artists (Glezer Collection)*.
1976 France, Montgeron. Russian Museum in Exile.
1976 West Germany, Konstanz. Kunstverein, *Russian Nonconformist Artists (Glezer Collection)*.
1976 West Germany, Saulgau. Stadtgalerie "Die Fähre", *Russian Nonconformist Artists (Glezer Collection)*.
1976 France, Paris. Salon des Realités Nouvelles.
1976 West Germany, Esslingen. Kunstverein, *Alternatives (Glezer Collection)*.

Vladimir Yakovlev

Born Balakhna, near Gorky, 1934. Inherited a love of painting from his grandfather, a well-known Russian artist who moved to Brussels after the Revolution. Yakovlev's father returned to Soviet Union at the beginning of the Thirties. At the age of sixteen contracted a serious eye disease which led to serious psychological depressions, as a result of which he has been in and out of mental hospitals at frequent intervals. Now has only 6 per cent of his vision. Is a self-taught artist and works mainly in water-colour and gouache.

Exhibitions
1962 USSR, Moscow. Druzhba Club, Chaussée Entuziastov, one-man show.

1968 USSR, Moscow. Moscow Section of the Artists' Union, one-day exhibition.
1968 Czechoslovakia, Bratislava. *Exhibition of Moscow Artists.*
1970 Switzerland, Lugano. Museo Belle Arti, *New Tendencies in Moscow.*
1970 West Germany, Cologne. Galerie Gmurzinska, *The Russian Avant-garde in Moscow Today.*
1974 West Germany, Bochum. Bochum Museum, *Progressive Tendencies in Moscow 1957–70.*
1975 USSR, Moscow. Bee-keeping Pavilion of the Exhibition of Economic Achievements, *Twenty Moscow Artists.*
1975 Austria, Vienna. Künstlerhaus, *The Russian February 1975 in Vienna (Glezer Collection).*
1975 West Germany, Braunschweig. Kunstverein, *Russian Nonconformist Artists (Glezer Collection).*
1975 West Germany, Freiburg. Kunstverein, *Russian Nonconformist Artists (Glezer Collection).*
1975 West Germany, West Berlin. Kunstamt Charlottenburg, *Russian Nonconformist Artists (Glezer Collection).*
1976 France, Montgeron. Russian Museum in Exile.
1976 West Germany, Konstanz. Kunstverein, *Russian Nonconformist Artists (Glezer Collection).*
1976 West Germany, Saulgau. Stadtgalerie "Die Fähre", *Russian Nonconformist Artists (Glezer Collection).*
1976 West Germany, Esslingen. Kunstverein, *Alternatives (Glezer Collection).*
1976 USA, St Louis. Convention of the American Association for the Advancement of Slavic Studies, *New Art from the Soviet Union.*

Vladimir Yankilevsky

Attended the Moscow Secondary Art School, graduated from the Academy of Design in 1956 and from the Moscow Polygraphic Institute where he studied painting under Belyutin *(q.v.)* in 1962. Took part in the Belyutin Studio exhibition and celebrated Manège exhibition in 1962, thereafter worked closely with the sculptor Neizvestny *(q.v.)*.

Exhibitions
1962 USSR, Moscow. Moscow University, Exhibition with E. Neizvestny.
1962 USSR, Moscow. *Exhibition of the Belyutin Studio Group*, Bolshaya Kommunisticheskaya Street.
1962 USSR, Moscow. Manège, *Exhibition to Mark the 30th Anniversary of MOSK (Moscow Section of the Artists' Union).*
1965 USSR, Moscow. Institute of Bio-physics, one-man show.
1965 Italy, Aquila. *Present Alternatives.*
1965 Czechoslovakia, Usti na Orlici and Most. *Exhibition of Drawings and Graphics by Young Soviet Artists.*
1965 Poland, Zloty Grun.
1966 Czechoslovakia, Prague. Capek Brothers Gallery, *Works by Neizvestny and Yankilevsky.*
1966 Poland, Sopot-Poznan. Nineteenth Festival of Fine Arts, *Sixteen Moscow Artists.*
1967 Italy, Rome. Galleria il Segno, *Fifteen Young Moscow Painters.*
1969 Italy, Florence. Galleria Pananti, *The New School of Moscow.*
1970 Switzerland, Lugano. Museo Belle Arti, *New Tendencies in Moscow.*
1970–1 Switzerland, Zurich. Galerie Renée Ziegler, *Six Soviet Artists.*
1970 West Germany, Cologne. Galerie Gmurzynska, *The Russian Avant-garde in Moscow Today.*
1973 France, Paris. Galerie Dina Vierny, *The Russian Avant-garde in Moscow, 1973.*

1974 West Germany, Bochum. Bochum Museum, *Progressive Tendencies in Moscow 1957–70*.
1975 USSR, Moscow. Bee-keeping Pavilion of the Exhibition of Economic Achievements, *Twenty Moscow Artists*.
1975 West Germany, West Berlin. Kunstamt Charlottenburg, *Russian Nonconformist Artists (Glezer Collection)*.
1975 Austria, Vienna. Galerie Brandstätter, *Seven from Moscow*.
1976 France, Montgeron. Russian Museum in Exile.
1976 France, Mulhouse. *Second European Print Biennale*.
1976 West Germany, Esslingen. Kunstverein, *Alternatives (Glezer Collection)*.
1976 USA, St Louis. Convention of the American Association for the Advancement of Slavic Studies, *New Art from the Soviet Union*.

Edward Zelenin

Born Novokuznetsk, 1938. Studied for four years at the Sverdlovsk College of Art. In 1958 moved to Leningrad and entered the art school of the Repin Academy of Arts. In 1971 moved to the ancient Russian town of Vladimir. Emigrated in 1975 and currently lives in Paris.

Exhibitions
1965 USSR, Moscow. Institute of Biophysics, one-man show.
1969 USSR, Moscow. Blue-Bird Café, one-man show.
1974 USSR, Moscow. Cheremushki, *First Autumn Open-air exhibition*.
1974 USSR, Moscow. Izmailovsky Park. *Second Autumn Open-air exhibition*.
1975 Austria, Vienna. Künstlerhaus, *The Russian February 1975 in Vienna (Glezer Collection)*.
1975 West Germany, Braunschweig. Kunstverein, *Russian Nonconformist Artists (Glezer Collection)*.
1975 West Germany, Freiburg. Kunstverein, *Russian Nonconformist Artists (Glezer Collection)*.
1975 West Germany, West Berlin. Kunstamt Charlottenburg, *Russian Nonconformist Artists (Glezer Collection)*.
1976 France, Montgeron. Russian Museum in Exile.
1976 West Germany, Konstanz. Kunstverein, *Russian Nonconformist Artists (Glezer Collection)*.
1976 West Germany, Saulgau. Stadtgalerie, "Die Fähre", *Russian Nonconformist Artists (Glezer Collection)*.
1976 England, London. Parkway Focus Gallery, *The Religious Movement in the USSR (Glazer Collection)*.
1976 West Germany, Esslingen. Kunstverein, *Alternatives (Glezer Collection)*.
1976 Austria, Vienna. Künstlerhaus, *The Russian February 1976 in Vienna*.

Yuri Zharkikh

Born Tikhoretsk, 1938. In 1961 graduated from the Leningrad Nautical College but a year later entered the Mukhina College of Art and Manufacture, from which he graduated in 1967 as a qualified designer. Has been painting since 1971.

Exhibitions
1971 USSR, Leningrad, *Group Exhibition of Young Artists*.
1973 USSR, Leningrad. Publishing house of the journal "Aurora", one-man show.
1974 USSR, Moscow. Cheremushki, *First Autumn Open-air Exhibition*.
1974 USSR, Moscow. Izmailovsky Park. *Second Autumn Open-air Exhibition*.
1974 USSR, Leningrad. Gaas House of Culture, *Fifty Artists*.

Yuri Zharkikh

1975 Austria, Vienna. Künstlerhaus, *The Russian February 1975 in Vienna (Glezer Collection)*.
1975 West Germany, Braunschweig. Kunstverein, *Russian Nonconformist Artists (Glezer Collection)*.
1975 West Germany, Freiburg. Kunstverein, *Russian Nonconformist Artists (Glezer Collection)*.
1975 West Germany, West Berlin. Kunstamt Charlottenburg, *Russian Nonconformist Artists (Glezer Collection)*.
1975 USSR, Leningrad. House of Culture of the Nevsky District, *Some Leningrad Artists*.
1976 France, Montgeron. Russian Museum in Exile.
1976 West Germany, Konstanz. Kunstverein, *Russian Nonconformist Artists (Glezer Collection)*.
1976 West Germany, Saulgau. Stadtgalerie, *Russian Nonconformist Artists (Glezer Collection)*.
1976 West Germany, Esslingen. Kunstverein, *Alternatives (Glezer Collection)*.

Boris Zhutovsky

Born Moscow, 1932. Graduated from the Moscow Polygraphic Institute in 1950, from the department of Artistic design. In 1959 worked in the studio of E. Belyutin.

Exhibitions
1962 USSR, Moscow. *Exhibition of the Belyutin Studio Group*, Bolshaya Kommunisticheskaya Street.
1962 USSR, Moscow. Manège, *Exhibition to Mark the 30th Anniversary of MOSK (Moscow Section of the Artists' Union)*.
1965 Italy, Aquila. *Present Alternatives II*.
1965 Czechoslovakia, Usti na Orlici and Most. *Exhibition of Drawings and Graphics by Young Soviet Artists*.
1966 Poland, Sopot-Poznan. Nineteenth Festival of Fine Arts, *Sixteen Moscow Artists*.
1967 USSR, Tbilisi. Georgian Artists' Union, *Paintings and Drawings (Glezer Collection)*.
1967 Italy, Rome. Galleria il Segno, *Fifteen Young Moscow Painters*.
1969 Italy, Florence. Galleria Pananti, *The New School of Moscow*.
1969 West Germany, Frankfurt. Galerie Interior, *The New School of Moscow*.
1969 West Germany, Stuttgart. Galerie Behr, *The New School of Moscow*.
1970 Switzerland, Lugano. Museo Belle Arti, *New Tendencies in Moscow*.
1976 France, Montgeron. Russian Museum in Exile.

Anatoli Zverev

Born Moscow, 1931. Graduated from the Moscow Regional College of Art. Almost from the very beginning of his working life as a creative artist has received moral and financial support from the well-known Moscow art-collector, Georgi Kostaki. In the middle of the Sixties, the artist met the French conductor Markevich, who took a liking to Zverev's work and organised a successful exhibition in Paris.

Exhibitions
1965 France, Paris. Galerie Motte, one-man show.
1965 Switzerland, Geneva. Galerie Motte, one-man show.
1967 USSR, Moscow. Druzhba Club, Chaussée Entuziastov.
1967 USSR, Tbilisi. Georgian Artists' Union, *Paintings and Drawings (Glezer Collection)*.

1967 France, St-Restitut, Drôme. Galerie ABC, Maison de la Tour, *New Painting from the USSR*.

1967 USA, New York. Gallery of Modern Art, *A Survey of Russian Painting, Fifteenth Century to the Present*.

1970 Switzerland, Lugano. Museo Belle Arti, *New Tendencies in Moscow*.

1971 Switzerland, Zurich. Kunstgalerie, Villa Egli-Keller, *Alexei Smirnov and the Russian Avant-garde from Moscow*.

1971 Denmark, Copenhagen. Kφbenhavns Kommunes Kulturfond, *Ten Artists from Moscow*.

1974 West Germany, Bochum. Bochum Museum, *Progressive Tendencies in Moscow 1957–70*.

1974 France, Grenoble. Musée de Peinture et de Sculpture, *Eight Painters from Moscow*.

1975 USSR, Moscow. Bee-keeping Pavilion of the Exhibition of Economic Achievements, *Twenty Moscow Artists*.

1975 Austria, Vienna. Künstlerhaus, *The Russian February 1975 in Vienna (Glezer Collection)*.

1975 West Germany, Braunschweig. Kunstverein, *Russian Nonconformist Artists (Glezer Collection)*.

1975 West Germany, Freiburg. Kunstverein, *Russian Nonconformist Artists (Glezer Collection)*.

1975 West Germany, West Berlin, Kunstamt Charlottenburg, *Nonconformist Russian Artists (Glezer Collection)*.

1975 Austria, Vienna. Galerie Christian Brandstätter, *Seven From Moscow (Glezer Collection)*.

1976 France, Montgeron. Russian Museum in Exile.

1976 West Germany, Saulgau. Stadtgalerie "Die Fähre", *Russian Nonconformist Artists (Glezer Collection)*.

1976 West Germany, Esslingen. Kunstverein, *Alternatives (Glezer Collection)*.

Anatoli Zverev

Manifestos by Leading Artists

Ilya Kabakov

My work cannot be divided into periods. I have been working on the same problem all the time – the problem of light, which shines down on us and bathes all the objects we see around us. One may either paint the objects that are bathed in light or concentrate on the light that suffuses them. I believe that my work is concerned with the streaming light that bathes these objects. There are things that are light-bearing, and there are things that bear less light. The artist's task is to reproduce in his work the light that he perceives.

Formally my pictures are modelled on products of a non-aesthetic character: labels, railway posters, amateur sketches, train time-tables, different sorts of diagrams. As regards their form there would seem to be nothing new in comparison with, for instance, Pop art. However, these apparently unaesthetic products are examined in the light of the laws of high artistic tradition, that is, the laws of three-dimensional space, the laws of symmetry and of the natural interrelations between the objects depicted. In these circumstances, as during the disintegration of the atomic nucleus, the enormous potential concealed in these representational objects is revealed. A label is not a work of art, but a label perceived in the context of a classical picture has the potential for gigantic dramatic collisions.

The content of my work is based on the following idea. Any picture consists of fiction and real essence. With some artists the covered surface of the whole picture is the sum total of what it depicts; with others the real essence lies at the centre of the picture or perhaps at one of its edges. Consequently, all the remainder is fiction. In my case everything depicted in my pictures is fictitious. The meaning, however, does not disappear, but remains all the time behind and beyond the painted surface. One simply has to know how to discern it.

Now a few words about the interaction between the painting and the spectator. There are three types of painter and, consequently, three types of picture. Let us call the first type attacking. The spectator is regarded as the ideal vacuum and the artist as the ideal filler of the vacuum. The second type reverses the position: maximum attention and mobilisation is required of the spectator, while the painter makes the maximum effort to conceal the message contained in the painting. The third type prefers a dialogue, presupposing a correlation

Ilya Kabakov
117
MENU
29 × 21 cm
Private collection

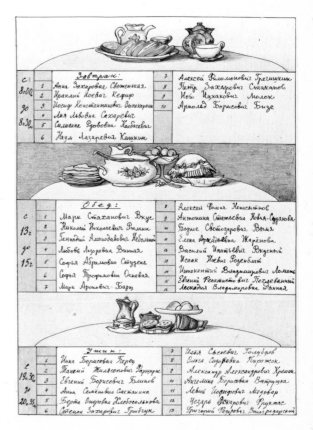

between the content of the painting and the perception of the spectator, and vice versa. Painting and spectator have a foreknowledge of one another and a dialogue between them springs up immediately, because it is a dialogue they have conducted before, albeit separately.

Hence there exist three "manners in which a painting speaks": the first by way of categorical statement, the second by a silence concealed within the picture which has the power to attract, and the third, by way of dialogue, an almost neutral calm. An example of the first type is Ernst Neizvestny, of the second Vladimir Yakovlev, and of the third – myself, Ilya Kabakov.

(From the archives of Alexander Glezer, Russian Museum in Exile, Montgeron. Recorded conversation with the artist.)

Otari Kandaurov

Metarealism
Creative Method and Creative Credo (Theses)

1. Spiritual aspect:
Appeal to the most deep-seated layers of being, to the bedrock of popular myths, legends and superstitions, of all that is termed the popular spirit.

The most deep-seated layers of being are the semantic layers. This is the world of forms, i.e.; of embodied ideas (in the Platonic sense of the word). This is the world of living essences, the world of spiritual *realia*.

It is this world in its entirety that is the focus of my examination, experience and representation. My activity ranges from sudden, instantaneous illumination to lengthy, co-existence-like contemplation.

2. Plastic aspect:
Two basic methods have been developed.

The first employs revelation in unbelievably concentrated form. In compositions which are intended to express something equivalent to the revelations of the prophets, the requisite objects are assembled almost at random (as in a lottery), for the objective essence of things is consumed in the crucible of revelation. Such are Dali's *Crucifixion of San Juan de la Cruz* and my own *Trinity*. In the case of meditation away from an object [towards prostration] the same method is applied. Such are Dali's *Bread* and some of my own still-lifes.

The second method is the method of plastic meditation, i.e., the object is irradiated, as it were, by the light of spiritual bodies; its earthly flesh is refined; it becomes transparent; matter begins to flow and to be transformed into air. Dali's *Ecumenical Council* and *Columbo* and my own *Celestial Improvisations* offer different versions of plastic situations of this kind.

In other words, *the invisible* is taken into the arsenal of the *realia* of representational art.

So what is the main objective of *metarealism*, a new shoot on the main, semantic branch of the great tree of art, which from the very earliest times has been known as "intelligent art"?

It is to make explicit the features of eternity on the face of time; the dialectical antinomy of statics, as the plastic indication of eternity, and the dynamics of lines of force having the leitmotif of the Divine Vertical, as the plastic expression of spiritual becoming and life.

I am not a painter of things but a painter of *ideas* (in the Platonic sense of the word).

I recognise painting as *language* irradiated by the light of the Heavenly Word, for "in the beginning was the Word".

I consider that painting has taken a new step forward, qualitatively speaking, for it has drawn into the representational sphere much that has hitherto been regarded as unrepresentable and, furthermore, much that is important as a matter of principle in the spiritual sense. Many new plastic horizons have been opened up.

I consider that in the semantic branch only the realistic method of representing *realia* can exist, for here, always, the subject depicted is superior to its creator, and in the process of its re-creation it is the subject which dictates and governs its own re-creation; the artist merely plays the role of instrument, workman, medium: ". . . My will be done . . ." Any genuine symbolism is no more than an outline, a first attempt, a temporary state of vision in progress.

Contemporary metaculture, which is now being born in the interaction between cultures of the past, successor and heir to the Great European Culture – which has brought with it a profusion of meta-sciences – has also bestowed upon the science of sciences, art, its meta-method.

So – forward to light and joy! Not colour-painting, but *light*-painting!

The way ahead has been indicated to us by the prophets of modern times – Dostoevsky and St-Exupéry.

Painting is the discovery of a subtlety, depth and perfection hitherto unparalleled, thanks to new plastic possibilities in the dematerialisation of the objective world, and this is an extraordinary qualitative leap forward towards the perfection of its language. As for the rest – he that hath spiritual eyes to see, let him see!

Lev Kropivnitsky

I was born in August 1922. And almost the first thing I remember are the huge Cubist canvases of my father and the water-colours of my mother – warm, lively portraits. And after that a continuous stream of painting, poetry, music in our house, conversations about art, artists, poets.

In the 1930s came museums, exhibitions, reproductions and books on art. At that time I did not have to make an effort to understand and accept Kandinsky, Malevich, Picasso and Blok, Pasternak or Khlebnikov. Everything flowed into me of itself, it was all self-evident.

However, when I entered the Moscow Institute of Applied and Decorative Art in 1939, the study of nature became my main concern. I could never shake off the feeling that it was essential to become a complete master of the techniques of the craft of painting.

1941. The army – military school – the Voronezh, Stalingrad, Kharkov fronts. The spectacle of suffering, cruelty, death. Marches, attacks, reconnaissance. Injuries, hospitals, operations.

1944. Moscow again, the Art Institute. Life again – or so it seemed. But worse was in store: after a trumped-up charge – nine long years of Stalin's concentration camps. Ukhta. Balkhash. The suppression of individuality, scorn, hunger, humiliation, back-breaking toil. Death always close-by.

And art departed from life. Even from memory.

It seemed to be the end of everything.

1953. 1954. The reforms began. The resurrection began.

It was a time of psychological cataclysms for many. For me it meant a return to art.

But I had changed. And my art could not remain as it was before. My spiritual world was still in a vice. I had to liberate myself from within. This can be difficult. But art whispered to me the means of liberation. The means was art itself.

The whole oppressive, gloomy world that I had experienced cried out to be put on the surface of a picture. But, of course, my former naturalistic style of painting was incapable of expressing this. I suddenly saw that only abstract painting – emotionally more comprehensive, more personal, in essence more realistic – could do this.

In 1954, in the sands of Kazakhstan, at first still behind barbed wire, then in exile, I began to create myself anew.

I had no information whatsoever about what was going on in world art. I knew that Cubists, Futurists, Suprematists, were a completed cycle in the history of painting. To repeat the past is meaningless. I had to make the future.

Much later I saw to my surprise that in my first works of that time I had not been so far from what was being created in the outside world.

Rehabilitation. Back to Moscow. But almost completely isolated. No one then understood the language of abstract art.

And I underwent a transformation.

The business of the artist is art. And only art. Teaching, propagandising, laying down the law, is not his business. This I knew. And know. All activism is alien to me. Even inimical

But then: could it be that I alone delighted in this perception of a new art? What about others? They were indifferent.

One must not be an egoist. Let others be happy too!

And so I arranged viewings and exhibitions. Discussed, argued, tried to persuade.

But all the same – the main thing – I painted. Painting comes first.

My relationship to art is always active. The way in art is always movement. In military service marking time may well be justified. In art it is not. At least for me.

What is this way? After all, many years have gone by.

The condition "MYSELF AND ART" is for me the only one. I know no other.

There are two periods:

THE FIRST – OF FORMAL POSSIBILITIES – from 1939.

THE SECOND – OF MY OWN RELATIONSHIP TO THE WORLD – from 1954.

The First Period

The artist is master of his art. HE creates it. HE is responsible for it. HE does what he wants to do. And HE must know how to. Otherwise the artist is not master but slave. The slave of his own inability, of his own irresponsibility.

The artist is master.

When he traces thousands of leaves on a tree one by one, this does not mean that his will is crushed by the aggression of a fatal conformity to natural laws. The artist is the master of fatality, if he is master.

When he throws a pot of paint over his head and the paint spreads over the canvas behind his back, making new forms, this does not mean that his will is crushed by the aggression of chance. The artist is the master of chance, if he is master.

I strove to be a master because I do not believe in art which can do without mastery. I learned to do exactly what I wanted.

The Second Period

Time passes, a person changes. Physically and spiritually. Older in years. More experience. Knowledge accumulates. The body often grows weaker.

Inner strengths sometimes revive. A new attitude to old truths. Some things disappear from view. Some things become more visible. Almost everything looks different.

And the work of the artist does not remain the same. It is a part of its creator: the main part. You cannot separate them. For the artist life is art, and art is life.

This explains for me the natural logic governing the fate of my second period, beginning in 1954.

The fate of man, the fate of the artist, the fate of his work, form one whole. The cycles of art correspond to the cycles of life.

There are three of these cycles – "a", "b", "c".

Cycle "a"
The time – 1954–7.
The place – Kazakhstan, the concentration camp, exile.
– Moscow, the first years.
The painting. Self-enclosed composition striving towards infinity. A two-dimensional spatial environment. Slack, drifting movements of curved forms with a hint of biologicality. Black, black, black. Grey, bluish, greenish, brown. Smooth lacquered surface. Painstaking sharp-edged studies of form. The tools – brush and then aerograph. Canvas, oils. The use of the aerograph gave the greatest possible evenness to the paint surface. But it was this which, by destroying the two-dimensional world, killed this cycle.

Cycle "b"
The time – 1957–62.
The place – Moscow.
At first the same forms. But not for long. They fetter freedom of movement. The hand makes a sharp stroke with the palette-knife. The harmonious curves of the painstakingly drawn forms are destroyed.

Before, a limited space was created by rational drawing; then it was filled with paint.

Now the moving pigment gives birth to pattern, form, colour – all at the same time. The paint is put on energetically with a palette-knife. It flicks out from the air, spatters, splashes out with force, flows freely across the canvas. The paint is always moving. Quickly.

One session. The size of the canvas does not matter.

The spontaneous method – the "emotional outburst". Consciousness switched-off. But there is concentrated and meticulous supervision.

And here is the picture. In terms of composition – a fragment torn from an active environment rushing in various directions. An infinite number of shifting planes. The swelling vibrations of the resonances of intense black and glaring white. The sharp conflicts of colliding colour masses in moving conglomerations. Shining accents of colour are interspersed with structurally dynamic grey blocks. The torn but distinctly drawn squares and rhombuses of palette-knife daubs, the jerky strokes of the hard, wide brushes. Impetuous, fine stripes sweep across the fluorescent material. Diagonally. Or from top to bottom.

There was a great stored-up need for spiritual liberation. Only after painting more than three hundred canvases did I begin to exhaust it.

Cycle "c"
The time – from 1962 on.
The place – Moscow.
For some reason, drawing first. Indian ink, watercolour, engraving.

Distinct figuration – faces, faces, faces. My

Lev Kropivnitsky
118
COMPOSITION 19?
Oil on hardboard
68 × 40 cm
Private collection

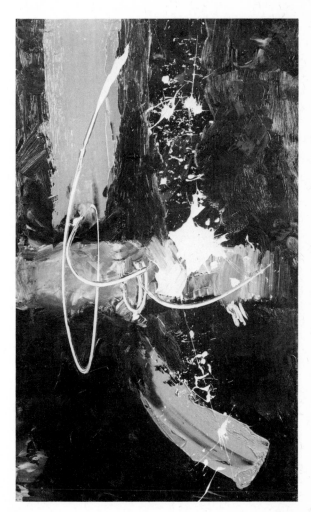

painting remained as before. I did not understand why this was. I became alarmed. It seemed I was splitting in two. This was not so. Simply, the old was growing weaker. Something else had to take its place. And it was coming in on the sly. I could not consciously, suddenly change my painting. Drawing was at that time somehow less crucial for me. And it turned out to be a loop-hole.

And so, unexpectedly, a merging took place. It was almost imperceptible. And when the bastard form appeared, I did not immediately understand *what* it was. A synthesis of drawing and painting!

Clear-cut, almost poster-like faces, front-on, passed from my sheets of paper to the canvas. Somewhere there remained the former daubs of the palette-knife. Somewhere those same people's faces or animal masks had become crudely textured. Almost in relief.

Black disappeared. White disappeared. All the bright colours disappeared. The contrasts disappeared. Everything became soft, greyish. But colour was everywhere. Muted. Absorbing itself.

And there was still light. The fickle play of light in the relief. The relief was freely worked with the palette-knife. An almost chance play of light.

And here is another kind of play. The twisting and vibration of clear-cut rhythmical forms of dark and light. Flowing multi-coloured checks, elongated rhombuses, uneven, concentric, complex shapes, neither circles nor ovals. Everything pulsates. The eye captures the shimmering in the movement of the unmoving. There is no chance at work here. Neither is there sharpness – the softness of the range of colour does not conflict with the clear-cut drawing.

And all this in a world of nothing but heads. Or even, rather, faces. Perhaps masks. Without bodies – face and soul. They are tectonic and almost monumental. Probably they are a little cramped in their severely enclosed space.

Again almost two-dimensional. Or perhaps three dimensions – but the first, the second and the fourth.

The means are varied as before. Even more varied. It is interesting to combine the uncombinable. I wanted to reconcile the old enemies in art – emotionalism and rationalism, naturalism and artificiality, the detailed nature of the study and the generalising manner of the form. How much can be drawn from their collaboration! What matter if one thing contradicts another – good relations are always firmer after a quarrel!

In this period antiquity suddenly revealed itself to me with special force. And not only painting, but also architecture, engraving, applied art. And all the details of Russian culture and the Russian way of life in the seventeenth and eighteenth centuries. I was captivated by the pagan traditions preserved at that time with their personification of natural forces and their humanisation of animals.

Drawing, engraving, the sketch, water-colour are for me no less important than painting.

My favourite artists are Leonardo, Breughel, Callot, Watteau, Munch. And from among Russian artists – A. Matveev, I. Nikitin, Vishnyakov, Rokotov, Chemesov, Bryullov, Somov, V. Grigorev.

(From the archives of Alexander Glezer, Russian Museum in Exile, Montgeron.)

Victor Kulbak

I am very interested in light and the surroundings in which it spreads. Now I am working with surface and space which are part of this problem – the problem of light. But I get more and more interested in light itself and less in its consequences – space and surface.

Now about visual perception. I feel that the work must not get stuck in the eye. The impression of the work must not remain merely on the surface of the eye but should penetrate much deeper. Only in this case can a feeling of catharsis be created – the most valuable sensation in art. I believe the work of the artist consists of the cultivation of beauty, which we all need so much today and which we destroy so cruelly – too cruelly. Even the brushes, paper and canvas with which the artist works, all this was in the past, flowers, trees and animals. We disturb the balance between the beautiful and the ugly in the world. Maybe the artist was created by nature especially in order to restore this balance? I don't know. In any case this is a mission that would suit me.

Lydia Masterkova

Is it necessary to speak of the anguish of the Russian? Of the depth of his thought? So much has been done in art. So many pictures have been painted, so much music of various kinds has been composed, and so on. But there are inaccessible and accessible summits – this is my credo.

To create, at the same time destroying. A feeling of the extinction of the planet, moral perfection – does this lead the artist to the summits? Does it lead him to find his own path, does he become an in-

dividual? A constant feeling of the great strength of the universe, or, if you like, of fate, fills the consciousness and becomes an inalienable part of existence. All through the inner world.

The essence of a work of high art is lofty spirituality.

The lofty aristocratism of art.

The influence of society in the case in question – isolation – is the tragedy of the Russian. Outside society. There is no feeling of the real world. There is only one's own world.

New forms. Contemporary music. Dostoevsky. The sphere of man's sufferings. MARINA TSVETA-YEVA. PASTERNAK: "The noise is stilled, I come out on the stage..." (Hamlet).

The manifestations of life. The first stroke of the bell, the Gregorian chant, the touch and flight of the violin bow, again music, the fusion of the German language with the great creations of the German composers, J. S. Bach. Sensibility scaling the heights. HEINE.

All through the inner world. All through oneself day after day, all the thoughts, movements of a microcosm aspire to the crowded canvas.

Humaneness. Love for everything which walks, flies, crawls.

A continuous spiritual creative process which Berdiaev spoke of. Was Goya humane? EL GRECO? REMBRANDT? Humaneness – like a higher spiritual creative process. The art of BENVENUTO CELLINI possessing outward qualities? All through man. The understanding of the beautiful past and the escalation of the present gives birth to a different attitude to the object. In part, to man. Should one exclude contemporary man because he is terrible in his aspirations? I do not think this is the thing that pushes one to the path of abstract expression. The cast of thought is abstractly directed. Everything is as if weighed up. But it is not a feeling of weightlessness, no, rather a striving upwards to that which is inaccessibly real – the real and abstract. The striving for the beautiful is not of the present, but it is an essential component of contemporary work. If everything comes through the spiritual image it is an inalienable part of the creative process in spite of the infinite variety of abstractionism. Whether or not this promises success has no significance. Dilettantism does not come into it . . . Much has been

Lydia Masterkova
119
COMPOSITION 1969
Oil and canvas collage
105 × 95 cm
Alexander Glezer –
Russian Museum in Exile

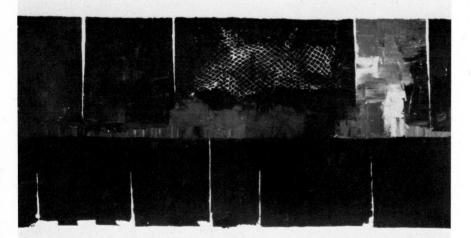

done in the twentieth century, although more than once a transvaluation of values will take place, but will there be time for this?

In my present period two colours predominate: white and black, with modulations of violet and blue. The intersection of the surface, the cleaving of the surface. The inner paths are complex. In order to achieve powerful expression, contrast, an infinity of creative thinking is required, and years of work.

An understanding of classical art. The expressive power of ZURBARÁN. The incomparable individuality of EL GRECO.

My path is as though from CÉZANNE to EL GRECO to abstract expression.

At times it is difficult to make out why you go along one path and not another. The artist is alone in his aspirations. And often he accomplishes a miracle and no force but chains can stop this aspiration in him.

(From a letter to Ernesto Valentino, 14.12.1969.)

Vladimir Nemukhin

I have painted ever since childhood, but I did not adopt a conscious attitude to my work until 1943, when I met a pupil of Malevich's, a marvellous man and artist, Pyotr Yefimovich Sokolov, who gave me my first serious ideas about creative work as a whole. It was at his house that I read my first books on art. I was particularly impressed by Seurat, Cézanne and the Cubists. Without fully understanding any of these schools, I literally mixed Cubism with pointillism, and my first still-lifes were piles of boxes painted in pointillist style. Gradually my understanding of Cubism deepened. I developed a wider grasp both of this school and of Constructivism. But I was young and inexperienced and for a long time I was tossed from one direction to another – from Seurat to Cézanne, from Cézanne to Malevich.

Later I enrolled in the evening section of the All-Union Central Trade Union Council Art School, where I studied for three years. During those years my accomplishments grew, thanks to my work in the life class, but as I worked on landscapes from life I became less and less enthusiastic about Cubism. Environment played its part too. Not a single one of the students painting around me depicted objects outside the context of their literal purpose in life, in ordinary, physical life. If it was a table, it was placed in a room and not in some space of the artist's own invention. Thus it came about that under the influence of my work from life and the atmosphere of my surroundings, by the end of the Forties, Cubism and my other youthful passions had been cast aside.

I was painting in a manner that had nothing in common with either Cubism or Impressionism. Perhaps my old enthusiasm did continue to play a part and was somehow reflected in my pictures, but there was no direct connection. It was only in 1956 that my acquaintance with Rabin and his first experiments revived in me the memory of my beginnings and made me reappraise the entire course my work had taken. The International Exhibition at the 1957 World Festival of Youth and Students in Moscow finally convinced me that I needed to

revise my creative attitudes and that I ought sincerely to regret that I had not continued along the course I had commenced in 1943.

In the pictures displayed at that exhibition I recognised myself and my youthful aspirations.

In 1957 I did many sketches and drawings of a Cubist-Constructivist type, where the same landscapes and still-lifes took the form of figurative abstractions. By now trees were already playing a more plastic rôle. At times the combination of objects was quite whimsical and without any logical connection. In 1959 I did my first abstract work in oils. It too was based on landscape principles. Light as reflection, as contact, as the blow of hammer against anvil and the recoil. Light falling on the ground and travelling back up to the clouds, through a mirror-like river refracted in the path of these two impulses of light. From 1959 to 1962 I painted pictures in the spirit of abstract expressionism, and at the bottom of it all in my subconscious there lay the experience I had gained earlier. In other words, my palette was guided by the experience I had gained in my landscape work.

Later on I felt a need to return to concreteness. It happened after the 1962 French exhibition, where I was as enraptured by Hartung and his absolute "I" as I was by Soutine and his absolute "I". What was the connection between them? It is said, after all, that Hartung is an abstractionist of the first water. I believe, however, that pure abstraction simply does not exist. What is it? Nothing? No. It is the artist's world and hence no more an abstraction. I believe that abstract painting makes a man develop new notions about the world in which he lives. Nevertheless, the stimulus provided by Soutine was not wasted. I pondered more and more often on the object, since the presence of an element of figuration that would play an active rôle in the picture had become essential to me. For me it became associated with the resolution of exclusively professional problems which are of paramount importance in my eyes: problems of plane, composition, technique, the definition of the very meaning of the concept "picture". Without dis-

regarding the experience accumulated by many generations of artists, I wanted to discover something of my own.

It is interesting that self-discovery may result from the most banal incident. Take Malevich's famous *Black Square*, for example. It is probably the acme of abstract thought, yet the artist Khazanov claims that Malevich himself used to say that the source of his inspiration for the picture had been a schoolboy with a black satchel running against a background of white snow. Something similar happened to me too when I saw some playing cards on a beach, scattered over the sand. Cards are trivial objects, totally banal, shallow and conventional in themselves. I wanted to work with these objects precisely because they possess no weight and are so banal. Yes, they are part of a game, but they have no significance in life. They are not spoons, tables, forks, that is to say, they are not concrete objects. I repeat: cards are a convention.

When I saw those cards on the sand in 1963 I made a sketch and began meditating upon it – upon its plastic, compositional and even literary features. Take, for instance, the knave of diamonds. I suddenly recalled the "Knave of Diamonds" group of artists and thought: surely that's why they adopted the name, because the knave of diamonds is coloured blue and red and the combination of blue and red gives off a very powerful emotional charge. I picked up the cards, stuck them in the sand and painted them from life. And the combined effect of the pink sand, the sunny day and those cards generated in me an entirely different notion of colour and plane.

Back at home my wife was playing patience on a Karelian birchwood table, and the combination of the cards and the texture and colour of the wood, and the rhythmical movements – the cards neatly dealt, organised and casually shuffled – all arranged itself into geometrical shapes on my canvases, where every card had a definite place and went to form an integral group. In this way I discovered my subject; and I have worked on playing cards ever since. I have never put into my cards anything I did not see or had not heard of. Cards on a table, on a varnished box, on a river bank, on an animal skin – these are not inventions. They are things I have seen or been told about.

It is curious that even in my modern work with cards I eventually came to landscape – not in the literal sense but subconsciously. For instance, the colouration of a picture is determined by when I paint it or put the finishing touches to it: in the daytime or in the evening, on a sunny or an overcast day.

I am sometimes asked why many of my cards are torn in pieces. Torn objects are not exclusive to me. Few artists are satisfied with a whole object in its whole state. It simply has to be pulled apart. This,

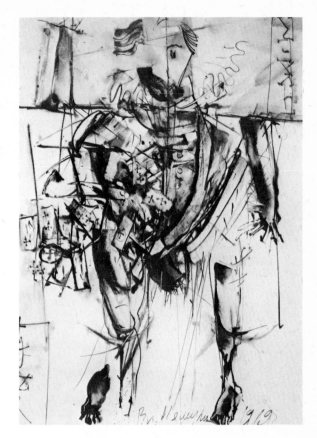

Vladimir Nemukhin
120
THE BLUE JACK 1969
Mixed media
55 × 42 cm
Private collection

to my mind, is connected with a subconscious, inner protest that demands dynamism, an antistatic condition. When you break up an object it acquires greater dynamism and tension. This is why you will observe in many pictures objects that are torn, shattered, crushed, crumpled or vigorously distorted. It all stems from inner protest, disquiet, uncertainty about the morrow, unease. For some, this protest is associated with their personal fate, for others it is of a social nature.

(From the archive of Alexander Glezer, Russian Museum in Exile, Montgeron. Recorded conversation with the artist.)

Oscar Rabin

In my pictures I express as fully as possible those moods and sensations that it is possible to express with the aid of painting. In a certain sense my works would be my diary if I were a writer. In them I transmit my impressions of life, but, of course, coloured by my mood, that is to say in a very subjective, very partial way. I am often told that my works have a social significance. I don't know. It is simply that so-called social moments are interpreted by me in the same subjective way, they influence my mood and condition and, naturally, are also reflected to some extent in my pictures.

My work can be divided into two periods: the early period – from the end of 1956 to 1962–63, and from 1963 to the present. Before 1956 I painted in the main from nature. Looking at it from a detached viewpoint, I came, as it were, by chance to the works which, strictly speaking, can be called mine. In fact it was hardly chance. Simply, in 1956 there was a jolt which was bound to take place sooner or later.

It was the time of that general move to the left which Ehrenburg called the "thaw". In Moscow they were holding exhibitions by young artists in preparation for the Sixth World Festival of Youth and Students. I took along some landscapes done from nature to show the selection committee for one of these exhibitions. I considered them quite good. However, they were examined with complete in-

difference and not one was accepted. I stayed to look at what other artists were showing and saw for the first time the works of Oleg Tselkov. At that time he was working under the influence of the late Russian followers of Cézanne. It seemed to me then that they were very flat, bright and primitively painted still-lifes: a flat piece of wall, a flat piece of table, and two or three flat circles signifying fruit. And of the five works which he showed, four works took them, as we say, "by storm". This surprised me somewhat.

Resentful, I went home and started to think: well, all right, if normal, honest, tasteful works from nature don't suit you, next time I'll bring something extravagant. Indeed, I looked through the albums of my little daughter, who drew very well on a childish level, and I took her tiny drawings done with crayons and enlarged them on canvas using a palette-knife. I took a whole series of such works to the selection committee. They were surprised. For an hour they discussed, argued, shouted. The works were bright, decorative and, of course, conventional. True, they did not find their way into the exhibition, but having started I could not stop. I was no longer interested in going and painting from nature. Literally at once I began transposing children's work and after a few pictures it was transformed into my own.

Fairly soon I understood that the free deformation inherent in children's drawing and children's vision gave me the opportunity to express myself very vividly. In my early work there is a lot of overt expressiveness and a lot of bright colours. Now there is almost nothing of this. The expressiveness gradually decreased, but not in a clear-cut, consistent way. Sometimes I returned to even greater expressiveness. At a certain moment, a year after I had begun to paint works like these, the deformation and distortion of objects almost went as far as the complete abstraction of these objects. I knew what I was drawing, but most people looked and saw nothing or saw little of it. Having painted several such pictures, I realised that I could go no further in this direction and I returned to greater concreteness, to greater, if I can put it this way, comprehensibility, because in this confusion I had lost contact with my public, which saw in my pictures, on the whole, abstraction – spots and lines. Also it was apparently in my nature to express myself through objects. This, it seems to me, is my strongest side. If my early works are more broken up, more fragmented, then later I began to pay more attention to the mood of the picture and not to outward expressiveness and the violent expression of emotion.

The themes of my pictures arise in various ways. I depict life through myself, taking objects and turning them into object-symbols, giving them a

Oscar Rabin
121
SELF-PORTRAIT 1958
Oil on paper
35.5 × 39 cm
Alexander Glezer – Russian Museum in Exile

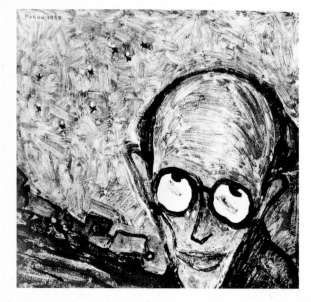

second meaning, a second function, in addition to the usual one which is characteristic of them in life. The addition of each new object to objects long since assimilated presents a problem every time. Sometimes this happens consciously, sometimes by chance. At times you stumble across an object which you have seen a thousand times before, thought about and even tried to draw. But suddenly, just like that, you see it in a different way, you see that additional meaning you can give it.

Take for example a version of my work *The Chemise*. I had seen these chemises drying in the bathroom a hundred, a thousand times. But for some reason a time came when I saw one chemise with different eyes. After this I could paint it. True, even before this I had put lines on which chemises were drying into my landscapes, but there it was only washing put out to dry. But now I painted the chemise from other points of view. It is not simply a piece of clothing which a person wears, here is a chemise presented not in its everyday meaning. I saw the sexual connotation which is perhaps contained in this piece of clothing – which I had completely missed before. Many objects pass before me every day. This tape-recorder here on which you are recording me or modern radio sets. And the telephone standing on the table! I often think about how I can paint it, how I can put its meaning into a picture. Today I don't know how. I have looked at many things for several years wanting to paint them, but I cannot imagine how to depict them so that they convey what I want, my moods. But perhaps tomorrow I will see them in a new way and be able to do it.

(From the archive of Alexander Glezer, Russian Museum in Exile, Montgeron. Recording of a conversation with the artist.)

Mikhail Shemyakin and Vladimir Ivanov

METAPHYSICAL SYNTHETISM
Programme of the "Petersburg" group, 1974.

[*The first of four chapters in the book.*]

1. God is the basis of Beauty. A drawing close to God means the highest tension in the existence of Beauty. A moving away from and forgetting of God means a weakening of the existence of Beauty.

2. Art means the paths of Beauty leading to God. The artist must always aspire to God. The power and viability of his style is determined by the extent of his faith. "As the branch cannot bear fruit of itself, except it abide in the vine; no more can ye, except ye abide in me." (St John, 15, 4)

3. Before the coming of Christ the canon was the most perfect embodiment of Beauty. After the coming of Christ it was the icon; as leaves are transformed into the calyx of a flower, so was the canon transformed into the icon.

4. When a flower fades, the seeds ripen and are scattered by the wind. So also in art, after conjunctive (synthetic) periods, there follow analytical periods, periods of the greatest possible deviation from the tension of the phenomena of Beauty, which lead to decomposition and the separation of form and colour.

5. The laws of art are the laws of Pythagorean numbers. These laws are in no way an abstraction, but the essences of life, recognised through intellectual contemplation. At the basis of the development of every style lie two triangles:

(i) The triangle is the triangle of form: the cone, the sphere, the cylinder; their complementary forms: the circle, the triangle, the square.

(ii) The triangle is the triangle of colour: blue, red, yellow; their complementary colours: green, orange, violet.

The hexagon is the symbol of the interpenetration and the unity of form and colour.

6. Seven basic concepts, like the seven spirits, govern the laws of form and colour defining the fate of every style, the length of its life; they also determine its legacy. These seven basic concepts make up the triangle and the square.

The square: Spontaneity. The demonic. Deformation. The absurd.

The triangle: The canon. The icon. The principle of unification.

7. Analytical periods dissipate that energy of form and colour which synthetic periods accumulate. Ultimately, a complete enfeeblement and decadence of the feeling of form and colour takes place. The hexagon disintegrates. The square triumphs. Art returns to darkness, chaos. Freedom is lost. Tyranny reigns. Art is no longer an embodiment, but a mask.

8. The Renaissance only possessed the power it did thanks to the extravagant and ungrateful dissipation of the treasures of the Middle Ages. The energy gathered in the Russian icon has remained undissipated until now. Using the analytical approach, that is, one which separates out the elements, it remains a tormenting enigma and an attempt to use it leads only to dead stylisation. The only way lies not in dissipating but in increasing the accumulated energy – in creating a new icon-painting.

9. The contemporary artist who examines the monuments of ancient cultures falls into a tormenting contradiction capable of damning him to total sterility: on the one hand he sees in the past an

unusual intimacy with his own quest, with his feeling of form, on the other, he is struck by the incredible gap between them and him, by their inner reserve and remoteness which stands in the way of any attempt at intimacy. This contradiction is determined by three causes:

(i) Forgetting the religious sources of style. Refusal to penetrate the pretersensual world of ideas.

(ii) Increased consciousness of the historical-chronological viewpoint – an arrangement which does not give a concrete scale for the measurement of the time distances between styles.

(iii) The resulting examination of style not as a form-producing force, but only as its ultimate and limited consolidation in the material.

The contradiction can only be removed in the following way:

(i) Through contemplation of styles as living organisms – in the unity of idea and material.

(ii) Through recognition of the basic law of the development of style as the law of metamorphoses.

(iii) Through the differentiation of styles according to religious principles:

 (a) Before the coming of Christ.

 (b) After the Mysteries of the Crucifixion.

10. Two kinds of contemplation of the metamorphoses of style are possible:

(i) Mythological (style as myth).

(ii) Morphological.

Morphological contemplation is in the spirit of the further development of Goethe's views on natural science. "The leaves of the calyx are the same organs as were hitherto visible in the form of stem leaves, but then, often in a much changed form, they turn up and gather around one common centre."

11. From the first method of presentation it follows that the origin of style is cosmogonical. The styles themselves are deities, "souls". The basic thing is the contemplation of the transformation of chaos into harmony, and then the inevitable disintegration of harmony into chaos. Form-producing forces collide with each other like gods and Titans. As the Titans were plunged into Tartary, so Greek antiquity conquered Eastern irrationalism, demonism and spontaneity. Orpheus.

12. From the second method it follows that styles are the pure, self-propelled movements of form and colour. Here it is not deities which are contemplated but pre-phenomena, ideas. The very styles form of themselves something whole – an absolute world. Each style presupposes the existence of another. Everything is organically interdefined and conditioned.

13. Form and colour for the second method are the same, whether as the object of study or the means of symbolising knowledge.

14. In its understanding of the number, meta-

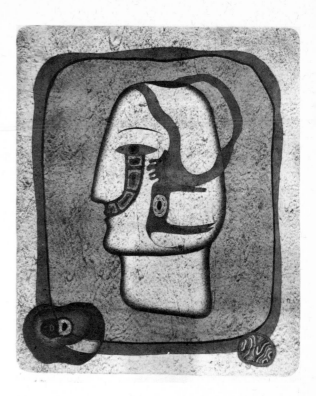

Mikhail Shemyakin
122
FROM THE CYCLE "METAMORPHOSIS OF THE HEAD"
1971
Lithograph and mixed media
Private collection

physical synthetism follows Pythagorean occult mathematics. If for the contemporary mathematician the number 3 is expressed by a segment of straight line with three equal divisions, then for Pythagorean mathematics the number 3 is a triangle, the symbol of the divine and perfect unity. All the numbers quoted in this book should be understood from this point of view.

15. The tension of Being in this world cannot be conveyed by simple mirror-like reflection. In reflection there is no tension. The job of the artist is to lift form and colour to the highest degree of tension. In analytical art this is called the principle of wholeness (Filonov).

16. The highest tension of form and colour is attained by styles originating in the principle of symbolisation. They achieve the maximum accumulation of energy. The model for this is ancient Egyptian art. A second kind of style is inspired by the naturalistic principle. In the first case God is felt in oneself, in the second, God is found in the world. The basis of the naturalistic principle is perception. It is possible to reproduce naturalistically a vision of the pretersensual world.

Only when the pretersensual world is embodied as a symbol is the icon born.

17. The symbol is a combination of the uncombinable. The following types of symbolisation exist:

(i) Astral-occult.

Each combination of the uncombinable is conditioned by the constellations contemplated in revelation. Fantasy as such plays no part here. All the means of symbolism are beyond arbitrary rule, they are canonical, holy. The Sphinx.

(ii) Rosicrucian

Esoteric Christian symbols as the basis for the combination of the uncombinable forms of the external world. At this stage a considerable degree of freedom is achieved. The artist relies more on his inner experience, using occult knowledge for the expression of his own pretersensual experiences. At the same time, for the depiction of the realms of the other world into which he cannot yet climb, he uses the description of the experiences of the Great Initiates. Such works no longer appear to be the objects of a cult. Bosch.

An example of symbolisation is the panels of the triptych, The Garden of Heavenly Joys: the realm of the pretersensual world is depicted, through which pass the souls of the dead on their way from death to birth; in the centre of the panel is the "man-tree"; its extremities – shrivelled branches – signify the loss of ethereal powers, its steps are two boats "without rudder and without sails" which wander over the waters of the nether regions of the other world. On the head of the man is a millstone; on it march demons which have taken possession of the soul of the dead man in the course of his life on earth: the Bear is the symbol of anger, the woman of voluptuousness, the purse of miserliness. In the middle of the millstone are huge bagpipes, the symbol of the tongue of this man which has fallen victim to Arimanic numbness.

(iii) Surrealist

Freedom of the imagination turns into demonic tyranny. Idolisation of the subconscious. Automatism of creation. The artist avoids trying to provide a basis for the combination of the uncombinable: the arbitrary symbolisation of tyranny. The incestuous introduction of the naturalistic principle into imagination. Salvador Dali: "The difference between me and a madman is that I am not mad."

(iv) Nihilistic-absurd

The principle of the simple anecdote. The symbol is no longer the voice of the subconscious but the voice of Nothing: speaking from the foundations of the world and speaking as a foundation of the world. The interpretation of the symbol, unlike surrealism, is not impossible, but it is not necessary, for everything leads to Nothing. Being thrown into Nothing. Kabakov. Black comedy.

(v) Metaphysical synthetism

This is examined in the last chapter of our book.

18. Form is one, but the creative processes of its embodiment are not one. In the twentieth century the birth of a new type of creative consciousness is taking place: those processes which earlier played in the subconscious and superconscious regions of the soul are now – thanks to the power of the "I" – boldly introduced into the realm of the conscious. The artist is no longer a holy fool. He is a creator, a friend of God. The degree to which he is permeated by Christ's impulse determines the degree of consciousness in his work.

19. The icon is the most complete and perfect form of the revelation of Beauty in the world. ALL THE EFFORTS OF THE METAPHYSICAL SYNTHETISTS ARE DIRECTED TOWARDS THE CREATION OF A NEW ICON-PAINTING. FROM PICTURES TO THE ICON.

20. Art renouncing Beauty is Eros. The artist creates harmony only through his love of Beauty.

Boris Sveshnikov

My work falls into two periods which differ strikingly. The first was my labour-camp period; the second began after my release.

In the camp I found myself as an artist immediately and was perhaps even more of a whole then than I am now. There my art was utterly free. I worked as a nightwatchman in a woodwork shop and spent my nights painting. I received my bread ration. Nobody controlled me and nobody took an interest in me.

For several years after my release I was unable to rediscover myself. I could no longer work as I had worked in camp, since that had been a certain period of my life which was now over. As an artist I am very closely bound up with life. I don't just paint for the sake of it, I don't just paint something abstract. Painting, for me, means experiencing reality. Of course, this reality undergoes a transformation and appears differently on canvas.

When I set about painting a picture I do not know exactly what the final result will be, because the main thing for me is the process of painting. I have an idea of sorts, not so much visual, one might say, as emotional; I know that I intend to paint a fallen leaf, for instance, and not a human face, in other words, I have a design, but I do not know what form of expression it will take. I don't know what the leaf will be like and how it will fit into the canvas. I just have a feeling inside about it. But a vision which is a mental image cannot be given an absolutely

accurate embodiment. It is transformed as it is embodied. I never do sketches beforehand either. I used to try doing them, but I invariably arrived at something different in the picture. I still feel that a sketch simply hampers me and paralyses my intention.

All my ideas spring from the daily routine of my existence. From day to day I live by observations, reflections, feelings, and thoughts and visions occur to me which I embody in my pictures. Somehow I cannot live without doing this. These visions occur spontaneously at the most unexpected moments. Sometimes it is when I am out walking. Sometimes when I am painting a picture, the motif for my next picture suddenly occurs to me. For a long time

afterwards I relive whatever it was that I suddenly saw then and which has engraved itself so deeply on my memory and lives within me. Then the moment comes when I say to myself: you must get down to this picture, it has to be painted. This is the beginning of the embodying period. But in general these periods are indivisible, since the art of painting is not the illustration of what one has seen. You don't just see something and record it, ever. The process of painting is a difficult process, a very private process . . .

(From the archive of Alexander Glezer, Russian Museum in Exile, Montgeron. Recorded conversation with the artist.)

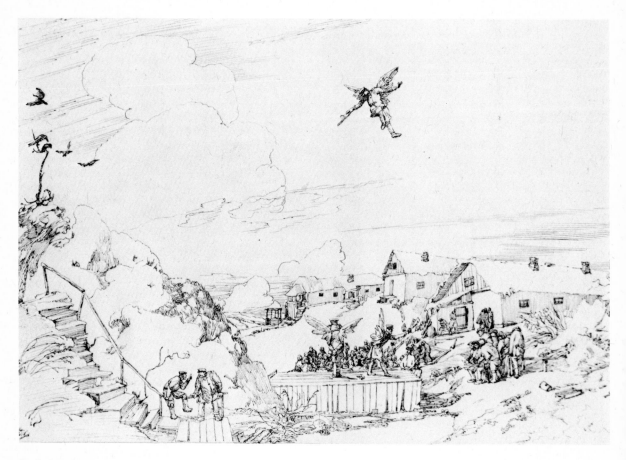

Boris Sveshnikov
123
ANGELS 19?
Indian ink on paper
27.5 × 39 cm
Private collection

Oleg Tselkov

In 1960, for the first time, I painted a canvas with two strange, pinkish-white faces. Suddenly I had a feeling that there was something in those faces, that I had found a path I could continue to travel. I had seen a large number of Malevich's pictures in 1958 in the storage cellars of the Russian Museum in Leningrad, and I was very much influenced by him. What I like about Malevich is the astonishing completeness of his plastic art and, most importantly, his extraordinary precision. One has the feeling that it is as if he subsumes all his emotions into an apparently very simple formula. Without losing or rejecting anything, he manages, figuratively speaking, to express the most profound emotional idea in a couple of words. Malevich taught me simplicity.

Later, when I was searching for my own path, I chose, or at least tried to choose, simplicity. I used essentially extremely simple compositions, extremely simple colours which contained no sham significance. I made every effort to discard what artists generally term painting, everything that was so noticeable in Cézanne and the Impressionists – complex, obscure use of colour and a generally impressionistic, indeterminate attitude towards the subject of the picture. I wanted definition. This is how I came to simple, curved lines and simple colour. But, as well as avoiding indeterminateness, I wanted to make my colour bright and utterly intelligible. It sometimes happens that people mumble nonsense and we may suddenly, if we listen closely, discover that there are some apparently intelligent ideas hidden in it. My aim is that if I do have any intelligent ideas, they should not be hidden, but should be on the surface and clearly visible.

At first I was less interested in saying a particular thing than in finding a simple formula to express my philosophy of life. I was eager for maximum laconicism, maximum definition – two or three colours, elementary lines. But it all had to have sufficient emotional depth and a single meaning.

The painting of the pink faces was a kind of illumination and marked the beginning of a ten-year period which ended in 1970. My work from this period contains a great deal of the social element. But I never tried to make any specifically social comment, in the way Rabin does, for instance. I tried to make my social attitudes "universal", to create works that would have the same impact everywhere, whether in my own country, in America or somewhere like Guinea.

My social model is not of a citizen of a particular country but of man, and not only man today. It is, so to speak, a social model of the whole of mankind as I see it. People say that my model of mankind is spiritually deformed. I would put it otherwise: spiritually immature. Then they point to Einstein,

for example. But that is not the sort of mankind I mean. People like Einstein, in my opinion, are freaks in relation to mankind as a whole. Although we usually apply the word freak to monsters, in this instance I am calling a genius a freak, because if the whole of mankind were on Einstein's level there would have been no outrages such as war for a long, long time. A race of Einsteins would not have gone to war.

But then let's take Einstein. There were people like him in the remotest times, yet mankind is still incorrigible. Consequently there is no point in doing as the Einsteins do and shouting at mankind: come to your senses! It is no use. It is like shouting at dogs and cats to come to their senses.

I am often asked what my attitude is to this mankind: do I pity it or do I despise it? My answer is: neither. It exists objectively for me and despite its immaturity it is the personification of physical life. My attitude is therefore one of a sort of strange rapture, rather like, say, the traveller who gazes on the mighty eruption of a volcano and exclaims: "What a wonderful sight!", although he finds it rather terrifying. To me, mankind is just that – a volcano which, although it wreaks destruction on surrounding nature, possesses, in its own way, by virtue of its immensity, something that is not exactly beautiful, but . . . something whose power cannot be denied, and consequently, something which it cannot be denied possesses a certain beauty.

The people in my pictures are indestructible, utterly indestructible, and will live for ever; there is no power that can wipe them from the face of the earth. That is why their typification is so vague. It is impossible to say what race they belong to. They are clearly not Negroes, but they have a great deal of the oriental about them. Someone has said that they represent "some kind of tribe, some clan, some new nationality". Personally I would like to think they represent the whole of mankind.

Naturally, they possess some indication that they have had a rather stormy, tragic life, despite the fact that they are powerful and unbending. It is because they have no scalp, as though all their hair had fallen out after an atomic explosion, and they have teeth missing . . . But notwithstanding all this, they feel that you are not their equal. That is why they gaze at the spectator as though pushing him away: "Don't come near us! Don't try to teach us, fool, we know everything for ourselves." They have small foreheads and heavy jowls. Those are signs not of feeble-mindedness but of brute force and firmness.

After 1970 I suddenly realised that I no longer wished to talk with people in the language I had previously used. Now I wanted to retire into my shell, or something of the sort, and I turned my

characters round so that spectators were confronted with the bare, clean-shaven backs of their heads. What their jowls and their eyes were like was unknown. One could see that these were powerful characters, but the features that had previously been the focal point of my canvases – their faces – were now invisible to spectators. I myself lost faith in those faces. Then, later, I returned to them; but now they are very indistinct and ill-defined. It is the kind of thing I used always to refuse to associate myself with.

(From the archive of Alexander Glezer, Russian Museum in Exile, Montgeron. Recorded conversation with the artist.)

Vladimir Weisberg

A CLASSIFICATION OF THE BASIC MODES OF COLOURISTIC PERCEPTION

The author's research in painting is based both on a study of the European masters and on self-observation in the creative process. The report is constructed according to these two divisions.

(1) Research into the European masters of colourism has led the author to the conclusion that before Cézanne colourism was more a quality in the talent of individual artists (El Greco) or of small groups (the Venetian school: Titian, Veronese, Tintoretto). Only after Delacroix was colourism gradually placed on a scientific basis and only with Cézanne did it finally become an absolute formal problem (the study of the arrangement of colour structures).

(2) The basic modes of colouristic perception and the corresponding realisation of their pictorial structures in composition and drawing (see table).

Table

Studies in self-observation for pictorial information	Studies of the masters					Studies in self-observation. Bio-mechanics. Method.
	Modes of perception	Absolutes	Pictorial structure	Composition	Drawing	
Momentary (short) information	Sensual, 1st signal	Matisse	Large spots of colour	Colour pattern (decorative pattern)	Silhouette	Comparison
Prolonged information	Analytical, 2nd signal	Cézanne	Construction (structure of large spots of colour)	Archi-tectural, Cubist	Constructive sphere, cone, cube	Comparative analysis
Infinite information	Sub-conscious, 3rd signal	The greatest periods of creativity in many painters, usually at the end of their life	Non-recognition of the colour pigment of large spots with complete arrangement of their construction	Balance between recognition and non-recognition; non-recognition as the composition of the structure	Plastic de-formation, changing of proportion, emphasis on non-recognition	Automatism (1) Children before maturity (2) Landscape painters in quickly changing conditions of nature (3) Experience and direction of old masters gives birth to automatic freedom

Vladimir Weisberg
124
STILL LIFE WITH
FOUR CUBES 1975
Oil on canvas
47 × 49.5 cm
Private collection

Vladimir Yankilevsky

The problems which troubled me when I began my conscious life as a man continually fused with the search I was conducting as an artist: because this search was the search for a language capable of expressing my outlook. In my development as a man I was invariably compelled to seek a form capable of expressing my idea of the world. As my idea of the world became more complex I had to make the form of expression more complex, but also, perhaps, to simplify it. I am interested in man as a kind of cosmic being in the universe: not on the level of science fiction but on the level of the prime causes and effects of existence, with a desire to understand him as something in which both the male and female principle are present, attempting to comprehend how they are personified in the man and the woman and how they fuse in a single person who can be called man. And also I tried to discover how man in his change and development is continually reflected against the background of eternity. All my triptychs are constructed according to this scheme of things.

There exists a canon: the male and female are the source and the medium. The latter may be the earthly, cosmic or abstract landscape for some kind of active forces. This medium combines two extreme sources. Through it a dialogue, an interaction, is always taking place between them. The triptych is for me the basic form. I painted the first one in 1961. Since then each new triptych marks a stage in my development. The triptychs are filled with and enriched by my understanding of the world and what happens in it. And the problems which I explore are always existential or lyrically existential ones. My triptych No. 3 is thus called *Existential*. There are also *The Anatomy of the Senses* and *Adam and Eve*. These are all age-old themes. They interest me because they are at the basis of all phenomena. But I do not want to strip away the remaining layers of life and existence and lay bare only the primary sources. No! Through all these layers of life and existence, as when you look through water at the bottom of something, I try to see what overlays and covers these sources.

Not one of my triptychs has a literary theme and therefore they are difficult to read. The triptych does not develop according to literary canons, but is

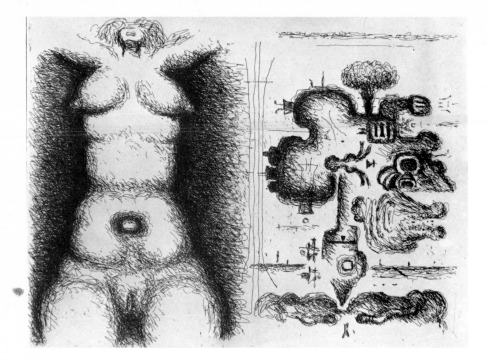

Vladimir Yankilevsky
125
FROM THE ALBUM
"ANATOMY OF THE
SENSES" 1972
Indian ink on paper
Alexander Glezer –
Russian Museum in Exile

126 *(right)*
FROM THE ALBUM
"CITY MASKS" 1973
Indian ink on paper
49.5 × 65 cm
Alexander Glezer –
Russian Museum in Exile

supported by those tensions and interactions which build up between the three parts. It is not three pictures united by the subject-matter but one picture consisting of three parts. Each is a link in a single dynamic process. Each triptych is a novel. The content is he, she and the medium. Everything which happens is codified by artistic means which the viewer can perceive to a greater or lesser degree, depending on the power of his emotional identification with the given theme and his general cultural level.

My first triptych was done in the traditional manner, i.e. a flat painting: oil on paste-board. It was the kind of painting which was behind the frame, on the other side of the frame. My later painting is different. I felt compelled to make what was happening in the picture more actual. I call this actual painting. I tried to drag the event taking place in the picture more to the fore, bring it forward outside the frame, so that the viewer looking at the picture might feel himself a participant in the event, might feel that the event was taking place not outside him, not over there, but here. It must make the same sort of impression on the viewer as a murder committed before him in his room. The picture must act just as aggressively and powerfully.

I began searching for a means of doing this, and came to relief painting. I don't need relief in order to create something like sculpture, but rather to rid painting of the dogma of occupying an exact place in space. Let us say I do a picture without locating a certain part of it in an exact position, as Cézanne did, at a distance of 20cms from the canvas, or 30cms and so on. I bring it forward and it loses its spatial orientation. It is suddenly dissolved. It is in a room, it is here, but we cannot define its position, i.e. it comes to life. It is there and here.

In my latest triptychs I have combined several problems. There is the aggressiveness, the actual event which is happening here, and at the same time the background is a classical (flat) painting. These are pictures which happen there, as if outside, but there is something immediate which is both there and here. This is a completely life-like situation. Here you are sitting in a room. We are talking to one another. I am actual for you. You can touch me. I really exist. And outside it is raining. You look at the rain as if it were a memory or as if looking into the past. Generally speaking, a look out of the window is a look into the past or into the future: but that is not here and now, it is outside. It is a diapason: me sitting in front of you, and what is taking place outside. At this particular moment this is your diapason of life. I try to introduce into a picture this diapason of experience. It can be personified. Instead of the actual source, the male principle can come to the fore in me in an aggressive form. Instead of the window, that which I call conditionally "window" or "there" as opposed to "here", can appear as a certain landscape, environment, a certain background for events in a place where the events can conflict, meet, happen. The female principle can exist simultaneously both there and here.

Work on the triptych is accompanied by the working out of all these themes in drawings. In these the male principle, the female principle, the theme of the cosmic landscape, can be examined

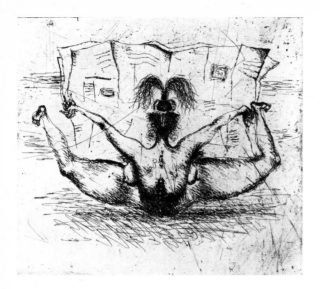

classify the basic groups of experiences in man. There is, for example, the experience "*I and He*", the experience of oneself and the experience of the man or object with whom you are carrying on a dialogue. This can be depicted in various ways: as an experience from within and as an experience from without. I never experience myself, so to speak, from without. I feel myself from within. But the artist also has the ability to penetrate into another person. He can experience that other as if from within. Therefore, there always exist two points of view on the representation of experience, from within and from without. This does not only concern "*I and He*". It can concern anything. I can turn into any object. I can, let us say, feel myself a woman and depict this, depict her experiences. Other experiences are, for example, the experiences of the head and the body, the experience of landscape, that is to say, the experience of oneself as part of a landscape or the experience of landscape as a part of oneself.

Another album of etchings, *City Masks*, is devoted to the problem of the destruction of the human personality as it ceases to live a conscious life and becomes a part of some mechanism. Neither album was made by chance: I had a great many human problems, in both the broad and narrow sense of the word, which could be expressed only in the form of a drawing or an etching. The albums are a personal working out of themes which can be introduced into the corresponding triptychs.

separately, not as a popular-scientific depiction of the sky with stars and a space ship, but as a landscape of tensions, a landscape of forces. In my album of drawings, *The Anatomy of the Senses*, the whole of my search is summarised. Here is an anatomy of the experiences of man, an attempt to express through man's attitudes, through human figures, the inner world of man. The album is preceded by five pages of introduction accompanied by commentaries. These commentaries describe and

(From the archive of Alexander Glezer, Russian Museum in Exile, Montgeron. Recording of a conversation with the artist.)

Yuri Zharkikh

In one way or another, all paintings are a reflection of what happens to us in life. The artist reacts to the slightest of events and the result of his reaction inevitably finds expression on canvas. All the stirrings of his soul evoked by external sources and outward circumstances are reflected in his painting. His pictures are, for the artist, a means of perceiving and comprehending reality.

My search in painting is in no way an attempt to find any formal progressions. I am searching for my life, for my attitude to life, for my philosophy and my own language in which to express all of this. One's own original thought must be expressed in an original language; there must be a fusion of language and thought. If I were to borrow the language, the result would not be art but its counterfeit. Language is the body of any painting and its framework.

In each of my pictures I am first and foremost expressing myself, my own attitude to reality and the influence of reality upon myself. A meeting of the two, as it were, takes place, and the painting is the record of that meeting. I want to record my own observations, my mental observations on life, my meditations. I meditate not only in my compositions but also when I paint portraits. If I see a person who interests me for some reason, I always want to paint him, because when I paint him I am talking to him, not in words, however, but "telepathically", or, to be more precise, "subconsciously".

I am not a passive observer. Nature, too, I view from the position not of an admirer but of one asking questions: to what end does it all exist, how does it exist, what place does this tree, for instance, occupy in nature, in the life of a human being, in his spiritual world? This is what interests me.

(From the archive of Alexander Glezer, Russian Museum in Exile, Montgeron. Recorded conversation with the artist.)

A Kinetic Manifesto

KINETICISTS OF THE PLANET EARTH!
TODAY'S WORLD: "I demand my own forms and
symbols!" In the 20th century TECHNOLOGY
has united ART with SCIENCE.
Man TODAY: "To everyone, absolute freedom of
imagination!"
IMAGINATION says: "Give me a new instrument –
and I will remake the world."
From the TREE OF SCIENCE springs many new
branches, from the TREE OF ART-FORM.
20th-century man.
KINETICISM – FRUIT of many branches.
NOT TO BE GRASPED ALONE. Even the strong,
if alone, are weak.
PRIEST OF KINETICISM – THE KINETICIST.
THE KINETICIST – this is one and many. He is –
both personal and collective.
THE WORLD SAYS: "MANKIND, if you are not for
yourself then who is for you? But if you are only for
yourself – what are you worth?"
TODAY'S WORLD: "Why is it people are not yet
united? Surely you have ART . . ."
TODAY – musicians, physicists, actors . . .
architects, psychologists, engineers, sociologists . . .
and poets – TOMORROW KINETICISTS.
A new quality in art is being born through the
COLLECTIVE. Together we make this art, which
alone it is impossible to do.

INTERACTION ⟷ INTERACTION
Artist Scientist and
Artist Technologist
= KINETIC WORK

"ENGINEER, what have you done for BEAUTY?"
"ARTIST, how are you perfecting the
INSTRUMENT of art?"
"WORLD, to you we offer an art of SOUL, MIND
and BODY."
KINETICISM – art that reveals the secrets of life
and transformation. Nearer and nearer is the era of
REAL ART, the time when all mankind will
understand through art. The era of KINETICISM
is coming.
KINETICISTS of the planet EARTH, in our hands
is the greatest spiritual task.
KINETICISM – not only is this a new form of art,
not only even a new aspect of art, but it is a new
relation to the world, to mankind, that has been
evolving over thousands of years.
Outside the man and without man there is no art.
We – are pioneers.
We unite the WORLD to KINETICISM!
TODAY'S man is torn apart, sick. "Man, are you not
tired of destruction?"
TODAY'S child – is already the cosmic generation.
The stars have come nearer. Then let ART draw
people together through the breath of the stars!

"PEOPLE, LET US CREATE A WORLD
INSTITUTE OF KINETICISM!"
Let kineticism bring life close to the world of
dreams and imagination.
We will push apart the horizons – let TOMORROW
see it. We will master a new language of the soul.
TODAY WE HAVE THE SEED – TOMORROW WE
WILL MAKE THE TREE BLOSSOM!!
TODAY WE PROPOSE THE PROJECT: TO CREATE
A WORLD INSTITUTE OF KINETICISM!

Moscow 1966. Lev Nussberg.
Members of Dvizheniye: Nussberg, Infante,
Kusnetsov, Buturlin, Koleichuk, Zanevskaya,
Glinchikov, Orlova, Muravieva, Bitt,
Dubovskaya, Stepanov.

Victor Stepanov
127
KINETIC COMPOSITION 1963
72.5 × 49 cm
Private collection

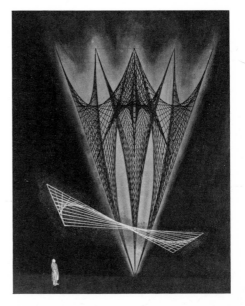

Bibliography

(arranged by country; (r) indicates articles that include reproductions, (cr) those with colour reproductions)

Austria
Exhibition catalogues
1975. *The Russian February 1975 in Vienna (Glezer Collection)*, Künstlerhaus, Vienna. Introduction Hans Mayr, Alexander Glezer and Viktor Tupizin. (r)
1975: *Seven from Moscow: Russian Nonconformist Art*, Künstlerhaus, Vienna. Introduction Alexander Glezer.
1976: *The Russian February 1976 in Vienna (Kholin, Masterkova, Sitnikov, Zelenin)*, Künstlerhaus, Vienna. Introduction Hans Mayr.

Articles
19 February 1975: "USSR: Beating for a Collector", *Neue Kroner Zeitung*. (r)
19 February 1975: "With Eighty Pictures in his Baggage: *Presse* Interview with Alexander Glezer", Hans Haider, *Die Presse*. (r)
20 February 1975: "Glezer Exhibition in Vienna: the Künstlerhaus Presents 80 pictures", *Kurier*. (r)
20 February 1975: "Glezer in the Künstlerhaus: Moscow: Second Nonconformist Exhibition is Open", *Die Presse*.
20 February 1975: "He Fights for Freedom", *Neue Kroner Zeitung*. (r)
23 February 1975: "Künstlerhaus: New Art in the USSR: A New Horizon", *Neue Kroner Zeitung*. (r)
24 February 1975: "First Stop in the West: Vienna: Russian Nonconformist Painting in the Künstlerhaus", Kristian Sotriffer, *Die Presse*.
24 February 1975: "Pictures Speak", Ernst Trost, *Neue Kroner Zeitung*.
24 February 1975: "The Vienna Künstlerhaus shows Alexander Glezer's Collection: Art from the Underground", Liesbeth Böhm, *Kurier*.
1 March 1975: "'Forbidden' artists in the USSR – the Glezer Collection, Art which was crushed with bulldozers...", Kurt Herwig, *Die Furche*, p. 10.
12 March 1975: "Glezer: Exhibition of the Dissidents", *Die Presse*.
22–23 March 1975: "Attention Art. New Tendencies or Illusions", Alexander Glezer, *Die Presse*. (r)
28–29 February 1976: "Tradition und Stillstand": On the exhibition "The Russian February 1976 in Vienna", *Die Presse*.

Czechoslovakia
Books
Dusan Konecny, *Hledani tvaru – Moskevske a leningradske ateliery (In search of form – Moscow and Leningrad studios)*, Svet Sovetu (Soviet World), Prague, 1968.

Exhibition catalogues
1965: *Moskevske kineticke umeni (Moscow Kinetic Art)*, Prague. Introduction Dusan Konecny.
1965: *Experiment, Drawings and Graphics by Young Soviet Artists*, Usti n/Orlici. Introduction Dusan Konecny.
1966: *Yankilevsky and Neizvestny*, Brothers Capek Gallery, Prague. Introduction Dusan Konecny.

Articles
1959: "Ze zivota mlady sovetskych vytvarniku" ("From the Lives of Young Soviet Artists"), Dusan Konecny, *Vytvarne umeni (Visual Art)*, nos 2 and 8.
17–18 October 1962: "Maliar z Lianozova", Tomas Straus, *Výtvarna práce*. On Rabin. (r)
1963: "Revolucni vytvarna fantasie" ("Revolutionary Vision in Art"), Dusan Konecny, *Domov (Home)*, no 6.
1964: "Mladi hledajici" ("Youth in Quest"), Dusan Konecny, *Svet Sovetu*, no 22.
1964: "Snaha o syntezu v umeni" ("Attempt at a Synthesis of Art Forms"), Dusan Konecny, *Domov*, no 4: On the Kineticists.
1964: "Program" (The programme of the Kineticists), Lev Nussberg, *Domov*, no 4.
1964: "Tri mladi grafici ze Sovetskeho Svazu" ("Three Young Graphic Artists from the Soviet Union"), G. Konecna, *Hollar*, vol 33, no 3–4.
1965: "Zema neznama II" ("Unknown Country II"), J. Padrta, *Kulturni tvorba (Cultural Creation)*, no 45.
1965: "Deset dni v Moskve a Leningrade" ("Ten Days in Moscow and Leningrad"), M. Lamac, *Literarni noviny (Literary News)*, no 24.
1965: "Mlade kineticke umeni v SSSR a tradice Sovetske avantgardy" ("Young Kinetic Art in the USSR and the Tradition of the Soviet Avant-garde"), Dusan Konecny, *Acta Scaenographica*, vol V, no 7.
1965: "Tvorba znama i neznama" ("Known and Unknown Works"), Dusan Konecny, *Knizni kultura (Book Culture)*, no 3.
1965: "Pozoruhodny experiment" ("A Notable Experiment"), Dusan Konecny, *Svet Sovetu*, no 28: On the Kineticists.
1965: "Kredo Ernsta Neizvestneho" ("Ernst Neizvestny's Credo"), L. Michailov, *Svet Sovetu*.
1965: "Vystava mladeho moskovskeho kinetickeho umeni" ("Exhibition of Young Moscow Kinetic Art"), Dusan Konecny, *Literarni noviny*, no 7.
1965: "Mladi moskevsti, vytvarnici" ("Young Moscow Artists"), P. Spielmann, *Plamen*, no 5: On the Kineticists.
1965: "Mladi moskevsti kinetiste" ("The Young Moscow Kineticists"), P. Spielmann, *Student*, no 6.

29 June 1965: "Moskevske kineticke umeni" ("Moscow Kinetic Art"), J. S. *Rude Pravo.*
1966: "Problem techniky a mlade moskevske experimentujici umeni" ("The Problem of Technique and the Young Moscow Experimental Art"), Dusan Konecny, *Praha-Moskva*, no 2.
1967: "U Sovetskych pratel II" ("Among Soviet Friends II"), Dusan Konecny, *Vytvarna práce (Art Work)*, no 25.
1967: "Umeni – lidske oceneni sveta" ("Art – a Human Perception of the World"), Vladimir Yankilevsky, *Vytvarne umeni (Fine Arts).* (cr)

France
Books
Raoul-Jean Moulin, *L'Art Russe*, Marabout-Université, 1968.

Exhibition catalogues
1969: *Sixième Biennale de Paris* (I. Belyutin), Musée National d'Art Moderne, Paris.
1969: *I. Belyutin*, Galerie Lambert, Paris. Introduction by Franco Miele.
1970: *Ernst Neizvestny, Oeuvres Graphiques,* Musée d'Art Moderne de la Ville de Paris. Introduction by John Berger.
1973: *Russian Avant-Garde, Moscow 1973,* Galerie Dina Vierny, Paris. Introduction by Dina Vierny.
1974: *Huit peintres de Moscou,* Musée de Grenoble. Preface by Maurice Besset. Anonymous Introduction. (r)
1976: *Trentième Salon des Réalités Nouvelles* (Weisberg, Nemukhin, Rabin, Krasnopevtsev, Kulbak, Shemyakin).
1976: *Le Salon international d'art de Toulon.* (Oscar Rabin.) (r)
1976: *La deuxième biennale Européenne de la gravure de Mulhouse*, (D. Plavinsky, V. Kropivnitskaya, V. Kalinin, O. Kudryashov, V. Yankilevsky). (r)
November 1976: *La peinture russe contemporaine*, Palais des Congrès, Paris. Introduction Alexander Glezer. (cr)

Articles
4 December 1962: "M. Khrouchtchev donne un coup d'arrêt au modernisme en peinture et en musique", *Le Monde.*
28 December 1962: "Le débat sur le modernisme intellectuel se poursuit à Moscou", Michel Tatu, *Le Monde.*
9 March 1963: "Nouvelle rencontre à Moscou entre les dirigeants du parti et les intellectuels", *Le Monde.*
January–March 1964: "Visages inconnus de la peinture soviétique", Jacques Catteau, *Cahiers du monde russe et soviétique.*
March 1964: "Can Communism and Creative Art Co-Exist", Muriel Reed, *Réalités*, pp. 32–37.
June 1965: "Découverte de l'art soviétique inconnu", J. Boudaille, *Lettres françaises.*
March 1967: "La Condition de l'Artiste en URSS", Paul Thorez, *L'Oeil*, no 147, pp. 42–49.
July–August 1967: "Les Peintures Soviétiques Anticonformistes", Paul Thorez: Review of the exhibition of 13 Soviet artists at the Maison de la Tour à Saint-Restitut, *ABC décor*, nos 33–34, pp. 30–33, 38–39. (cr)
December 1967: "Numéro Special sur l'Art Soviétique", Edited by Paul Thorez, *Opus International*, no 4, pp. 22–36 (including "Ouverture à Moscou" by Jindrich Chalupecky; "Quelques Jeunes Peintres" by Miroslav

Lamac; "Nusberg: Lumière et Mouvement" by Jiri Padrta.)
March 1971: "Insights into Contemporary Soviet Art Criticism", G. Gassiot-Talabot, *Opus International*, pp. 24–25.
July–August 1971: "Peintures et Sculptures Clandestines en URSS", Michel Ragon, *Jardin des Arts*, no 200–201, pp. 2–6. (r)
September 1971: "L'art avant-garde de l'URSS", special issue devoted to the Soviet avant-garde, *L'Art Vivant*, no 3. Includes a lexicon of Soviet art terms; "Le Dessin en Union Soviétique" by Daniel Maurandy; extract from the Soviet journal *Dekorativnoye Iskusstvo* SSSR, 1970 no 3 by A. Pavlinskaya; "La Nouvelle Gauche à Moscou" by Jane Nicholson; brief biographies of Yankilevsky, Kabakov, Bulatov, Yakovlev and notes on a few others; "Le Groupe Cinétique, 'Djivenie'" by Michel Ragon. (r)
19 March 1974: Interview with E. Neizvestny, *Le Monde.*
1974: "Paradoxes of the Grenoble Exhibition", Igor Golomshtok, *Kontinent*, no 1. On the exhibition *Huit peintres de Moscou* (in Russian).
18 September 1974: "Trois jeunes peintres condamnés à 15 jours en prison", *Le Monde.*
22–23 September 1974: "The Nonconformist Painters Can Hold their Exhibition in a Moscow Park", *Le Monde.*
5 December 1974: "The Difficult Victory of Alexander Glezer", *Russkaya Misl (Russian Thought)*, Paris (in Russian).
6 December 1974: Article on the exhibition at Izmailovsky Park, *L'Humanité.*
December 1974: "From the Kitchen of the Moscow Avant-garde", Arsen Pohribny, *Svedectvi* (in Czech).
February 1975: "Etre peintre en URSS", Alliance Ouvrière, *Bulletin Spectacle*, no 11.
22 March 1975: Open letter by Alexander Glezer, *Russkaya Misl*, Paris (in Russian).
27 March 1975: "Nonconformist Painters in USSR", interview with Alexander Glezer, *Russkaya Misl*, Paris (in Russian).
28 April 1975: "La jeune peinture perce le front russe", Gérard Niraslov, *Le Figaro.* (r)
April–May 1975: "The Black Market of Russian Painting", Otto Hahn, *L'Express.*
23 September 1975: "Les Artistes non-officiels tiennent leur second Salon d'Automne à Moscou", Nicole Zand, *Le Monde.*
1975 "The September Exhibition of Moscow Artists", Evgeni Barabanov, *Vestnik RSKD (YMCA Journal)*, no 16: On an exhibition of unofficial artists in Moscow (in Russian).
4 December 1975: "Exhibition of Non-Official Soviet Painters", *Russkaya Misl*, Paris (in Russian).
18 December 1975: "Meeting in Vienna" by Alexander Glezer, *Russkaya Misl*, Paris (in Russian).
January 1976: A series of brief illustrated brochures (in Russian) was published by the Russian Museum in Exile at Montgeron to mark the opening of the Museum: the artists dealt with were: Yuri Zharkikh (author Maya Muravnik); Edward Zelenin (Alexander Glezer); Ernst Neizvestny (Alexander Glezer); Ilya Kabakov (Evgeny Shiffers); Valentina Kropivnitskaya (Maya Muravnik); Dmitri Krasnopevtsev (Alexander Glezer); Lydia Masterkova (Alexander Glezer); Otari Kandaurov (artist's own work); Vladimir Weisberg (Alexander Glezer); Mikhail Shemyakin (Tatyana Panshina); Oleg Tselkov (Alexander Glezer); Boris Sveshnikov (Alexander

Glezer); Vladimir Nemukhin (Alexander Glezer);
Vladimir Yankilevsky (Alexander Glezer); Oscar Rabin
(Alexander Glezer); Evgeni Rukhin (Alexander Glezer);
Dmitri Plavinsky (Alexander Glezer).

1 January 1976: "Answer to A. Oudodor", Alexander
Glezer, *Russkaya Misl*, Paris (in Russian). (r)
18 January 1976: "Un 'Voyou' Soviétique Vient
Présenter en France la 'Peinture Décadente' condamnée
par Moscou", Louis Savant, *Le Journal du Dimanche*, p. 3.
(r)
22 January 1976: "Peintres ou Fonctionnaires",
Alexander Glezer, *Informations Ouvrières*, p. 11. (r)
22 January 1976: "Un Musée en Exil: La Peinture
Marginale Soviétique Présentée à Montgeron", Jacques
Dubessy, *Le Figaro*.
29 January 1976: "Russian Independent Artists
Celebrate", T. Panshina, *Russkaya Misl*, Paris: On the
opening of the Russian Museum in Exile (in Russian).
February 1976: "The Russian Museum-in-Exile",
Ronald Tyler, *The Paris Post*. (r)
1976: "Not Provincialism but Originality", Alexander
Glezer, *Vestnik RSKD*, no 117: Commentary on
Barabanov's article in previous issue (in Russian).
1–2 February 1976: "Expositions: Un Musée d'Art
Russe Non Officiel", *Le Monde*, p. 17.
1976: "Twenty Years Later, Notes on the Russian
Nonconformists", Alexander Glezer, *Kontinent*, no 6 (in
Russian). (cr)
9 February 1976: "Art Russe: Le Salon des Interdits",
Sabine Marchand, *Le Point*, no 177, p. 89. (r)
9–15 February 1976: "Le Musée en Exil de Gleser",
L'Express, no 1283, pp. 26–27.
10 February 1976: "Musée Russe en Exil", François
Laville, *Loisirs Jeunes*, no 982.
March 1976: "L'Evénement du Mois: Les Peintres
Maudits par l'URSS", Christine Masson, *L'Estampille*,
no 75. (cr)
18 March 1976: "Exhibition of Russian Artists in Vienna",
Maria Razumovskaya, *Russkaya Misl*: On the exhibition
"The Russian February 1976 in Vienna" (in Russian). (r)
7 October 1976: "Two Years Later", Alexander Glezer,
Russkaya Misl: On the Unofficial Artists since 1974. (r)
1976: "The Sculptural Alphabet of E. Neizvestny",
Evgeni Shiffers, *Kontinent*, no 8 (in Russian).
4 November 1976: "Independent Artists talk about their
Work", Oscar Rabin and Ilya Kabakov, *Russkaya Misl* (in
Russian). (r)
11 November 1976: "Independent Artists Talk about
their Work", Oleg Tselkov and Boris Sveshnikov,
Russkaya Misl (in Russian). (r)
18 November 1976: "Independent Artists Talk about
their Work", Vladimir Nemukhin and Yuri Zharkikh,
Russkaya Misl (in Russian). (r)

Great Britain
Books
John Berger, *Art and Revolution, Ernst Neizvestny and the
Rôle of the Artist in the USSR*, Weidenfeld and
Nicholson, 1969. (Also published in USA.) (r)

Exhibition catalogues
1964: *Aspects of Contemporary Soviet Art*, Grosvenor
Gallery, London. Introduction Eric Estorick.
1965: *Oscar Rabin*, Grosvenor Gallery, London.
Introduction Jennifer Louis.

Articles
January 1960: "Varieties of Communist Experience",
Arthur Schlesinger Jr., *Encounter* 14.
21 February 1963: "Dogma's Tail", Alain Besançon,
Guardian: On Khrushchev at the Manège.
April 1963: "Khrushchev on Modern Art", *Encounter* 20,
no 4.
July 1963: "Pictures from an Exhibition", R. Etiemble,
Survey, no 48.
12 June 1964: "Dull Russian Paintings", Peter Stone,
Jewish Chronicle. On the Grosvenor Gallery exhibition,
excepts Oscar Rabin from criticism.
13 June 1964: "Pictures from Russia", *Scotsman*.
14 June 1964: "Soviet Painters on the Move", *Observer*.
14 June 1964: "Russian Invasion", Robert Melville,
Sunday Times: Brief comment on the Russian exhibition
at the Grosvenor Gallery, London.
May–June 1965: "Rabin: The Grosvenor Gallery",
Laurence H. Bradshaw, *The Arts Review*, vol xvii, no 10,
p. 4. (r)
June 1965: "Oscar Rabin: Soviet Solitary", Jennifer
Louis, *Studio International*, pp. 246–249. (cr)
10 June 1965: "Russian Painter's Pictures", *Yorkshire
Post*.
2 July 1965: "The Art of Oscar Rabin", Charles Morris,
Daily Worker.
October 1965: "Oscar Rabin, Painter", Jacques Catteau,
Survey, no 57.
April 1966: "Soviet Painting: Old Tradition and New
Painters", Jacques Catteau, *Survey*, no 59.
15 June 1966: "A Soviet Artist Is Told: Your Works Are
Rubbish", *Morning Star*: Takes issue with attack on
Oscar Rabin in *Sovietskaya Kultura*.
August 1966: "Moscow Kineticists", *Studio International*,
pp. 90–92.
24 January 1967: "Officials Close Art Show for Good",
Morning Star: On the Druzhba Club exhibition in
Moscow.
15 April 1967: "What is Kineticism?", Lev Nussberg,
Form, no 4, Exeter.
December 1967: "Kinetic Performance in Leningrad",
Studio International, p. 287: On the group "Dvizheniye"
("Movement"). (r)
December 1967: "Russian Unofficial Art – A Fairy Tale
without a Firm Road?", Stuart Lawrence, *Form*, no 6,
Exeter.
July 1969: "Art and Rhetoric", Alun Falconer, *Studio
International*, p. 44: Review of the book *Art and
Revolution*, by John Berger.
February 1970: "Art and Revolution in the USSR", John
Berger, *Architectural Design*, pp. 66–67.
October 1970: "Soviet Kinetic Display", *Studio
International*, p. 131. (r)
10 December 1972: "Tractor Artists", David Floyd,
Sunday Telegraph.
February 1973: "Moscow Diary", Jindrich Chalupecky,
Studio International, pp. 81–96: Record of impressions of
Moscow and artists visited, during a week in summer 1972. (r)
4 May 1973: "Paris is looking at Russian Unofficial Art",
The Times.
21 June 1973: "Russian Avant-garde Art, Moscow 1973",
Sarah White, *New Scientist*, p. 774: Review of the
exhibition at Galerie Dina Vierny, Paris. (r)
16 September 1974: "Ivanovich Knows What He Likes",
Jonathon Steele, *Guardian*.

16 September 1974: "Russians use Bulldozers to Halt Art Show", John Miller, *Daily Telegraph*. (r)

17 September 1974: "Soviet Artists Whose Show Was Wrecked by Police Jailed", John Miller, *Daily Telegraph*.

21 September 1974: "Tate Gallery Director Cancels Visit to Russia", Philip Howard, *The Times*.

21–27 September 1974: "The KGB Just Isn't Itself These Days", *Economist*.

27 September 1974: "Abstract Art Truce in Russia", John Miller, *Daily Telegraph*.

30 September 1974: "Frames of Reference for Soviet Images", *The Times*.

30 September 1974: "Moscow Art Show a Success", Frank Robertson, *Daily Telegraph*.

30 September 1974: "Muscovites Flock to See Art Show in Park", Edmund Stevens, *The Times*. (r)

October 1974: "A Moscow Event: The Soviet Union's First Autumn Outdoor Art Show", *Studio International*, p. 164.

9 November 1974: "Art survives the KGB", Theo Richmond, *Guardian*: An Interview with Igor Golomshtok.

December 1974: "The Mechanism of Control: Unofficial Art in the USSR", Igor Golomshtok, *Studio International*, pp. 239–244: Discussion of the implications of the two open-air exhibitions in Moscow, 16 and 29 September 1974. (r)

14 December 1974: "KGB Interrogate Organiser of Art Displays", *The Times*.

1975: "Education and Ideology in the USSR", Dimitri Pospielovsky, *Survey* 21, no 4.

17 February 1975: "Russian Art Promoter Emigrates to West", *The Times*.

17 February 1975: "Unofficial Art Show Organiser Leaves Russia", *Daily Telegraph*.

28 April 1975: "The Tropic of Cancer Ward", *Guardian*, 8.

18 June 1975: "When the Moscow Municipal Authorities sent the Bulldozers into an Exhibition . . . The Echoes went round the world", Ben Jones, *Guardian*. Report on waning optimism in Moscow in the wake of the hopes of September 1974.

18 June 1975: "Michael Kustow Interviews Alexander Glezer", *Guardian*. A long and detailed account of Glezer's life – his first contact with art, his activities as dissident collector and organiser. (r)

12 June 1975: "From Russia to Britain with 600 Pictures in Mind", Richard Lay, *Daily Mail*, p. 20. Account of Glezer's arrival in Britain, and future plans.

September–October 1975: "A Year after the Bulldozers". Alexander Glezer. Detailed account of the ambiguous and contradictory attitudes of the authorities towards dissident artists in the year that followed the two open-air exhibitions. *Studio International* pp. 152–153.

Winter 1975: "Soviet 'Unofficial' Art." Alexander Glezer. Analysis of the struggles of dissidents with the authorities since the "Manege Incident" in 1962. Detailed account of the repercussions for individual artists as a result of the "bulldozer" exhibition. *Index on Censorship*, vol 4, no 4, pp. 35–40. (r)

14 May 1976: "Image of Modern Russia". *Arts Review* no 10. Review of small exhibition of religious paintings at Parkway Focus Gallery, London (Glezer Collection).

Italy
Books
Franco Miele, *L'avanguardia tradita : arte russa del XIX al XX sec*. Carte Segrete, 1973.

Exhibition catalogues
1965: *Russi Anni 20 Avanguardia e Rivoluzione*, Gallerie D'Arte "il centro". Introduction by Elio Mercuri.
1965: *Alternative Attuali II (Topical Alternatives II)*, Aquila.
1967: *Fifteen Young Moscow Painters*, Galleria il Segus, Rome. Introduction by Angelica Savinio de Chinco.
1969: *I. Belutin*, Galleria "La Barcaccia", Montecatini. Introduction by Franco Miele.
1969: *Ernst Neizvestny*, Galleria "La Barcaccia", Montecatini. Introduction by Franco Miele.
1969: *New School of Moscow*, Galleria Pananti, Florence. Introduction by A. Pohribny.
1971: *Ernst Neizvestny*, Galeria "Il Gabbiano", Rome. Introduction by John Berger, R. Guttuso.
1971–72: *V. Sitnikov*, Centro di Iniziative Culturali, Arezzano. Introduction by Franco Miele.
1972: *Neizvestny and Other Soviet Artists*, Galleria Anthea, Rome. Introduction by Giuseppe Selvaggi.
1975: *From Moscow to Milan, Soviet Dissident Paintings*, Galleria del Circolo, Milan.

Articles
September 1962: "Disgelo in Tavolozza", Giovanni Crino, pp. 68–74. (cr)
October 1965: "Alla mostra dell' Aquila, le esperienze dei giovani sovietici", Elio Mercuri, *Realta Sovietica*.
October 1965: "'Op-art' in Russia", *Domus*, no 431.
9 November 1965: "Soffre come per una seconda nascita il 'cosmonauta' di Neizvestny", Augusto Pancaldi, *Unita*.
July 1967: "Non na Scelto la Facile Accademia Neizvestnyj", Konstantin Teljatnikov, *Realta Sovietica*, pp. 18–23. (r)
July 1967: "A Roma i maestri della grafica", Elio Mercuri, *Realta Sovietica*. (r)
28 July 1967: "I giovani artisti", A. del Guercio, *Rinascita*.
August–September 1967: "I Giovani Pittori di Mosca", Miroslav Lamac, *La Biennale di Venezia 62*, pp. 18–26. (cr)
1967: "Mosca all'ora del risveglio", Miroslav Lamac, *D'Ars Agency*, no 34, Milan.
1968: "Ricerche dopo l'Informale", Enrico Crispolti, Rome.
1969: "I pittori del dissenso", Asiaticus, *L'Espresso*, no 16.
16 April 1973: "Pittura russa d'avanguardia", Franco Miele, *Umanita* (Rome).
16 September 1974: "Moscow: Painters are Beaten up and the Paintings destroyed", Luigi Vismara, *Il Giorno*, Milan.
16 September 1974: "Police Anger in Moscow: Charge against the Abstracts", *La Stampa*.
16 September 1974: "Painter in Russia", Antonio Scialota, *Il Giornale*, Rome.
29 September 1974: "Moscow – 5,000 visitors for the exhibition of the Modernists – five weeks after the hard Repression", Luigi Vismara, *Il Giorno*, Milan.
29 September 1974: "The Exhibition of the Abstracts in Moscow almost a Happening", *La Stampa*.
3 September 1975: "Uniono Sovietica – La Cultura Imbavagliata: Quatto Storie della Persecuzione", Giuseppe dall'Ongaro, *Il Settimanale*, no 36, pp. 24–27. (cr)

Poland
Exhibition catalogues
1966: *Sixteen Moscow Artists*, Sopot-Poznan. (r)

Scandinavia
Exhibition catalogues
20 August–30 September 1971: *10 Künstnere fra Moska
(Ten Painters from Moscow)*, Københavns Kommunes
Kulturfond, Copenhagen. Introduction by Dea Trier
Mørch.

Articles
1967: "Oscar Rabin – ryska kakars malare", Jacques
Catteau, *Ordoch Bild*, Stockholm.
16 September 1974: "Graumaskiner Vapen Mot Konst",
Dagens Nyheter.
25 September 1974: "Norsk Klage: Moskva", Nils
Morten Udgaard, *Aftenposten*, Oslo.
12 October 1974: "Sovjets Unoffisielle Kunstnere", Nils
Morten Udgaard, *A Magasinet*, no 41, pp. 18–22, 39. (cr)
18 January 1975: "The Situation of the Painters in the
Soviet Union. The Dissidents are Greeted with
Sympathy", Nils Morten Udgaard, *Aftenposten*.
19 February 1975: "Västdi plomater Smugglade", Peter
Hoffer, *Svenska Dagbladet*, Stockholm. (r)
19 February 1975: "Kupp i Sovjet: Misshaglig Konst
Ford till Sverige", Peter Hoffer, *Goteborgs Posten*.
19 February 1975: "Förbjuden Sovjetkonst till Sverige"
and "Rysk Konstkupp: Jattesamling Smugglad Hit",
Svenska Dagbladet. (r)
21 February 1975: "Rysk Konst för Miljone Göms i
Bastu", *Svenska Dagbladet*. (r)
4 August 1975: "Han Viser Vest-Europa Sovjets
Förbudte Konst", Per Luthander and Bela Unger,
V. G. (Norway) p. 30. (r)

Soviet Union
Books
V. Vanslov (ed.), *Sovietskoye izobrazitelnoye iskusstvo i
zadachi borby c burzhyaznoi ideologiyei (Soviet Art and the
Tasks of the Struggle against Bourgeois Ideology)*,
Izobrazitelnoye Iskusstvo, 1969. Contains an article by
A. Lebedev attacking the 1966 exhibition of the
Kineticists and another by S. Chervonnaya attacking
Oscar Rabin, Lev Nussberg, Ernst Neizvestny, Mikhail
Grobman, Vladimir Yankilevsky and Anatoli
Brusilevsky.
N. Malakhov, *Sotsialisticheski realizm i modernizm
(Socialist Realism and Modernism)*, Iskusstvo, 1970:
Criticizes Rabin and Krasnopevtsev.
A. K. Lebedev, *K sporam ob abstraktsionizme v iskusstve
(On the debate about abstractionism in art)*, Izobrazitelnoye
Iskusstvo, 1970. General attack on abstractionism in the
West and attacks on the Dvizheniye group, Rabin and
other unofficial Soviet artists.

Articles
1958: "Pomoika no 8", *Moskovski komsomolets*: Attack on
Oscar Rabin.
1962: "Poiski i zhiznennaya pravda" ("Searches and
Truth to Life"), A. Yagodovskaya, *Tvorchestvo
(Creation)*, no 5.
1962: "Bez geroya" ("Without a Hero"), Y. Khalaminski,
Tvorchestvo, no 11.
April 1963: "Art and Pseudo-Art", Lev Nikulin, *Soviet
Literature Monthly* (in English).

1965: "Klub na Maryinskoi" ("The Club on Maryinski
Street"), S. Ilyin, *Yunost (Youth)*, no 7: On the
Kineticists.
14 June 1966: "Dorogaya tsena chechevichnoi
pokhlebki" ("A High Price to Pay for a Mess of Pottage"),
V. Olshevski, *Sovietskaya Kultura*: Attacks Oscar Rabin
for his 1965 exhibition at the Grosvenor Gallery in
London.
1967: "Zrelishche poka bezimyonnoye" ("A Spectacle
Still Without a Name"), Y. Aikhenvald, *Teatr (Theatre)*,
no 1: On the Kineticists.
February 1967: "Opinions Differ: Seven Artists'
Exhibition", Vladimir Makarenko, *Soviet Literature
Monthly*, pp. 176–180 (in English).
25 May 1967: "Byt' dostoinym pochetnogo zvaniya
khudozhnika strany Sovietov" ("Be Worthy of the
Honoured Title of Artist in the Land of the Soviets") and
"Ne izvrashchat' Sovietskuyu deistvitelnost" ("Do not
Deform Soviet Reality"), *Sovietski khudozhnik (Soviet
Artist)*: Both articles attack the exhibition at the Druzhba
Club and its participants.
26 May 1967: "Seminar", V. Zaporozhchenko,
Komsomolskaya Pravda: On the Kineticists.
September 1968: "O bombakh nachinennykh ideyami"
("On Bombs Stuffed with Ideas"), B. Shcherbakov,
Agitator, no 8 (the journal of the Central Committee of the
Communist Party): Criticises Western art and its Soviet
followers such as Rabin, Neizvestny, Weisberg and
Kabakov.
20 February 1970: "Chelovek s dvoinym dnom" ("The
Man with the Double Bottom"), R. Strokov, *Vechernyaya
Moskva (Moscow Evening News)*: Lampoon of Alexander
Glezer.
20 September 1974: Letter to the editor of *Sovietskaya
Kultura* from a group of "workers" protesting against the
actions of the painters in preventing them from carrying
out their "Sunday voluntary work" on the patch of waste
ground in Belyayevo-Bogorodskaya.
18 September 1974: "Letopis zhizni narodnoi" ("A
Chronicle of Popular Life"), Fyodor Reshetnikov,
Vechernyaya Moskva: Attacks the exhibition in
Izmailovsky Park.
23 October 1974: "Kak rasseyalsya mirazh" ("How the
Mirage was Dispersed"), N. Ribalchenko, *Vechernyaya
Moskva*: Another attack on the Izmailovsky Park
exhibition.
12 December 1974: "I vsyo-taki s dvoinym dnom"
("A Double Bottom after All"), R. Strokov, *Vechernyaya
Moskva*: Accuses Glezer of organising the two open-air
exhibitions as "provocations" and of undertaking "anti-
Soviet" activities.
10 March 1975: "Avangard meshchanstva" ("An Avant-
garde of Philistines"), Y. Nekhoroshev (editor-in-chief of
Tvorchestvo), *Vechernyaya Moskva*.
16 April 1975: "Ostalis ot kozlika" ("They Picked Him
Clean"), V. Kazakov, *Literaturnaya gazeta (Literary
Gazette)*: Asserts that Glezer is starving in the West
because no one is interested in his collection of pictures.
17 May 1975: "Tretyego puti net" ("There is No Third
Way"), I. Gorin, *Moskovskaya Pravda (Moscow Pravda)*:
Asserts that there is only Socialist art and bourgeois art
and can be no "third way". Assigns unofficial artists to
category of bourgeois.
August 1975: "Falshiviye tsennosti abstraktsionizma"
("The False Values of Abstractionism"), Dmitri

Nalbandyan, *Ogonyok (The Lamp)*, no 32.
16 March 1976: "Glazami Sovietskogo khudozhnika"
("Through the Eyes of a Soviet Artist"), Evgeni
Rastorguyev, *Sovietskaya Kultura*: A hostile account of
the Berlin exhibition of the Glezer Collection.

Switzerland
Exhibition catalogues
1965: *Zverev: Peintures, Gouaches, Aquarelles*, Galerie
Motte, Geneva. Introduction by Igor Markevich.
1970: *New Tendencies in Moscow*, Museo delle Arti,
Lugano.
1972: *The Russian Avant-garde 1960–1970*, Galerie
Liatowitsch, Basle.

Articles
1 July 1967: "Contemporary Art in the Soviet Union:
Concerning the exhibition of unofficial painters in Rome",
Neue Zürcher Zeitung.
4–5 November 1967: "50 ans de peinture sovietique.
Le combat des jeunes peintres", Jacques Catteau,
La Gazette Litteraire, Lausanne. (r)
17 September 1974: "Prison for Soviet Nonconformist
Painters", *Neue Zürcher Zeitung*.
February 1976: "Die Widergeborene Kunst und die
Sowjet-Inquisition", Alexander Glezer, *Kunst-Bulletin*,
no 2, pp. 1–7. (r)

USA
Books
Priscilla Johnson and Leopold Labedz (eds), *Khrushchev
and the Arts – the Politics of Soviet Culture 1962–64,
Documents*, M.I.T. Press, Cambridge, 1965.
Paul Sjeklocha and Igor Mead, *Unofficial Art in the Soviet
Union*, University of California Press, Berkeley and
Los Angeles, 1967. (cr)
The Horizon Book of the Arts of Russia, American Heritage
Publishing, New York, 1971. (cr)
Gervaise Frere Cook (ed), *The Art and Architecture of
Christianity*, Western Reserve University Press,
Cleveland, 1972. (cr)
Susan Jacoby, *Moscow Conversations*, Coward McCann,
New York, 1972.
Abraham Rothberg, *The Heirs of Stalin – Dissidence and
the Soviet Regime 1953–1970*, Cornell University Press,
Ithaca, 1972.
Rudolph L. Tokes (ed), *Dissent in the USSR – Politics,
Ideology, People*, Johns Hopkins University Press,
Baltimore, 1975.

Exhibition catalogues
1967: *A Survey of Russian Painting from the Fifteenth
Century to the Present*, Gallery of Modern Art, New York.
(r) Catalogue to part of the same exhibition, entitled *The
Nina Stevens Collection of Twentieth Century Russian
Paintings*. Introduction Margaret Potter. (r)
1970: *Contemporary Unofficial Soviet Painting*, Pollock
Galleries, Owen Arts Center, Southern Methodist
University, Dallas, Texas. Introduction Arthur M. Odum.
1975: *Boris Birger: A Catalogue*, Ardis, Michigan.
Preface Heinrich Böll. Introduction Shirley Glade,
Ellendea Proffer. (cr) No exhibition accompanied this
catalogue in fact.
1975: *Eugene Rukhin: a Contemporary Russian Artist*,
North Carolina Museum of Art, Raleigh. Introduction
Moussa M. Domit, biographical note Ruth Mayfield.

1976: *Soviet Art: Exhibit and Sale*, Woodward and
Lothrop Gallery, Washington, D.C. Introduction
"A Soviet School of Painting", John E. Bowlt.
1976: *New Art from the Soviet Union*, Cremona
Foundation, Mechanicsville, Md. Introduction Norton
T. Dodge. Accompanied exhibition at annual convention
of American Association for the Advancement of Slavic
Studies, St Louis.

Articles
December 1957: "Abstract Paintings by an Anonymous
Leningrad Painter at Daniel Cordier", *Arts Magazine*,
p. 13.
April 1958: "Art and Artists under Communism today,
a Compendium of Interviews", *Art News*, vol 57.
March 1959: "I was an abstractionist in the USSR",
Pierre Schneider, *Art News*, vol 58.
March 1960: "The Art of Russia . . . That Nobody Sees",
Alexander Marshacke, *Life Magazine*.
October 1960: "Avant-garde and Revolution:
Modernist Art in the USSR is tentatively asserting itself
anew", K. A. Jelenski, *Arts Magazine*, pp. 36–41.
17 December 1962: "Art for the Party's Sake", *Newsweek*.
5 July 1965: "Russian Painters' Exhibition",
New York Times.
April 1966: "Varvardisty: Soviet Unofficial Art",
Paul Sjeklocha and Igor Mead, *Russian Review*,
pp. 115–130.
Autumn 1966: "Soviet Art: The Changing Scene",
Paul Sjeklocha and Igor Mead, *Per/se* pp. 3–13.
29 January 1967: "About Art Russia Doesn't Know What
It Likes", R. H. Anderson, *New York Times*.
March/April 1967: "The New and the Old: From an
Observer's Notebook", George Gibian, *Problems of
Communism*, pp. 57–64.
25 May 1967: "The Russians and the Bauhaus", *Luminism*.
9 June 1967: "Russian Art show in Rome", *International
Herald Tribune*.
September–October 1968: "Outsider Art inside Russia",
Nina Stevens, *Art in America*.
September 1969: Review of John Berger's book *Art and
Revolution*, J. Jacobs, *Art in America*.
February 1970: "The Attacks on Soviet Artists Are Quite
Serious", Anthony Astrachan, *Washington Post*.
April 1970: "Art and Artists of the Underground",
Arsen Pohribny, *Problems of Communism*, no 4.
2 December 1970: "The Current USSR Art Scene",
J. F. Clarity, *New York Times*.
1 August 1971: "Breaking Free: Contemporary Art in
Russia", Susan Jacoby and Anthony Astrachan,
Washington Post.
December 1971: "Refreezing the Thaw", J. Rubenstein,
Art News, pp. 40–41.
June 1972: "Russia's Underground Art Market",
S. Schwarz, *Art Forum*, no 10, pp. 54–55.
November 1972: "The Virtues of Socialist Realism",
Art in America, vol 60.
February 1974: "The Other Cultural Revolution",
R. Del Renzio, *Art and Artists*, no 8, pp. 20–23.
16 September 1974: "Soviet Officials Use Force to Break
Up Art Show. Painters, Newsmen Roughed up in
Turbulent Public Confrontation", Christopher S. Wren,
International Herald Tribune.
16 September 1974: "Soviet Authorities Use Gang of
Hoodlums to Break up Art Show", Michael Parks,
Baltimore Sun.

17 September 1974: "Art Under the Bulldozers", *Christian Science Monitor*.

17 September 1974: "Five Russians Charged after Scandal at Art Show", Hedrick Smith, *New York Times*.

23 September 1974: "Modernist Art in the Soviet Union. A Legacy of Khrushchev", *New York Times*.

30 September 1974: "The Kremlin Improves Its Image. Enthusiasts of Op-art and Pop-art Crowd into the Russian Woodstock", Robert Toth, *Los Angeles Times*

30 September 1974: "Historic Exhibit", Pester Osnos, *Washington Post*.

30 September 1974: "Detente: Now the Questions", *Newsweek*. (r)

30 September 1974: "Soviet Union: Art v. Politics", *Time*.

30 September 1974: "10,000 flock to Moscow Park to see Show of Modern Art", Hedrick Smith, *Herald Tribune*.

1 October 1974: "Soviet Artists Sense a Thaw in Art", Michael Parks, *Baltimore Sun*.

3 October 1974: "Soviet Union: Broken up with Water Cannon", *Panorama*.

5 October 1974: "Nonconformists Ask Permission for Exhibition Indoors", *New York Times*.

6 October 1974: "Soviet Art – What Next?", *New York Times*.

14 October 1974: "The Russian Woodstock", *Time*.

November 1974: "The New Expatriates", Eduard Roditi, *Art News*.

November 1974: "Under Stalin you Could Have Been Shot", *Art News*, p. 72.

2 November 1974: "Russian Unofficial Artists see Threat to 'Ruin Their Lives'", Hedrick Smith, *International Herald Tribune*.

December 1974: "Art and Politics in Russia", P. Gardner, *Art News*, pp. 44–46.

6 December 1974: "Soviet Artists Reject an Offer of Exhibition, Citing Harassment", Christopher S. Wren, *International Herald Tribune*.

27 December 1974: "8,000 Visit 4-Day Exhibition of Unorthodox Art in Leningrad", *International Herald Tribune*.

1975: "The Art of Change", John E. Bowlt, *Journal of Russian Studies*.

3 March 1975: "Rebels in the USSR", Douglas Davis with Alfred Friendly Jr, *Newsweek*, p. 43.

March–April 1975: "Art and Politics and Money: The Moscow Scene", John E. Bowlt, *Art in America*.

11 August 1975: "Premiere Exhibit: Correspondents bought Russian's Art", Mary Burch, *The Raleigh (N.C.) Times*.

11 September 1975: "Unofficial Art in the Soviet Union", Alexandria Johnson, *Christian Science Monitor*.

22 September 1975: "Moscow Artists Compromise: Nonconformist Show Opens", *International Herald Tribune*.

December 1975: "The Soviet Art World: Compromise and Confusion", *Art News*.

December 1975: "The Tupitsyns Come in Search of Intellectual Freedom", Susan Jacoby, *Mainliner* (The United Airlines and Western International Hotels Magazine).

4 December 1975: "'Unaccepted' Russian Artist at the Phillips", Benjamin Forgey, *The Washington Star*.

7 February 1976: "Art Smuggled out of Russia Makes Satire Show Here", Grace Glueck and "Impish Artists Twit the State", David K. Shipler in Moscow, *New York Times*, p. 23.

11 April 1976: "Why Khrushchev's Favorite Sculptor Chose Exile", Anthony Astrachan, *New York Times*.

13–14 November 1976: "The Russian 'Avant-garde' and Its Enemies", Michael Gibson. *New York Herald Tribune*.

West Germany

Exhibition catalogues

1974: *Progressive Tendencies in Moscow 1957–1970*, Bochum Museum, Bochum. Introduction Arsen Pohribny.

1974: *Gruppe Bewegung-Moskau 1962–1972 (Dvizheniye Group)*, Museum Hans Lange, Krefeld. Introduction P. Sager.

1975: *Russian Nonconformist Artists* (served for exhibitions in Braunschweig, Freiburg, Konstanz). Introduction Alexander Glezer.

1975: *Russian Nonconformist Artists*, Berlin. Introduction Alexander Glezer. (r)

1976: *Alternatives*, Esslingen. Introduction Alexander Glezer. (r)

Articles

April 1967: "Neue Kunst in Moskau", J. Padrta, *Das Kunstwerk*, Baden Baden, no 7–8, pp. 3–18.

February 1968: "Brief aus Moskau", *Das Kunstwerk*, pp. 38–40.

October 1969: "Das 'Kiber' Theater", L. Nussberg, *Das Kunstwerk*, pp. 44–45.

4 February 1970: "The Exhibition of Contemporary Soviet Painters Outside the Soviet Union", Ursula Foss, *Kölner Stadt Anzeiger*.

4 February 1970: "Hintergründiger Witz", Ursula Vob, *Kölner Stadt Anzeiger*. (r)

16 February 1970: "Norm Umgangen", *Spiegel*.

26 February 1970: "Russische Avangarde – Ausstellung in Köln", Werner Schulze Reimpell, *Die Welt*. (r)

28 February 1970: "Um einen Zipfel Freiheit. Russische Avangarde in der Galerie Gmurzynska", *Frankfurter Rundschau*. (r)

October 1970: "Aspekte zum Thema Kollektivkunst", edited by V. Graf, 11 *Werk*, pp. 670–1.

14 January 1973: "Child of Kandinsky against the Kremlin", Peter Michalski, *Welt am Sonntag*.

7 October 1973: Article on Evgeni Rukhin, *Stuttgarter Nachrichten*.

March 1974: Review of the exhibition "Gruppe Bewegung-Moskau 1967–1972", P. Sager. *Das Kunstwerk*, pp. 47–48.

September–October 1974: "Soviet Union: From the Wasteland", *Spiegel*.

16 September 1974: "Social Realism for the State: In the Suburbs of Moscow a Rare Event, a Demonstration of Painters – and its Suppression", Rudolf Chimelli, *Süddeutsche Zeitung*.

17 September 1974: "Moscow is Mounting a Campaign against Nonconformist Painters", Ernst-Ulrich Fromm, *Die Welt*.

23 September 1974: On the First Open-air Moscow Exhibition, *Spiegel*.

19 February 1975: "In Vienna Seven of the Forbidden Painters from the Glezer Collection", *Süddeutsche Zeitung*.

24 February 1975: "Russian February 1975: 80 paintings of Nonconformist Soviet Artists from the Collection of

Glezer shown in the Vienna Künstlerhaus", Hilde Spiel, *Frankfurter Allgemeine Zeitung.*
26 February 1975: "With 80 Pictures to the West: Alexander Glezer shows Nonconformist Russians in Vienna", Otto F. Beer, *Süddeutsche Zeitung.*
21 March 1975: "Aus Moskau Verjagt: Bilder im Exil", Thomas Schröder, *Zeit Magazine*, pp. 40–47. (cr)
April 1975: "Inoffizielle Künstler, Kulturhaus Gaza, Leningrad", *Pantheon*, p. 82.
7 April 1975: "Sowjet-Union: Wachsen im Keller", *Spiegel*, pp.129–132.
10 May 1975: "At the Braunschweig Art Association: Painters from Moscow – Who Refuse to Toe the Line", *Braunschweiger Zeitung.* (r)
13 May 1975: "Informative Exhibition of the Art Association at the 'Salve Hospes' house: 70 pictures by Nonconformist Russian Painters", *Braunschweiger Zeitung.* (r)
15 May 1975: "Pictures of the Outcasts: Braunschweig Russian Nonconformists", Ingrid Kulenkampff, *Hannoverche Allgemeine Zeitung.* (r)
23 May 1975: "The Apolitical Message", Gottfried Sello, *Die Zeit.* (r)
24 May 1975: "The Rebirth of Art and the Soviet Inquisition: the Nonconformist Painters of Russia", Alexander Glezer, *Frankfurter Allgemeine Zeitung.* (r)
26 May 1975: "Rewarding Cross-Section in the Vienna Künstlerhaus: Forbidden Pictures from the Soviet Union", *Braunschweiger Zeitung.*
30 May 1975: "Our Picture", *Deutsches Wirtschaftsblatt*, Mainz.
31 May 1975: "Exhibition of Russian Painters: Art Association has Success", *Braunschweiger Zeitung.*
August 1975: "Emigrant Pictures: Nonconformist Art in the USSR from the Glezer Collection", Peter Sager, *Westermanns Monatshefte*, pp. 49–59.
20 October 1975: "Desperate Escape Attempt: the Freiburg Art Association Shows Nonconformist Russian Painters", Hans Joachim Müller, *Freiburg Kunstverein*, p. 12.
6 November 1975: "Art Gallery Director Loaned a Truck and 99 Pictures were secretly brought out of W. Berlin", *Bild-Berlin.*
6 November 1975: "In Charlottenburg Town-Hall: Russian Critics of the Regime Exhibit their Paintings", *Bild-Berlin.* (r)
6 November 1975: "Now in Berlin: Pictures Which Nobody is Allowed to See in Moscow", *Bild-Zeitung.* (r)
8 November 1975: "He [Glezer] Brought the Russian Pictures to Berlin", *Bild-Zeitung.*
8 November 1975: "The Other Face: Art from the Black Market: Soviet Nonconformists", Peter Hans Göpfert, *Berliner Morgenpost.*
8 November 1975: "Town Hall Showed 99 Pictures from the Soviet Union", *Berliner Morgenpost.*
9 November 1975: "The Secret Variety: Nonconformist Russian Painters from the Glezer Collection", Werner Langer, *Der Tagesspiegel Feuilleton*, p. 5.
9 November 1975: "Town Hall Charlottenburg: Dangerous Art", *Spandauer "Volksblatt"*, Berlin.
25 January 1976: "A Museum for Russia's Forbidden Works of Art", *Die Welt.*
3 February 1976: "Painters from the USSR: In Exile", *Sudkurier.*
23 March 1976: "New Ways of Art at −20°", *Schwäbische Zeitung.*

24 March 1976: "Sad Pictures from the Opposition – Alexander Glezer's Collection of Nonconformist Russian Artists now in Saulgau", *Schwäbische Zeitung.*
24 March 1976: "Surrealism is Truth", interview with Alexander Glezer, *Schwäbische Zeitung.*
11 September 1976: "Nonconformist Art in the USSR – in the Face of Oppressive Ideology", Alexander Glezer, *Esslinger Zeitung.* (r)

Yugoslavia
Exhibition catalogues
1965: *Ernst Neizvestny*, City Museum, Belgrade. Introduction D. Cosic and N. Stipcevic.
1966: *New Tendencies III*, Zagreb.